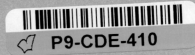

X-RAY

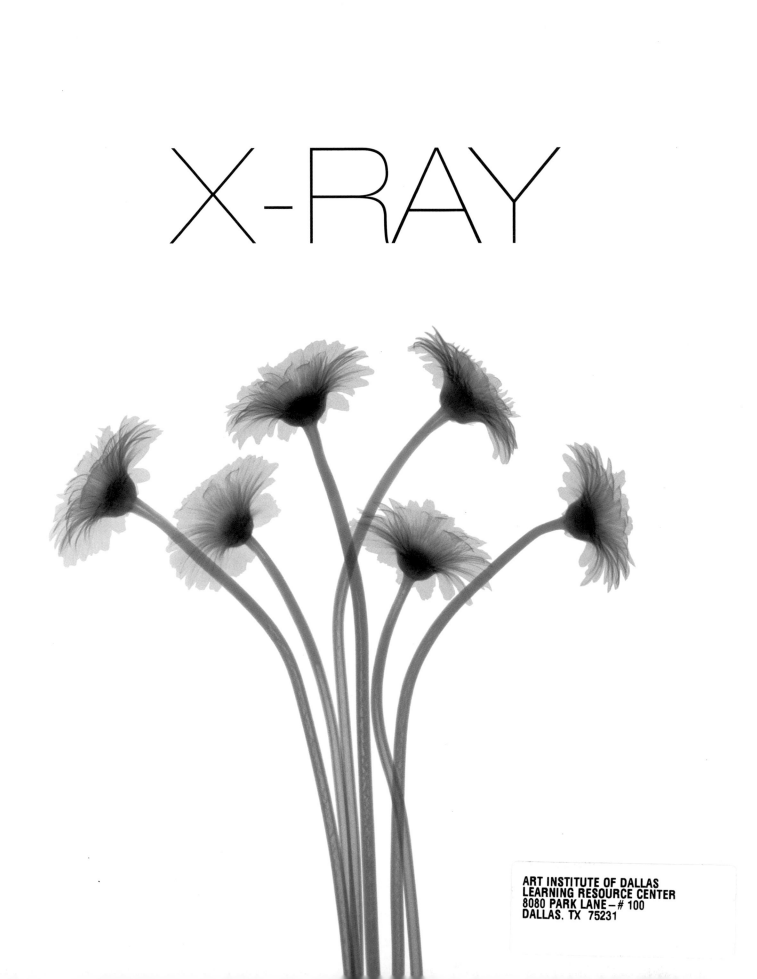

For Molly and Herbie. Show this to your own kids one day.

VIKING STUDIO
Published by the Penguin Group
Penguin Group (USA) Inc., 375 Hudson Street,
New York, New York 10014, U.S.A.
Penguin Group (Canada), 90 Eglinton Avenue East, Suite 700,
Toronto, Ontario, Canada M4P 2Y3
(a division of Pearson Penguin Canada Inc.)
Penguin Books Ltd, 80 Strand, London WC2R 0RL, England
Penguin Ireland, 25 St. Stephen's Green, Dublin 2, Ireland
(a division of Penguin Books Ltd)
Penguin Books Australia Ltd, 250 Camberwell Road, Camberwell,
Victoria 3124, Australia
(a division of Pearson Australia Group Pty Ltd)
Penguin Books India Pvt Ltd, 11 Community Centre, Panchsheel Park,
New Delhi – 110 017, India
Penguin Group (NZ), 67 Apollo Drive, Rosedale, North Shore 0632,
New Zealand (a division of Pearson New Zealand Ltd)
Penguin Books (South Africa) (Pty) Ltd, 24 Sturdee Avenue,
Rosebank, Johannesburg 2196, South Africa

Penguin Books Ltd, Registered Offices:
80 Strand, London WC2R 0RL, England

First published in the UK in 2008 by Goodman
An imprint of the Carlton Publishing Group

First published in the United States of America in 2008 by Viking Studio,
a member of Penguin Group (USA) Inc.

1 2 3 4 5 6 7 8 9 10

Copyright © Nick Veasey, 2008
All rights reserved

ISBN 978-0-670-02040-9

Printed in China
Set in Berthold Akzidenz Grotesk
Designed by Lucy Coley

X-RAY

See Through the World Around You

Nick Veasey

VIKING STUDIO

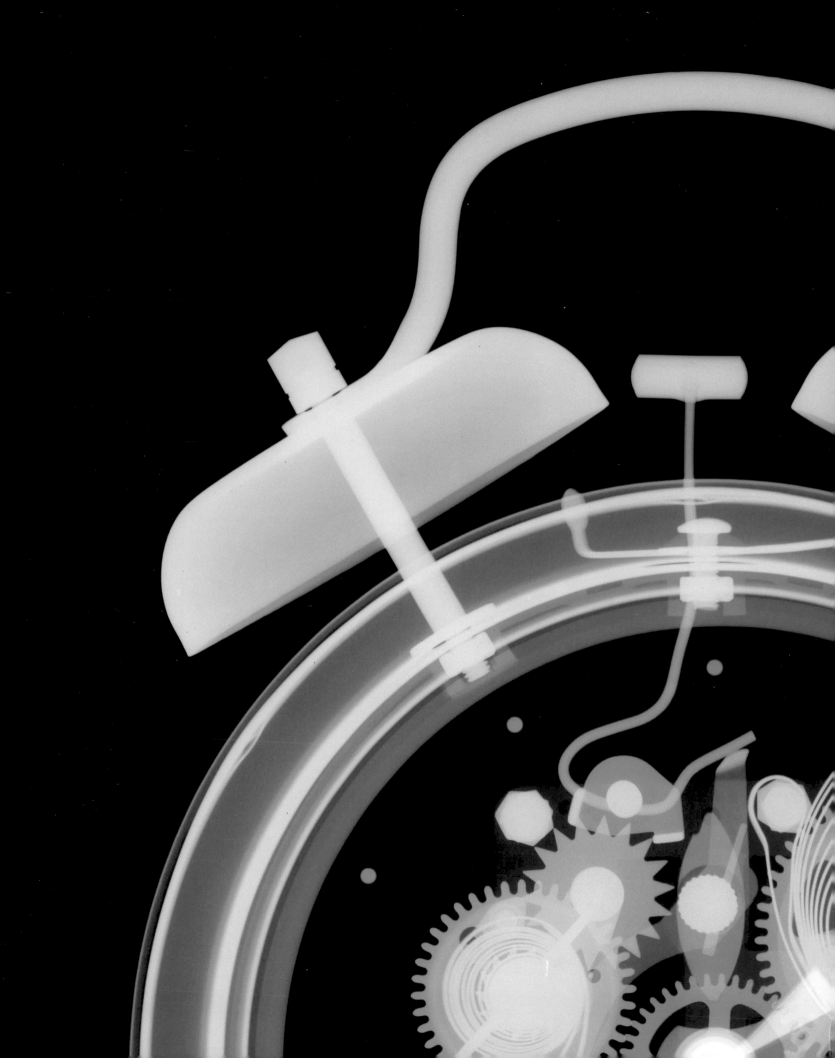

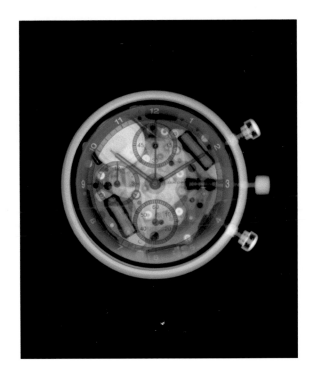

CONTENTS

ABOUT GE INSPECTION TECHNOLOGIES

Non-destructive testing has long been considered to be a black art rather than a pure science. Historically, many of its major techniques, such as ultrasonics, eddy current and radiography, have relied on the subjective interpretation of images, whether these images be of the structure of welds, the turbines of a jet engine or the insides of a human body. The visual arts too rely on the subjective appraisal of images although, here, the appraisals tend to be made more on an emotional basis than a logical basis. To be involved in a project which harnesses and exploits modern technology to advance the boundaries of art, is something that we, at GE Inspection Technologies are particularly proud of.

Our involvement with this project really extends much wider than being the providers of the very high quality Agfa film which Nick Veasey uses. GE Inspection Technologies, through its various heritage companies, has been, and continues to be, one of the world's leading innovators in non-destructive testing generally and radiography specifically. We continue to develop film and film-processing equipment and we have led the way in many aspects of digital radiography. Many of these advances have been pioneered in the medical field through other companies in the GE family. This technology transfer has provided even greater opportunities for non-destructive testing, especially in terms of quality of imaging, safety of operation, analysis and storage of data and ease of interpretation. We also continue to develop and advance within our own specific discipline.

X-ray machines are used in virtually every segment of industry. Computed radiography is making increasing in-roads in all aspects of radiography. Direct radiography is considered one of the most significant breakthroughs in x-ray imaging in the last 25 years. And we are now very much involved in microfocus and nanofocus radiography, inspecting tiny components such as those used in the electronics sector.

But it is not just in radiography that we are constantly evolving new techniques and equipment. In the ultrasonics sector, our new phased array systems are bringing easier image interpretation, as well as better probability of flaw detection. The same can be said of our new pulsed eddy current equipment and our video borescopes and endoscopes now provide even higher definition and resolution.

GE technology helps to provide images so that we have a better understanding of our world. Hopefully, Nick's creative and ambitious use of some of our technology will help you also to gain a better understanding of our world, in a refreshing and stimulating way.

If you want to learn more about GE Inspection Technologies, please visit www.ge.com/inspectiontechnologies <htttp://www.ge.com/inspectiontechnologies>.

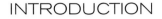
INTRODUCTION

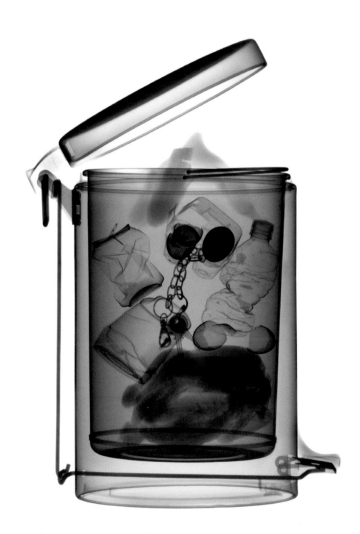

I am not Superman, I do not have x-ray vision. And I would look particularly unsavoury in skin-tight lycra.

But I have found a way to see beneath the surface. Nothing gives me more pleasure (well, very little anyway) than revealing the inner beauty of a subject. The unseen can be seen, the internal elements and workings revealed. The inside becomes the outside.

We live in a world obsessed with image: with what we look like, what our clothes look like, our houses, our cars.... I like to counter this obsession with superficial appearance by stripping back the layers and showing what things are like below the surface. Often the integral beauty of the underlying structure adds intrigue to the familiar. We all make assumptions based on the external visual appearance of what surrounds us and we are attracted to people and things that are aesthetically pleasing. I like to challenge the automatic way in which we react to external physical appearance by highlighting the often surprising inner beauty of things.

This society of ours, obsessed as it is with image, is also becoming increasingly controlled by security measures and surveillance. Take a flight or go into a high profile courtroom and your belongings will be x-rayed. The post arriving in corporations and government departments has often been x-rayed. Security cameras track our every move. Mobile phone records can place us at any given time. Information is key to the fight against whatever we are meant to be fighting against. To create art with equipment and technology made to help Big Brother delve deeper, to use some of that fancy complicated equipment that helps remove the freedom and individuality in our lives, to use these instruments to create beauty brings a smile to my face. I am no major subversive artist, but I do like to see the reaction of people in authority when they see my work. I'm sure they think something along the lines of, "we didn't spend all this time and money improving x-ray technology, for you to make pretty pictures." Well I have anyway. You can keep making your advances, and I'll keep making mine.

Most of us are familiar with the human form in x-ray, so although this book has a chapter devoted to x-rays of the body, I will not dwell here on this aspect of my work. Instead, I would like to take you back to the beginning. Long before I was around, in 1895, Willhelm Roentgen invented x-rays. The processes I use are fundamentally the same, but technology

has helped make the x-ray process quicker, better and safer. Safety is a subject that I pay particular attention to as I'm messing about with some dangerous stuff – cobalt iridium, ionising radiation, chemicals... x-rays are dangerous, especially as they are invisible and have no smell. Look what radiation does to cancer patients undergoing radiotherapy, and that is in therapeutic use. Like many artists before me I am prepared to risk my safety for my art, but I do what I can to minimise that risk. I've got two healthy children and all my vital organs still function.

My first x-ray sessions had very mixed results. I was on a steep learning curve at the start, and I'm still learning. Fortunately, after months of experimentation I became more confident and built up a portfolio. I then went to New York to show this early work and luckily a magazine liked what I had to show and ran an article about it. It may seem a melodramatic cliché, but this article was a life-changing moment for me. The interest in my work blossomed. I became a real pest to radiographers, scientists and equipment manufacturers around the world, hassling them for information. What could I achieve with x-ray? How far could I go with it? I am still answering these questions and hope to continue to do so for many years to come.

To create my x-ray images I work in a lead-lined room, with a very heavy lead sliding door that has to be sealed before my x-ray machines will operate. High-voltage electricity is sent to a radioactive source that emits x-rays. The x-rays pass through the subject I am working on and create a same-sized image on special film placed in a light-safe bag. This film is then processed and edited. In my studio I then use a beast of a high-quality scanner that is four metres (13 feet) long and weighs 300kg (660lb) to turn these images into digital files for enhancement and other digital tweaks on our Macs. We do not use 3-D or any synthetic image creation software.

To capture very fine subjects like flowers and insects, I convert the lead-lined room into a darkroom, as I have to rest the subject directly on the film. So I can (vaguely) see what I'm doing, I wear infrared goggles developed for the military. It is surreal; the environment I work in is dirty, basic and industrial, the technology and equipment complicated and dangerous, yet out of all this come pictures of ethereal beauty.

Like many people in the creative community, I find it hard to stop my mind wandering into my work even when I am not supposed to be working. I often dream about x-ray and sometimes have dreams in x-ray. I have been through the nasty obsessive phase that all artists pass through; looking back, I did not really like the way my work changed my personality during that obsessive phase, as it made me arrogant and introspective. Fluctuating fortunes and having children soon got

me back on the level though, and my wife Zoe is my rock. I am lucky to be extremely motivated and inspired by the everyday, along with artists such as Bridget Riley, Eadweard Muybridge, Doc Egerton and James Turrell.

I have many x-ray projects still to complete and will continue to refine my technique and processes, but it is fair to say I've already pushed image-making with x-ray equipment further than any of the other artists who have used this technique. This book shows the depth and range of my work over many years.

I hope the pictures here engage you. We may all say that beauty is more than skin deep, but this collection proves it.

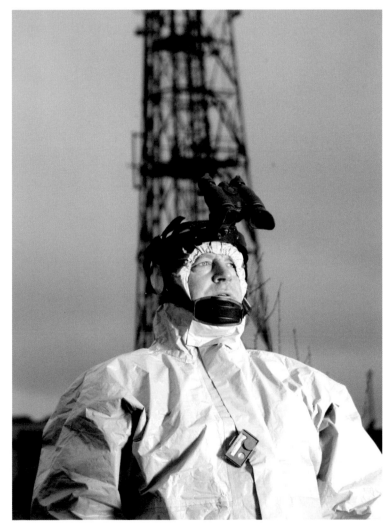

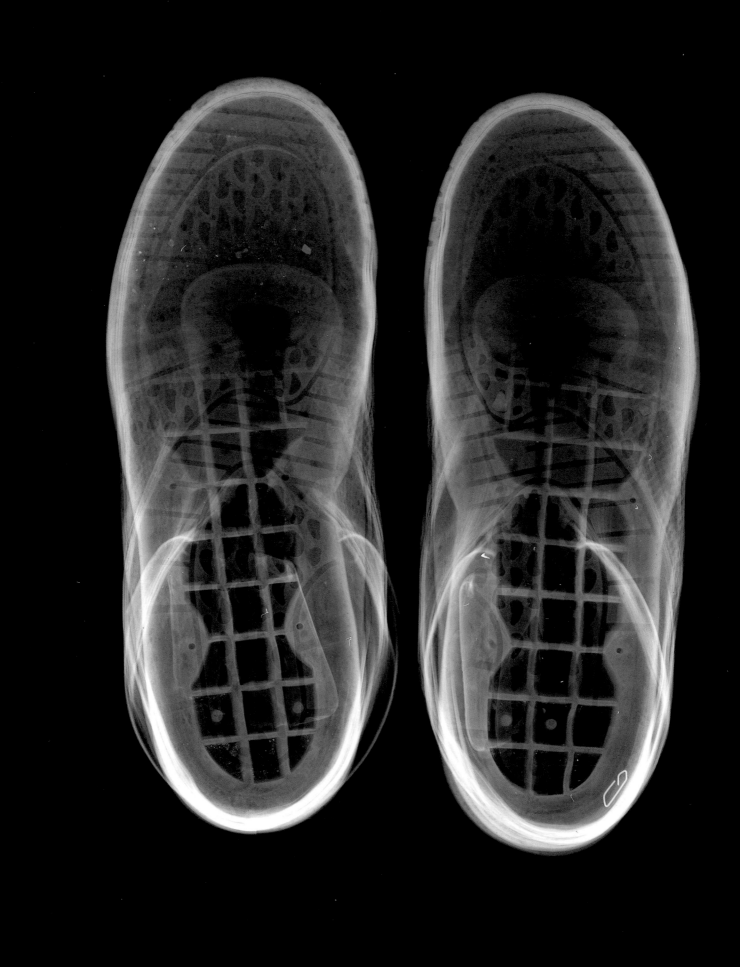

1 OBJECTS

The picture on the left is the first x-ray I took that really got me excited. These are the shoes I was wearing on that fantastic day I first dabbled with radiation. I tiptoed joyfully back from the darkroom, blown away by the quality in the image, to kiss these cheesy-smelling trainers (sneakers) before reuniting them with my feet.

This early experimentation quickly mutated into an obsession. I couldn't walk down the aisle of a supermarket without stopping to consider various items and their suitability for an internal examination. Car boot sales, eBay and junk shops are a great source of unusual and cheap subject matter. Often the tackiest things are the most fun to work with. They may look awful on the surface, but once the internal workings are revealed and the superficial visual manifestation is removed, all objects can be appreciated for their structure. My studio is full of strange things resting after doing their duty in my laboratory. There have also been specific projects that have produced collections of relevant images – and more clutter. I must have a clear out one day.

As x-rays work on the density of the material being exposed, I often have to use several different exposures of the same object to get the best detail. Occasionally a "normal" photograph is overlaid to bring in necessary surface texture. Other technical challenges in x-raying objects are controlling distortion of large objects, angled x-rays, moisture content,

movement over long exposures, electro-magnetic interference from parts of powered electrical equipment… the list goes on.

The original x-rays are monotone. Colour is added as and when we (I work closely with a small team of experts at my studio) think fit. Most are shot from a straight perspective, as x-raying an object from an angle often creates confusing shapes.

Revealing the inner complexity and workings of objects makes us think about how these things function, and why they are intrinsically what they are. Sometimes the pictures illustrate exactly how they work. Other objects are made curious by revealing what happens within. I'm often surprised by what I see. All manufactured objects are designed in some way. Components are brought together, and positioned in a particular place. Different materials and ergonomics are considered. Then the object is made, and then I x-ray it. Each x-ray picture of an object says something extra about that object than what you learn when you merely look at or use it.

Some objects don't need to be crammed with gizmos to look beautiful. A simple teacup and saucer gains elegance and the structure of an ice-cream cone is revealed to be as complex as honeycomb.

That's the beauty of objects. Because I didn't make them, I can only make an educated guess at what they will look like in my little inside out world. Sometimes I'm wrong, and that is why I continue to x-ray them.

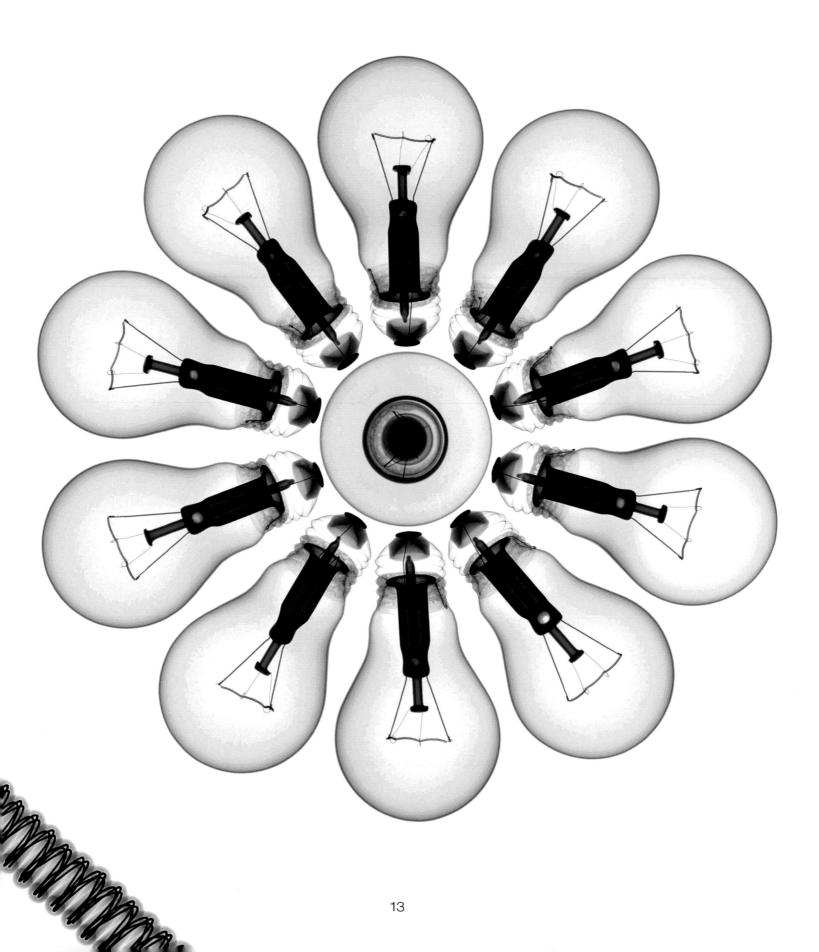

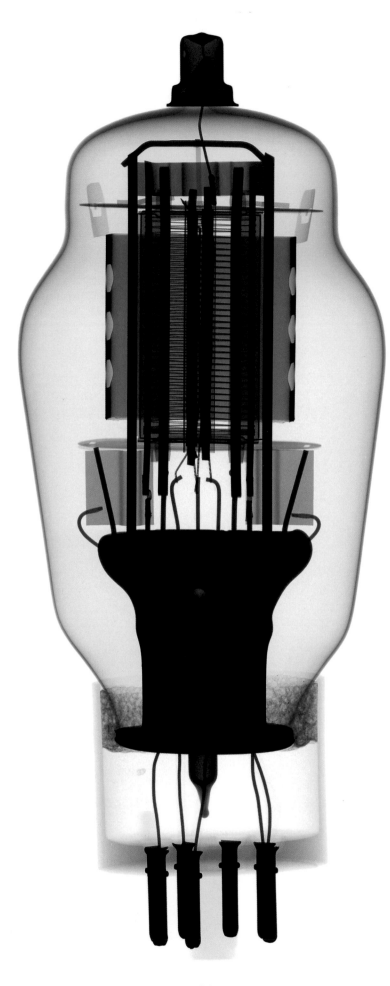

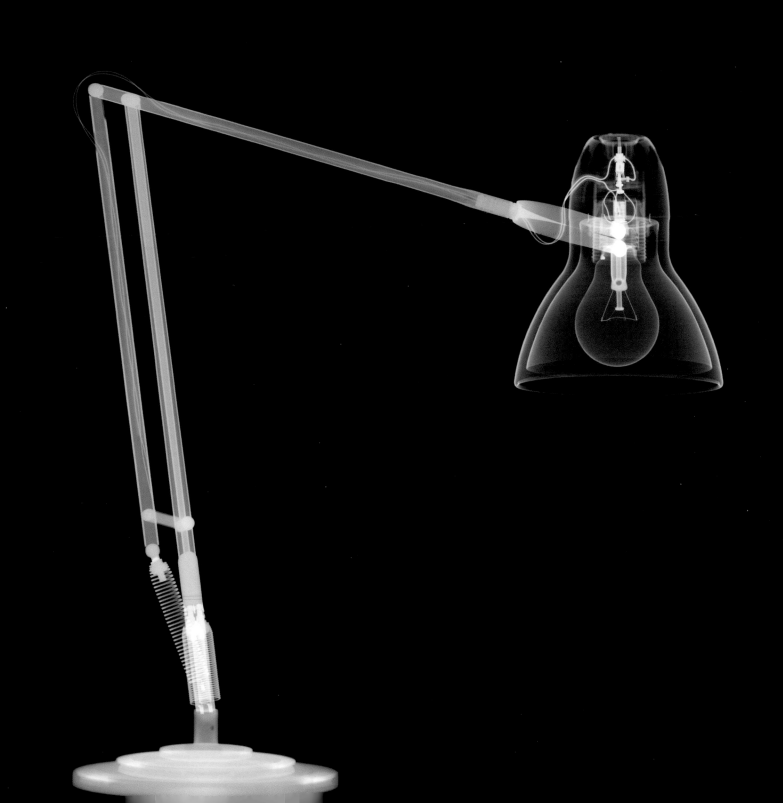

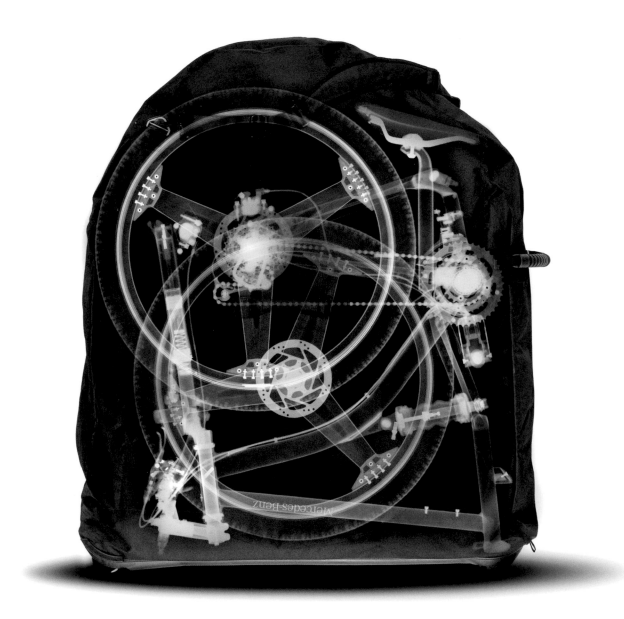

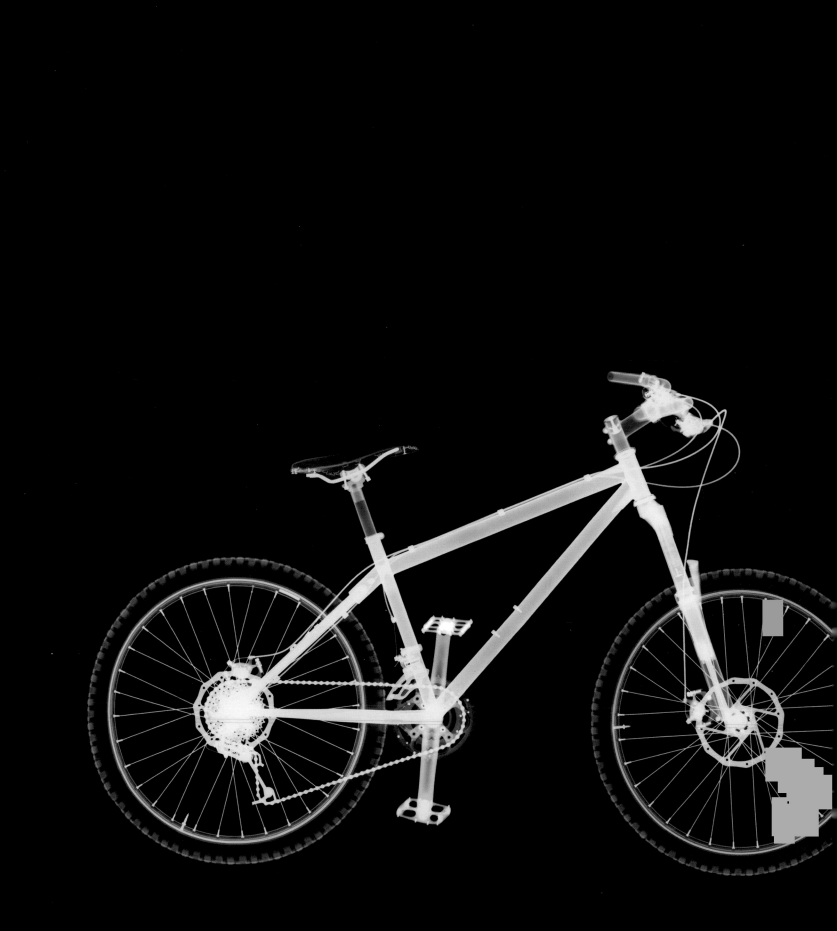

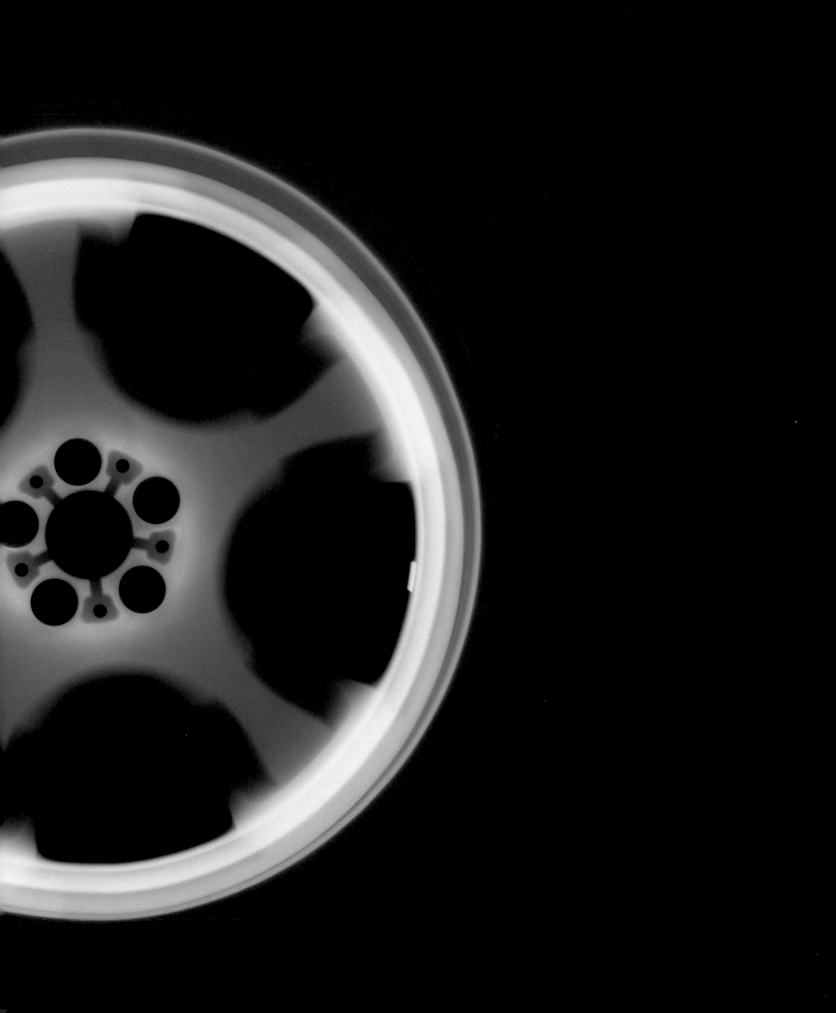

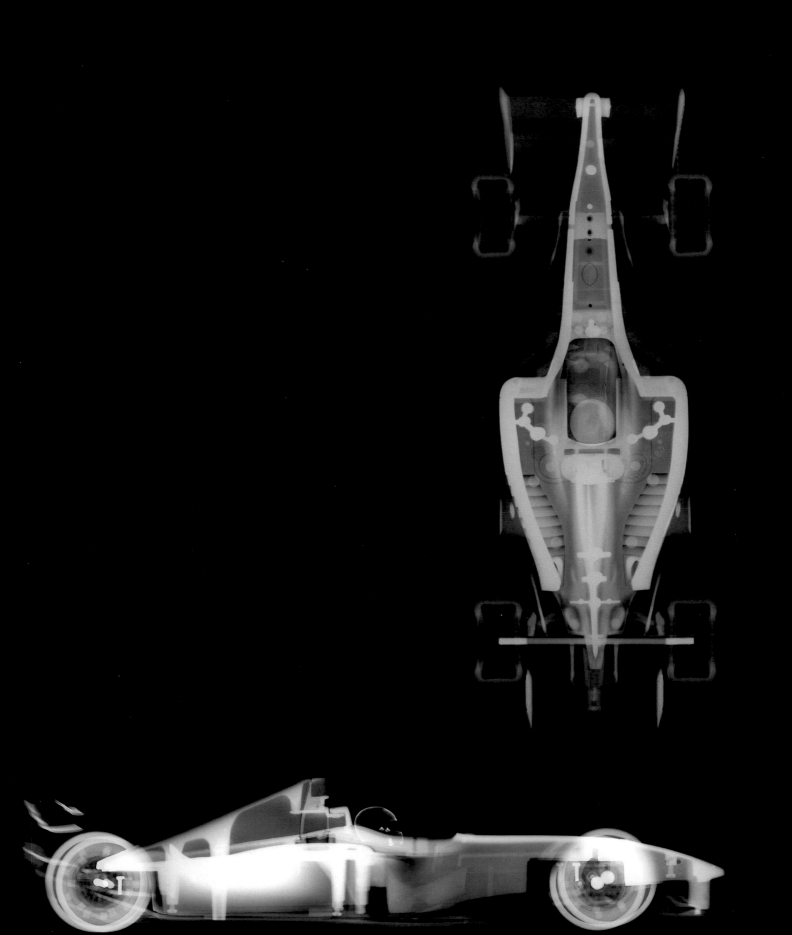

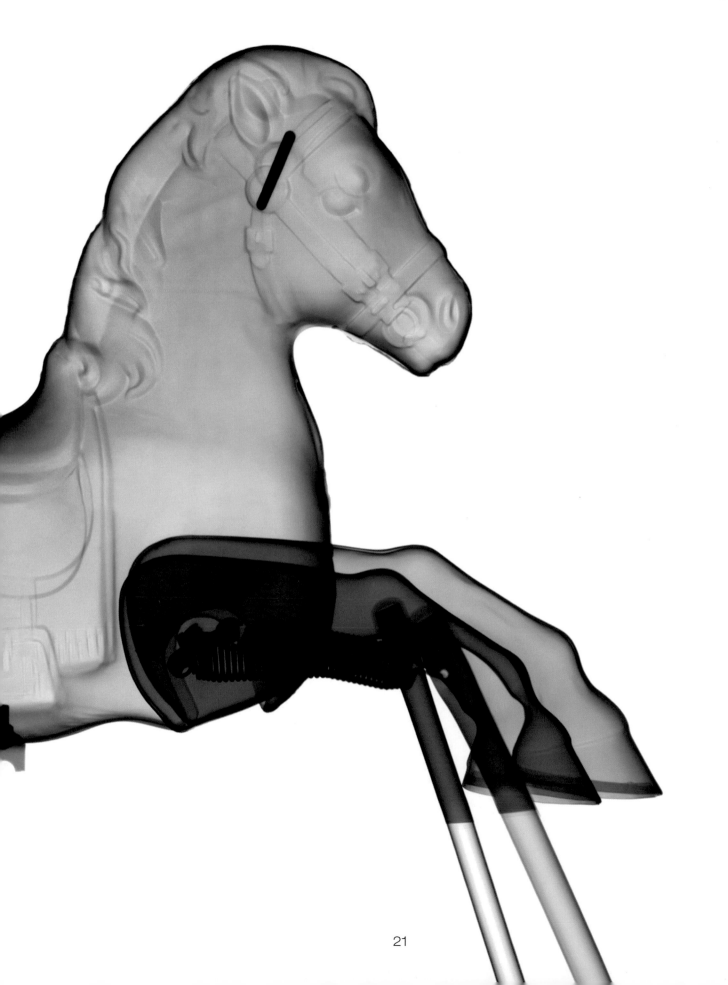

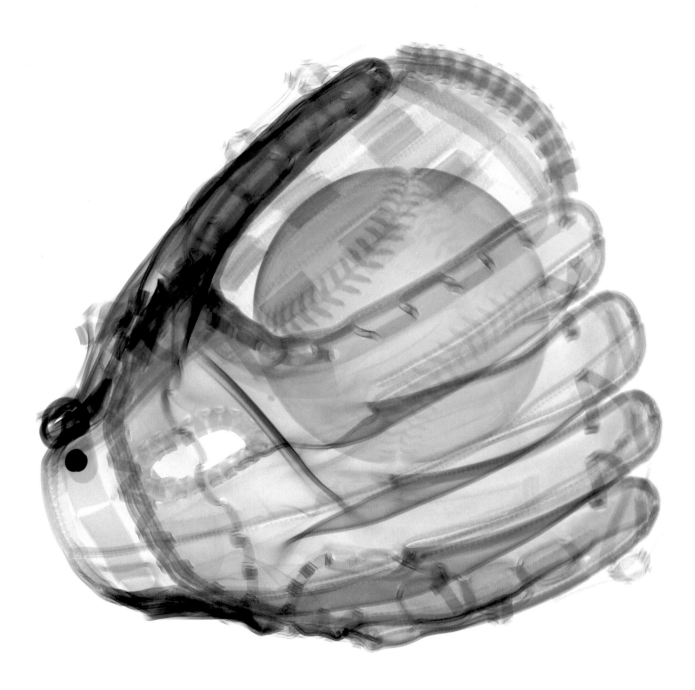

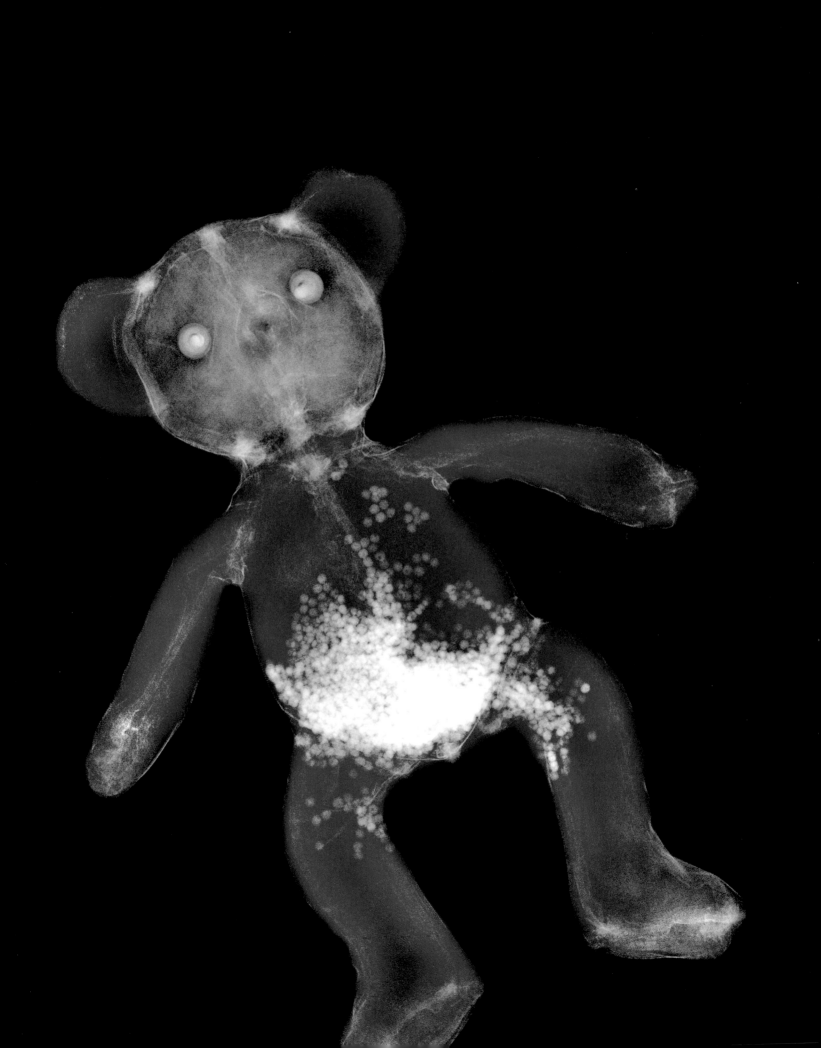

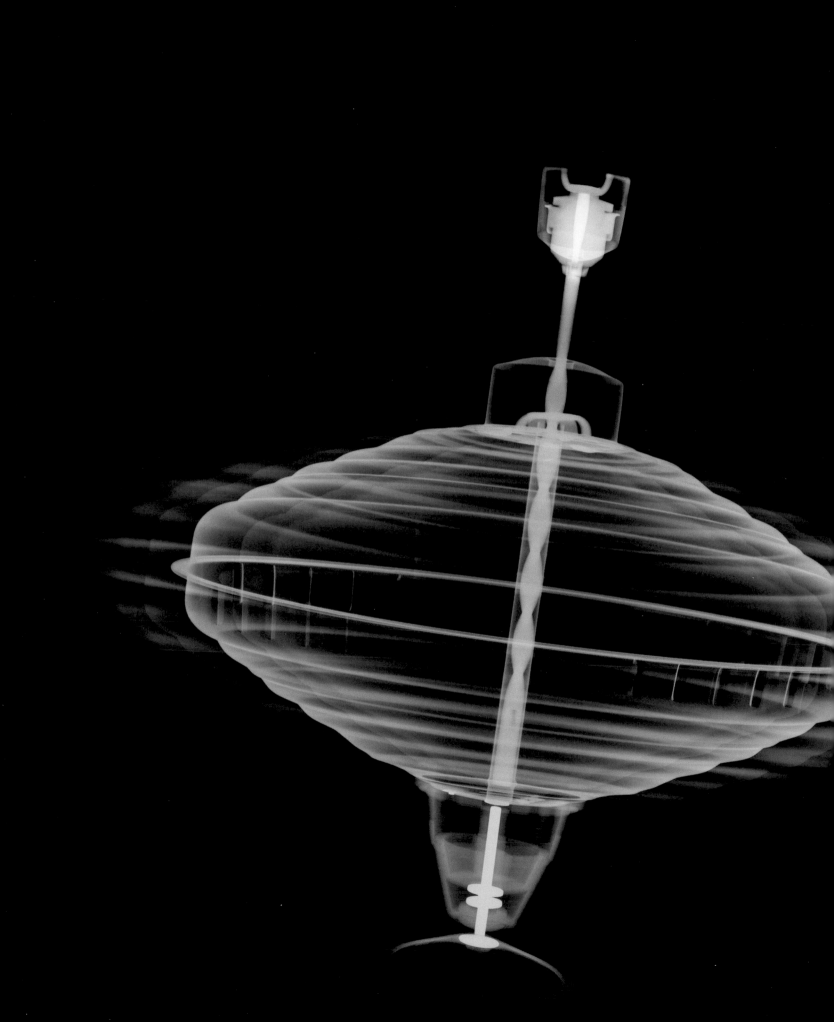

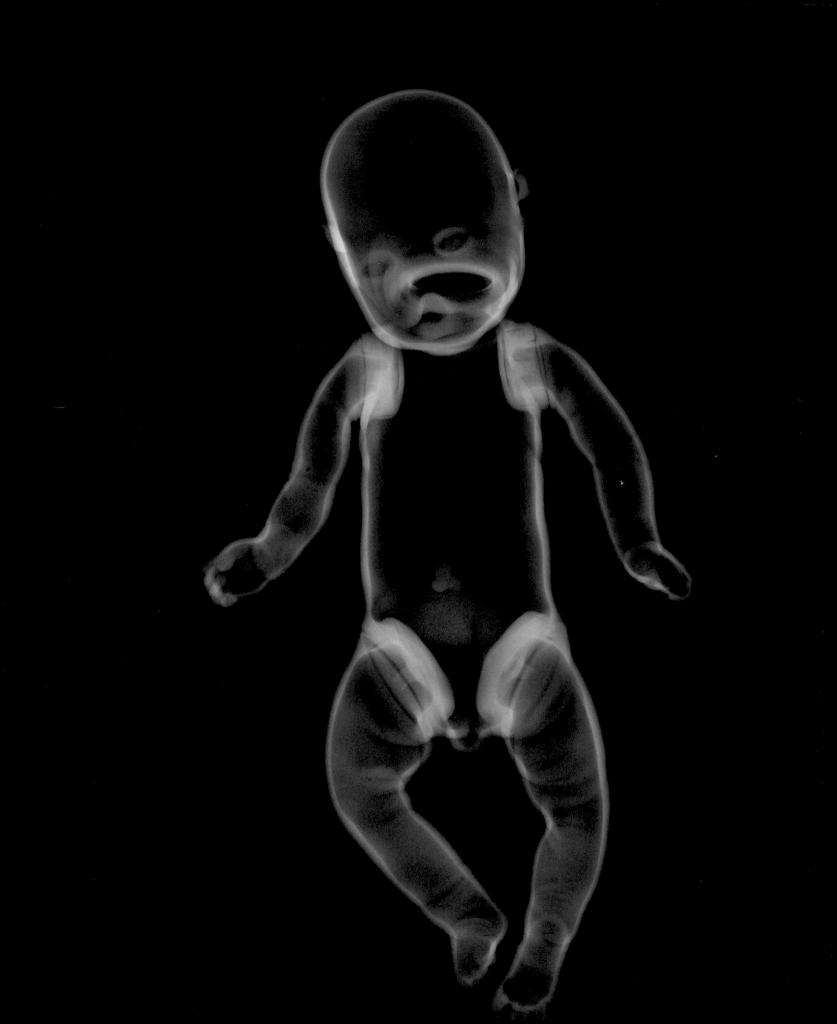

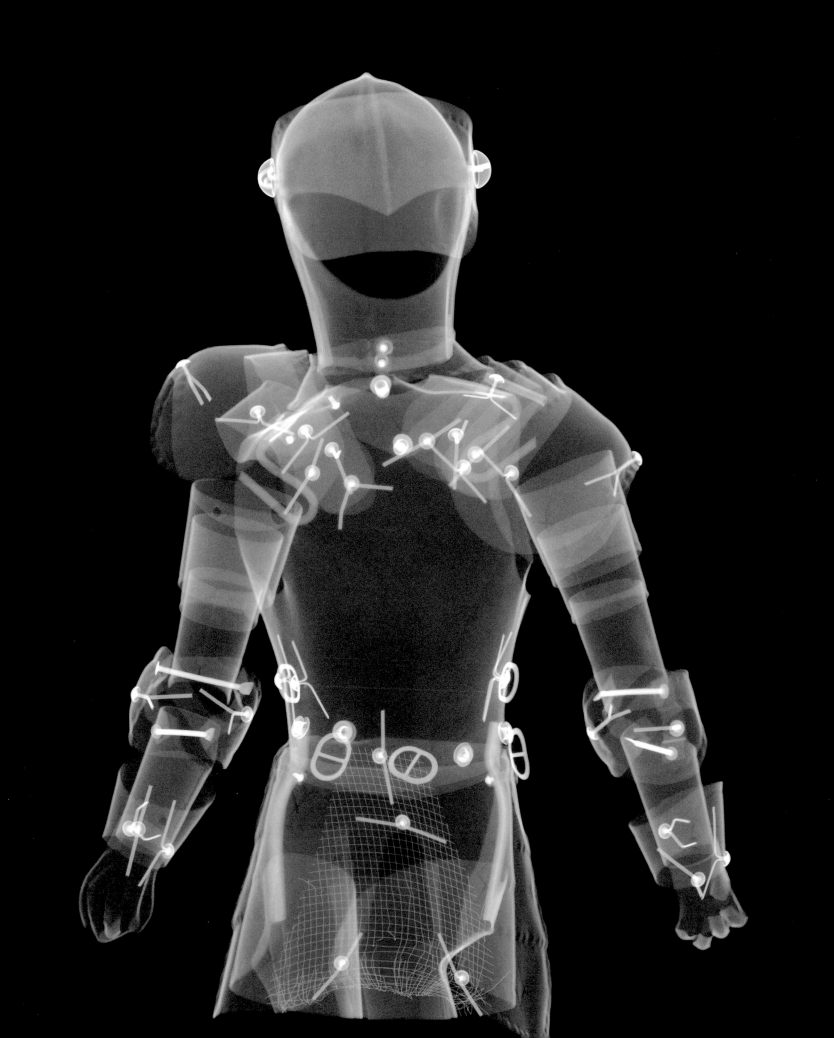

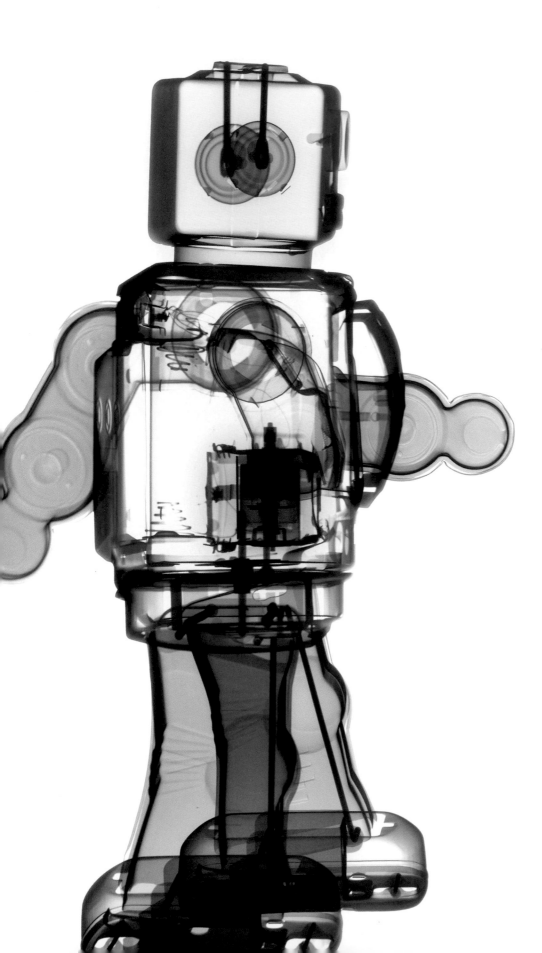

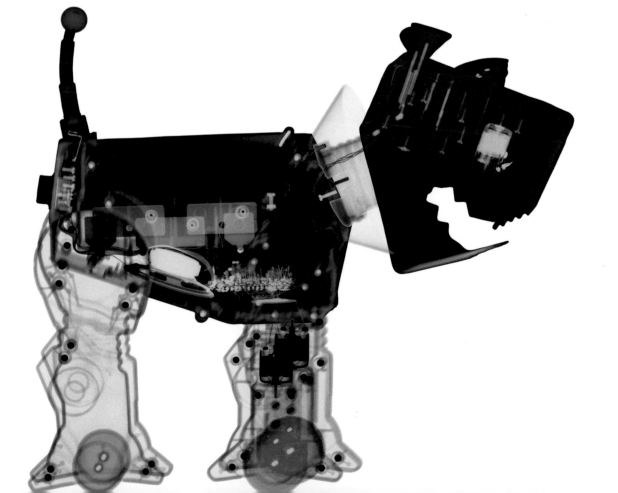

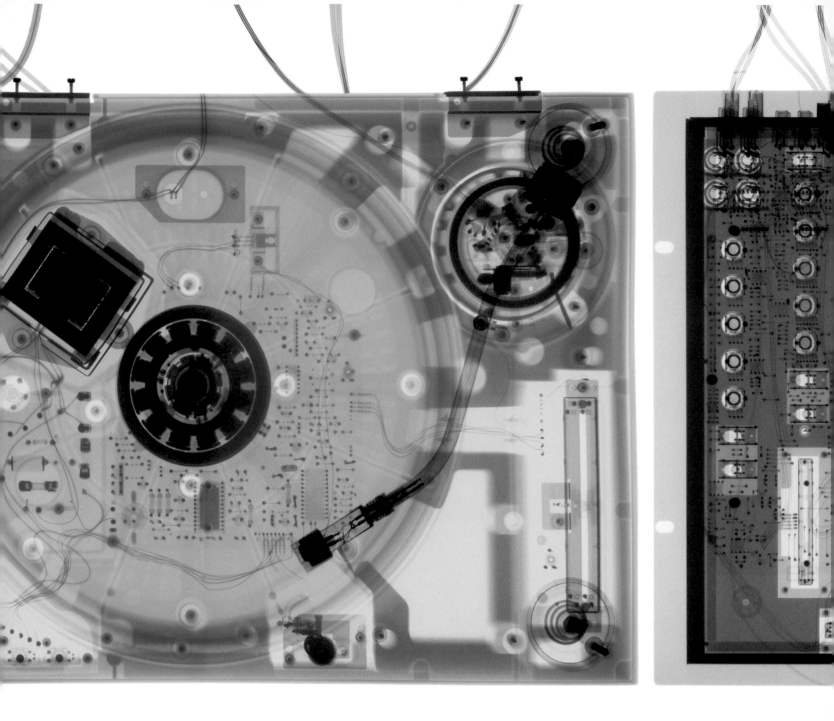

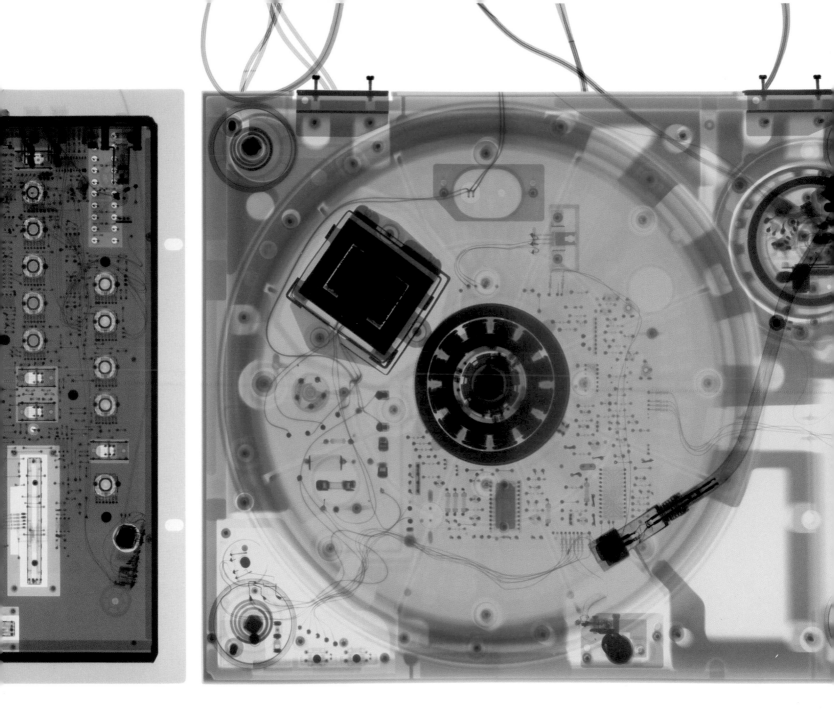

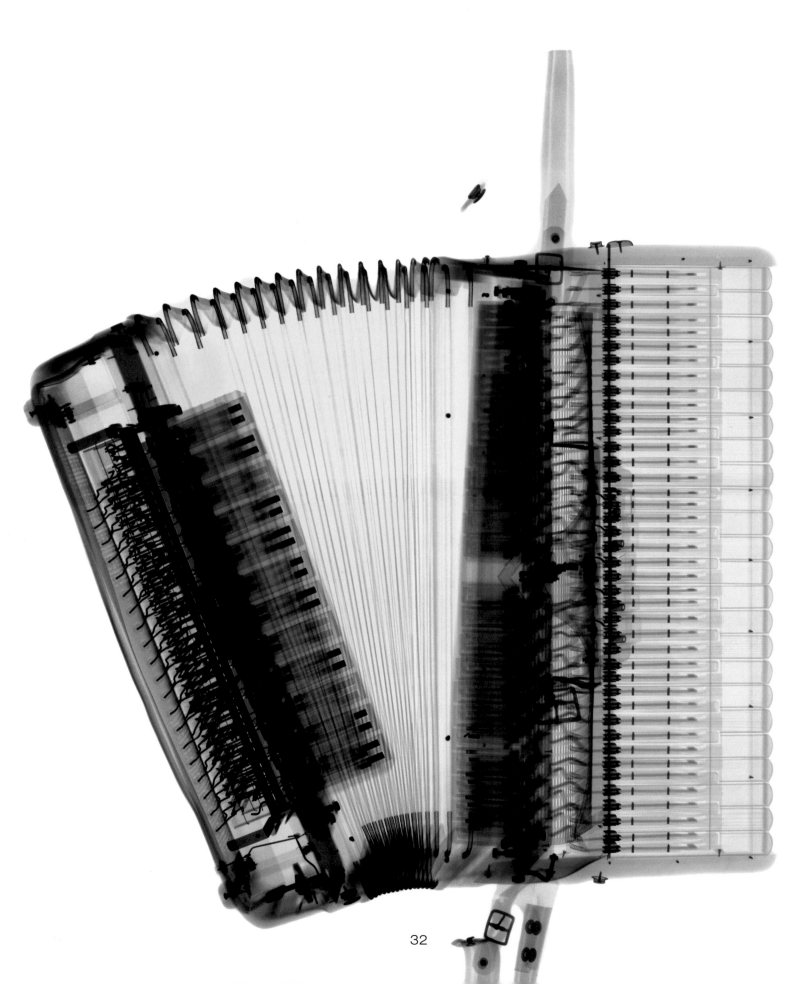

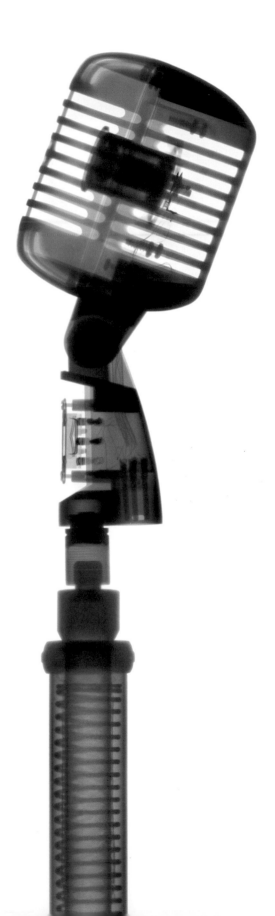

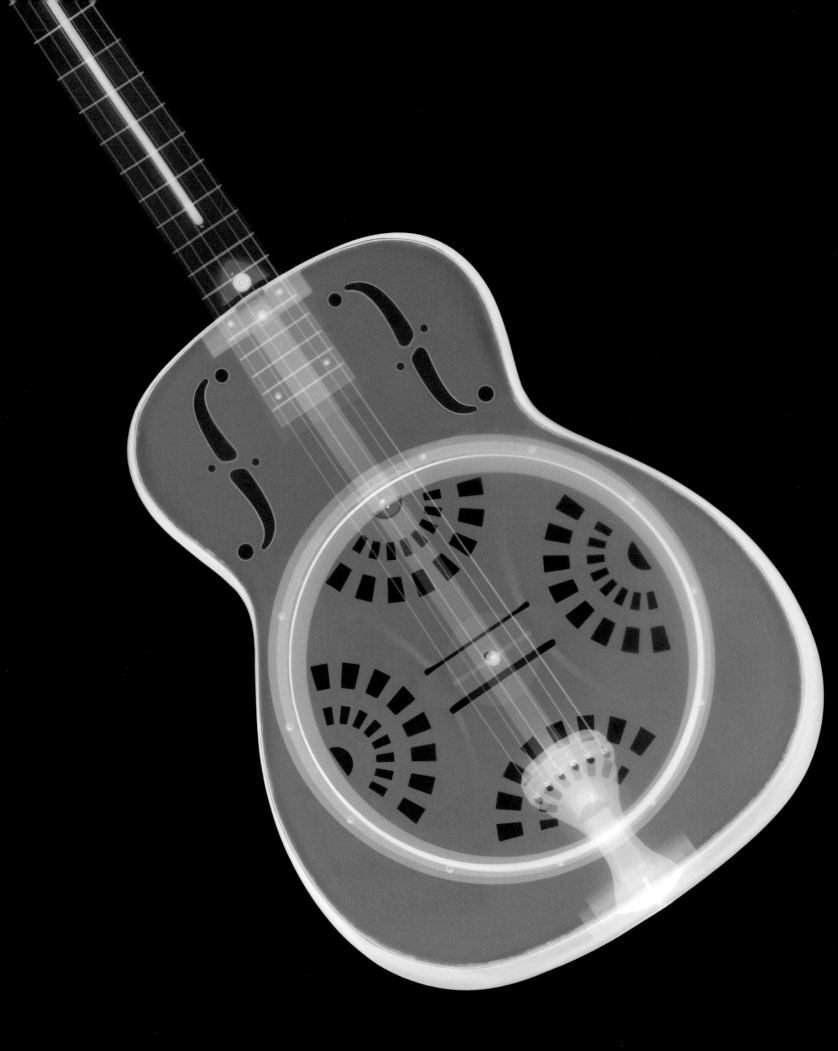

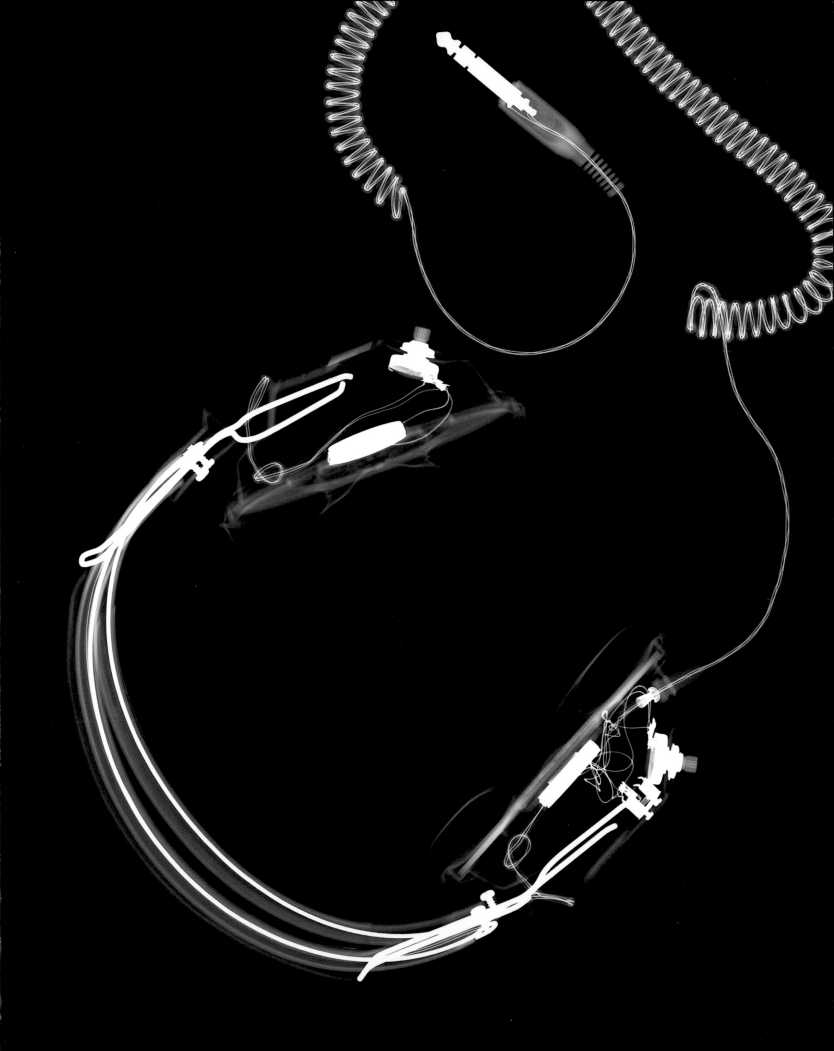

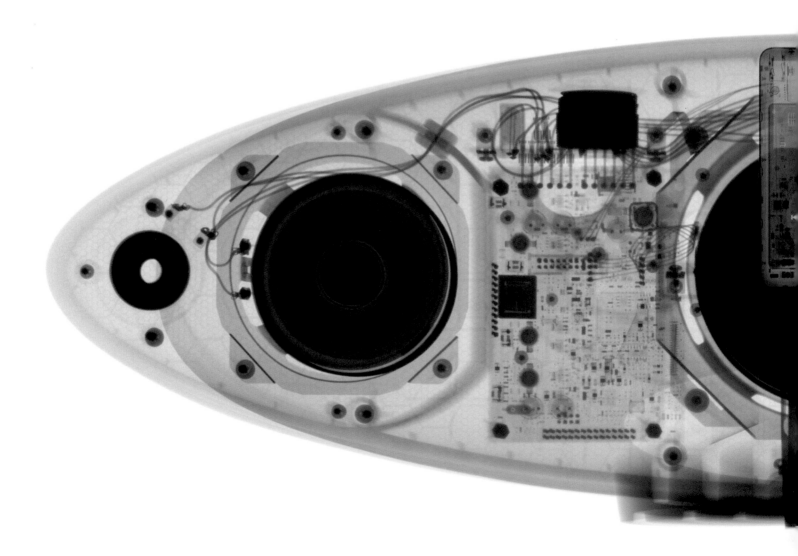

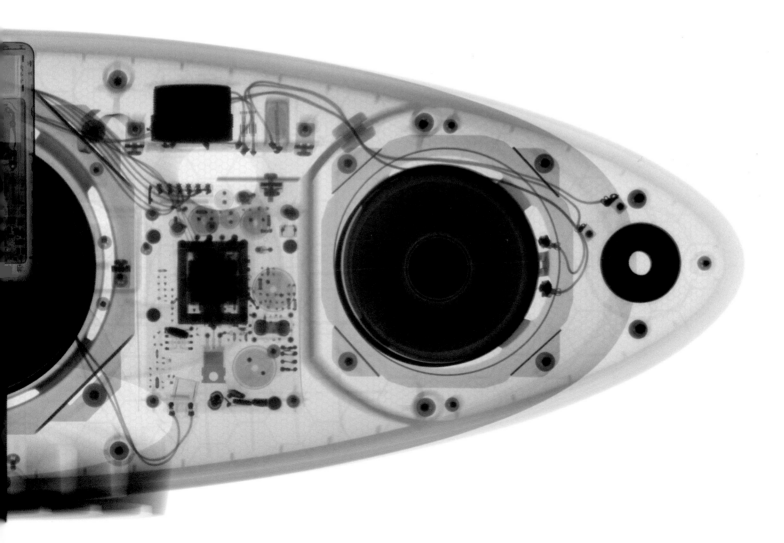

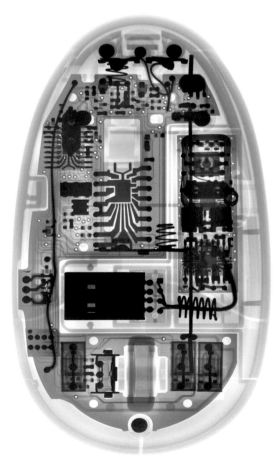

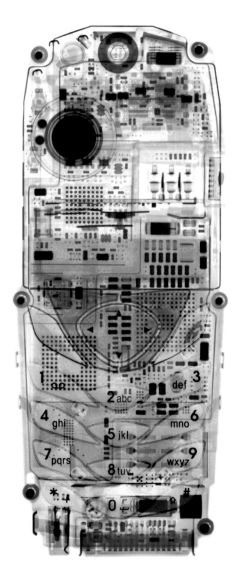

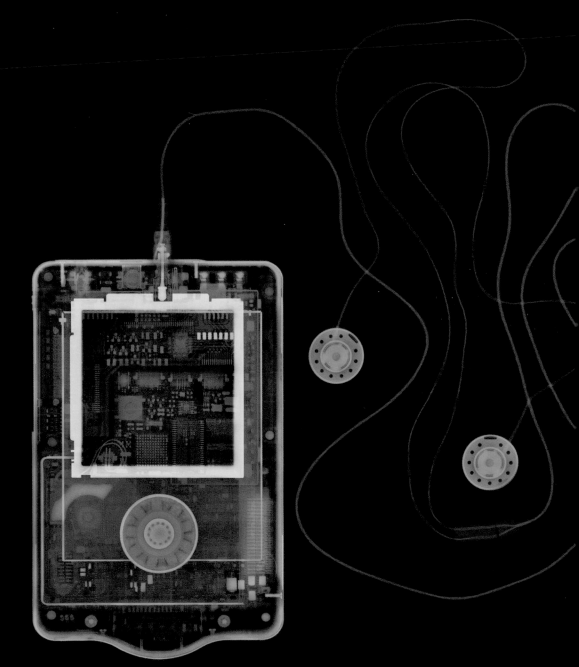

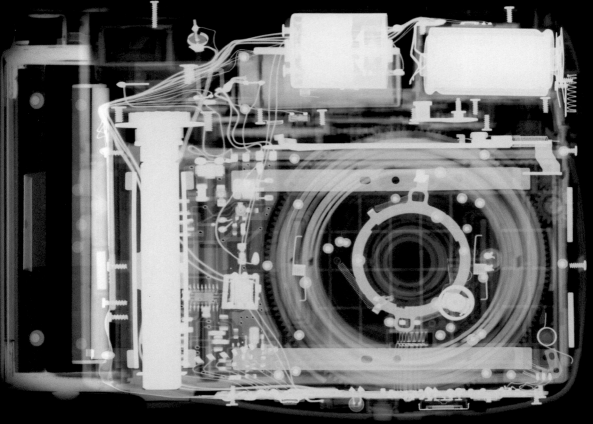

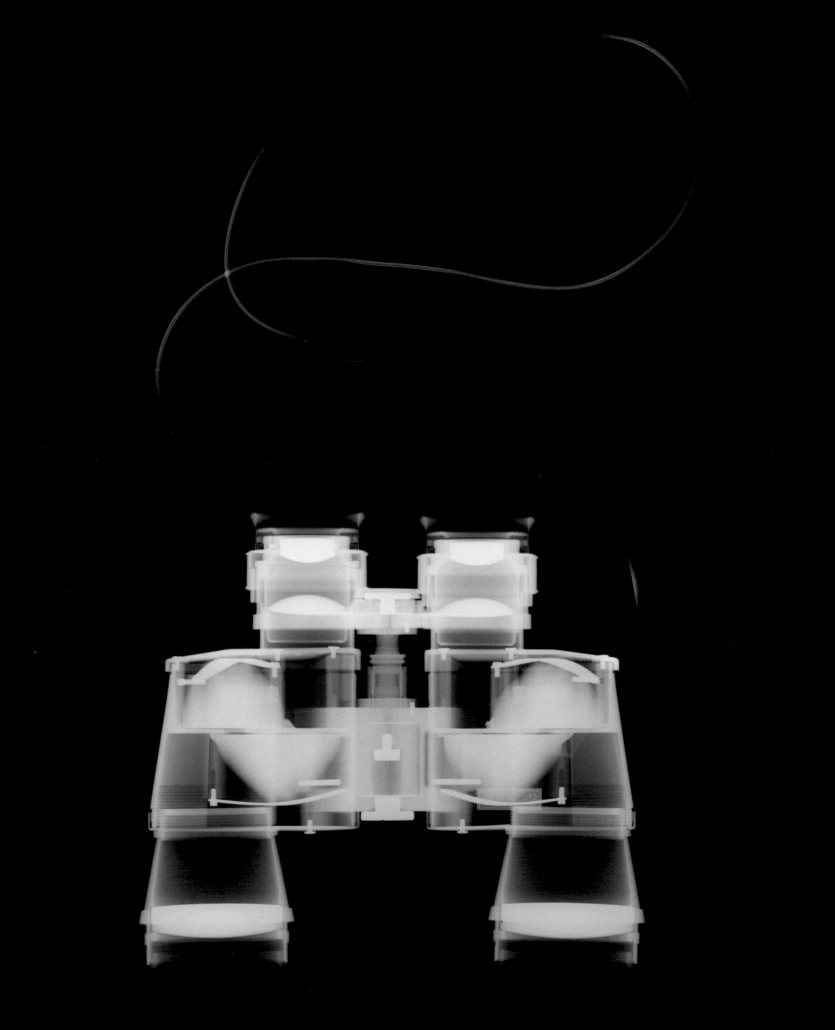

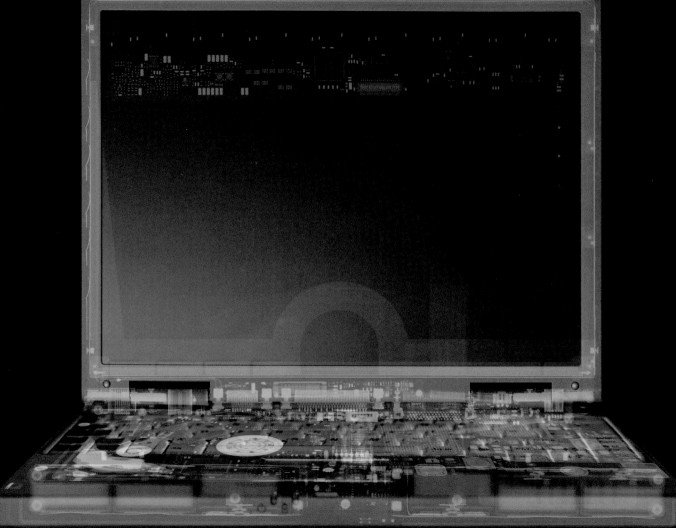

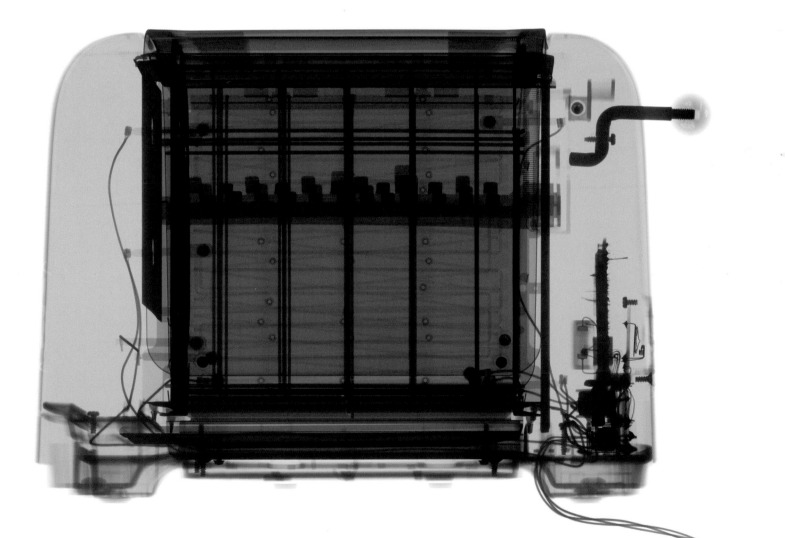

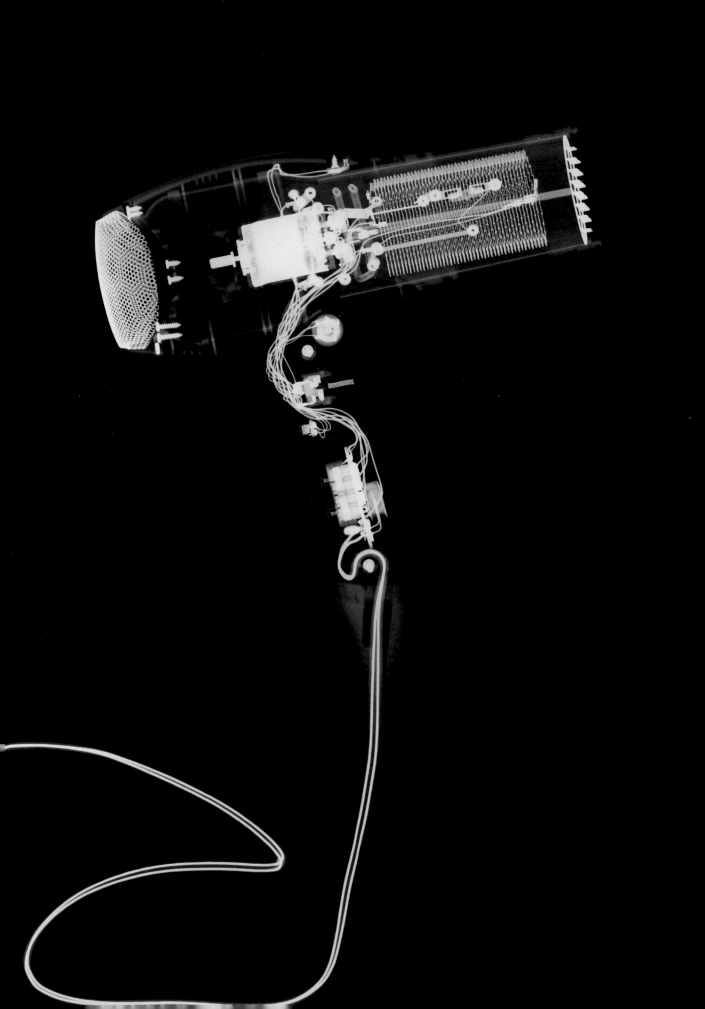

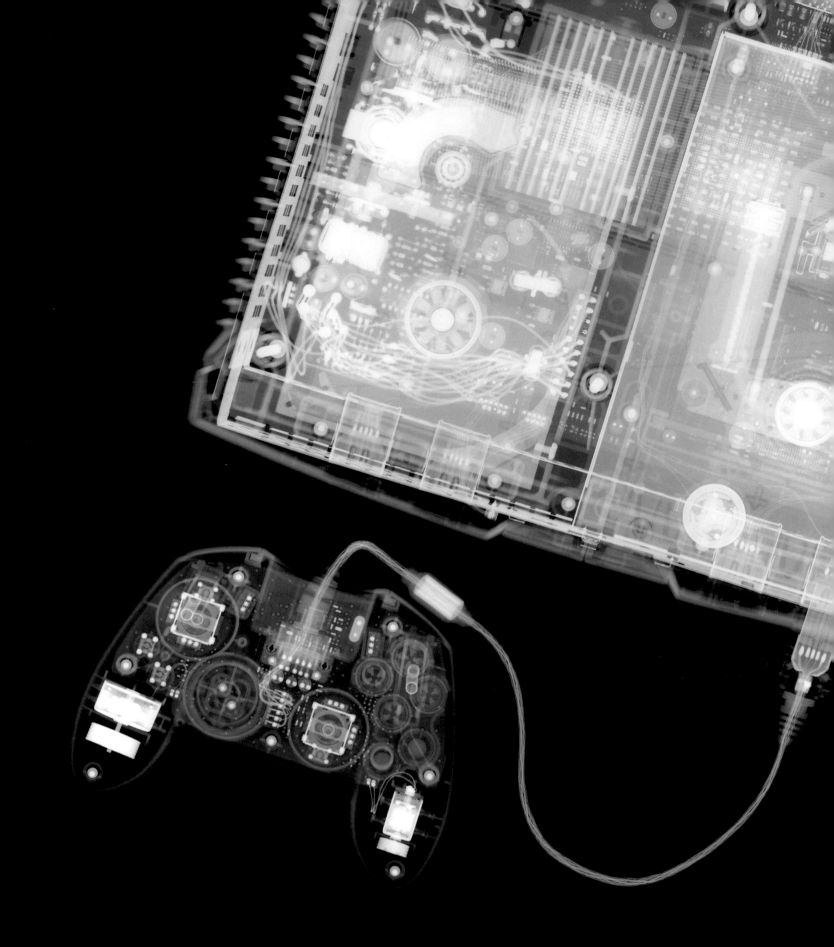

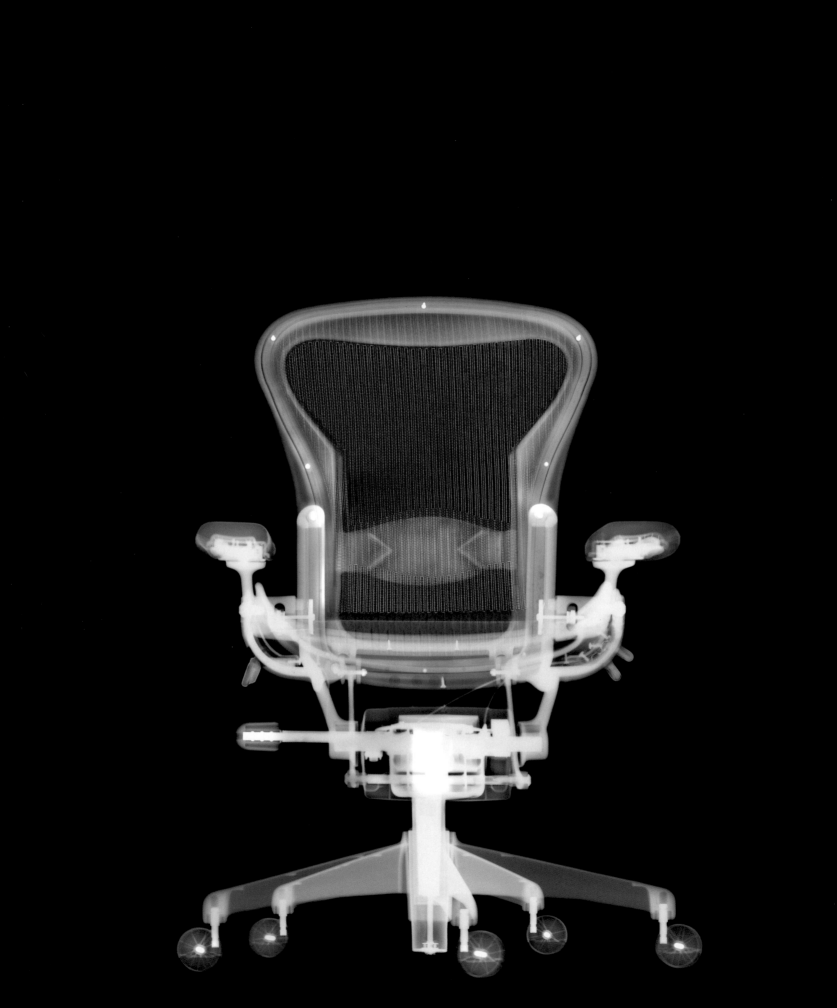

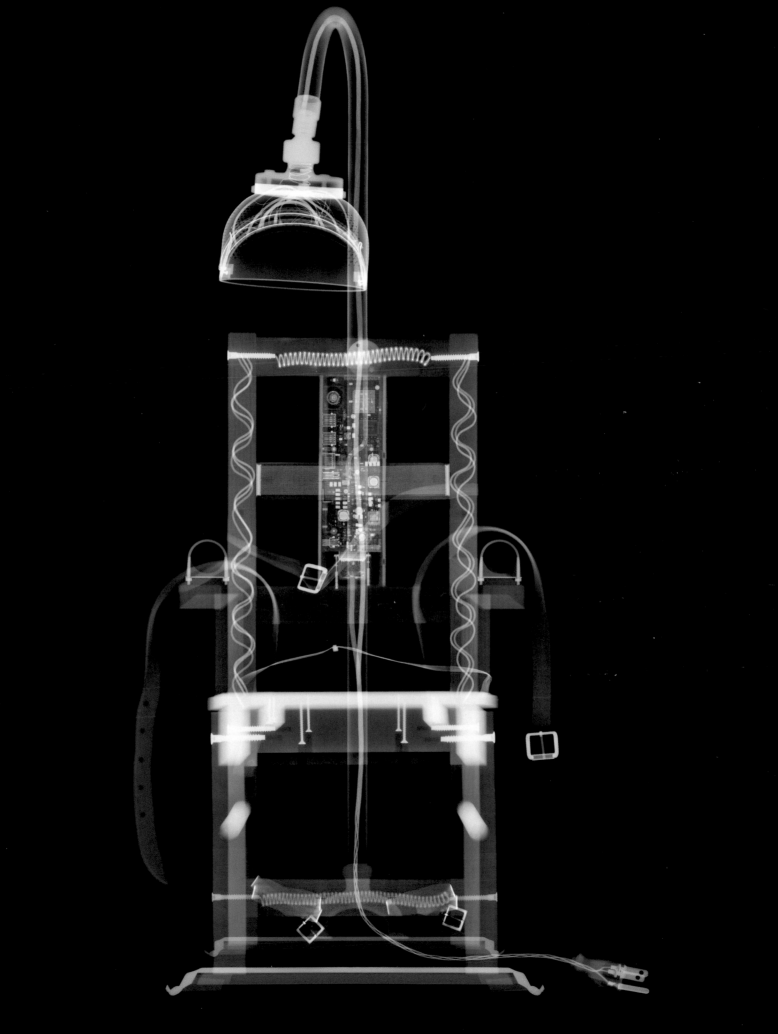

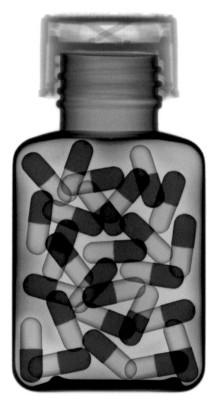

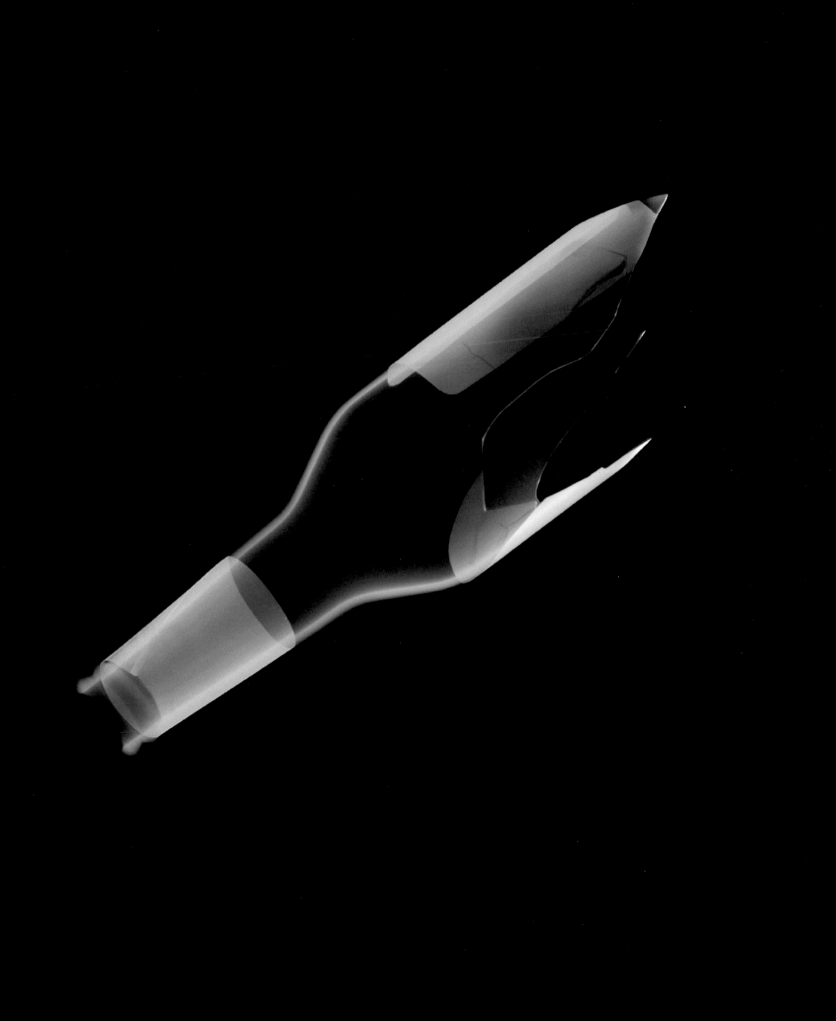

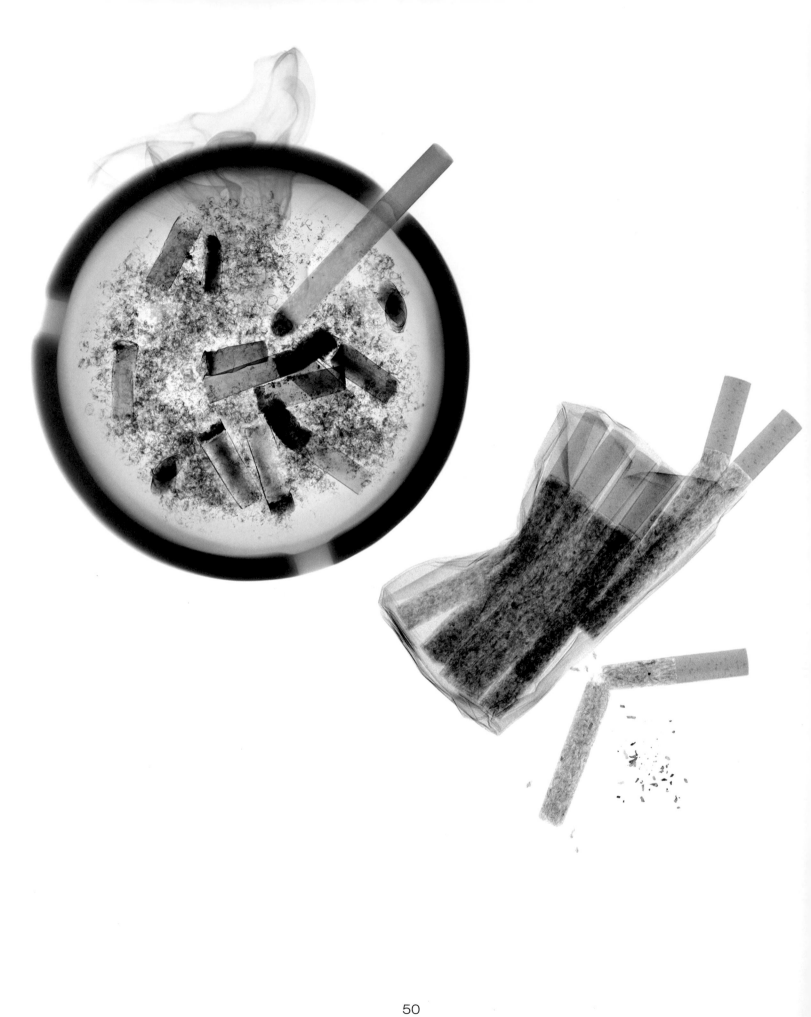

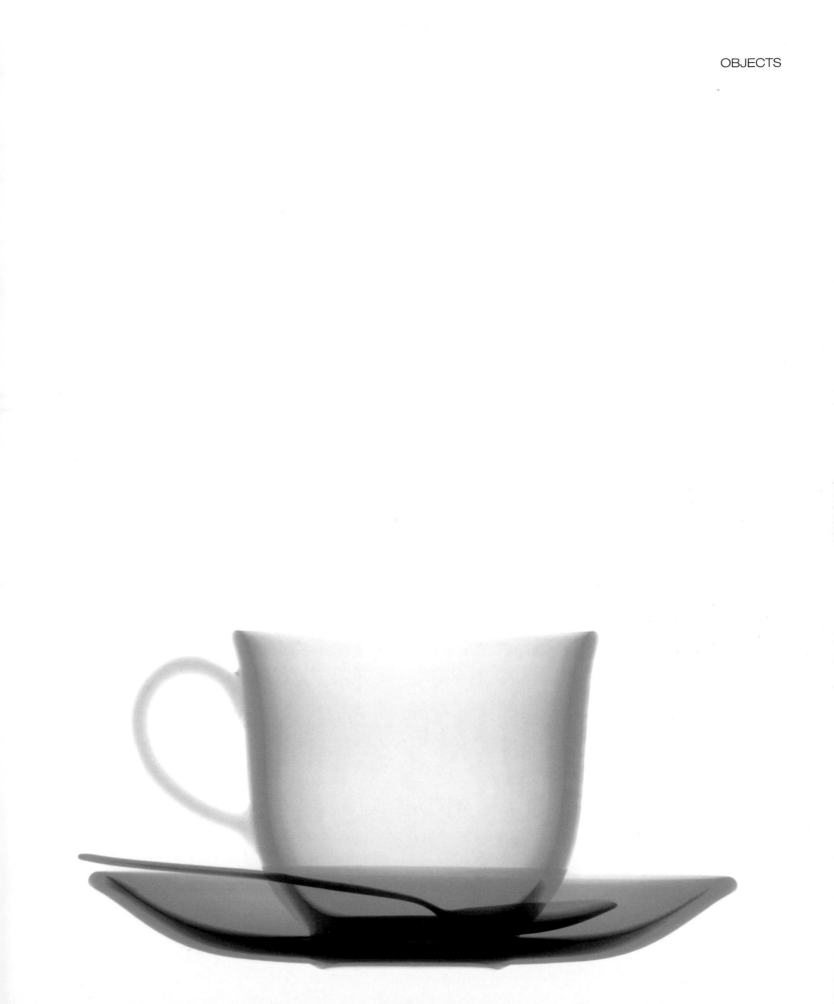

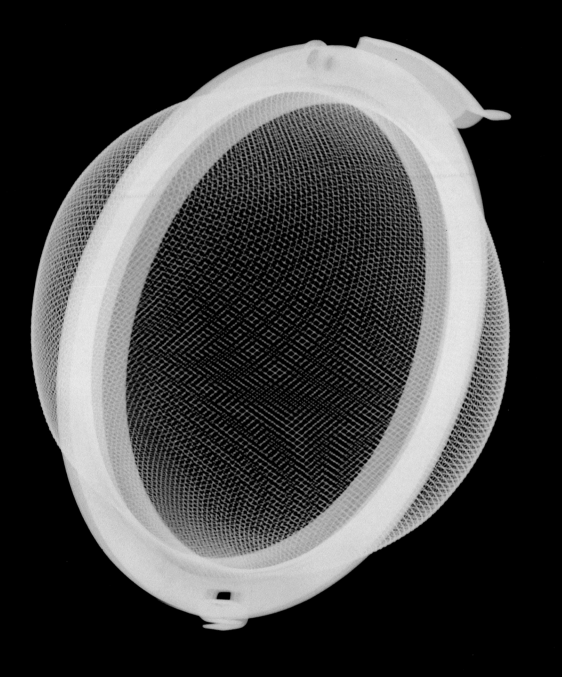

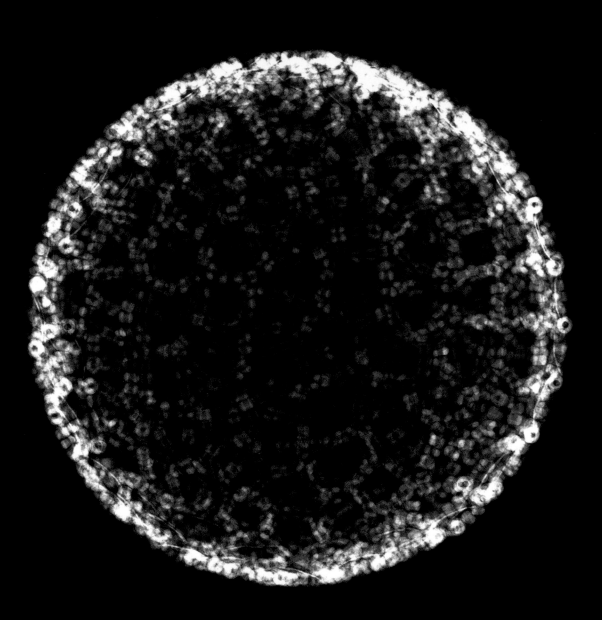

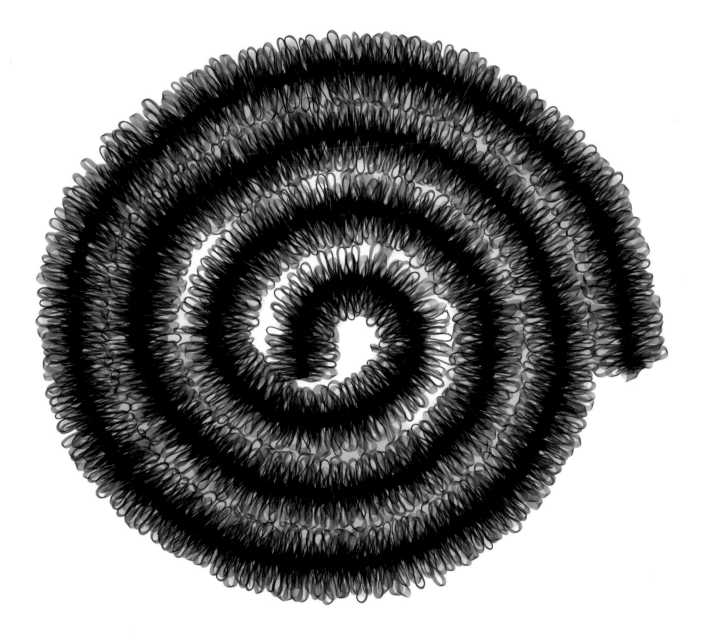

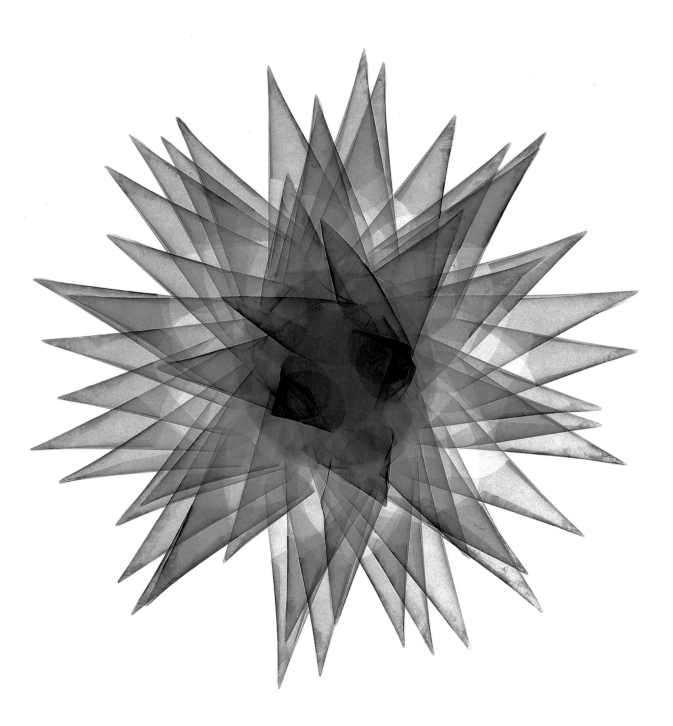

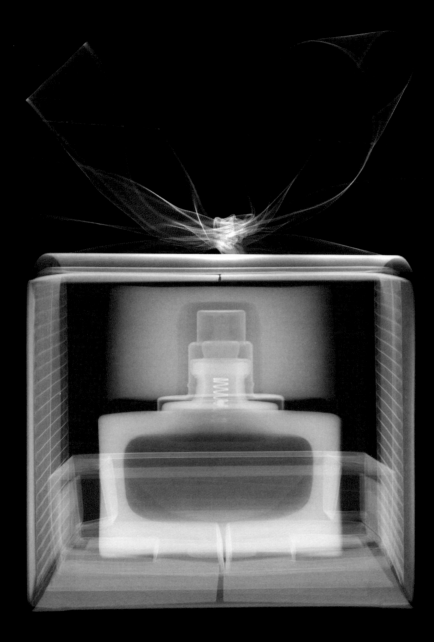

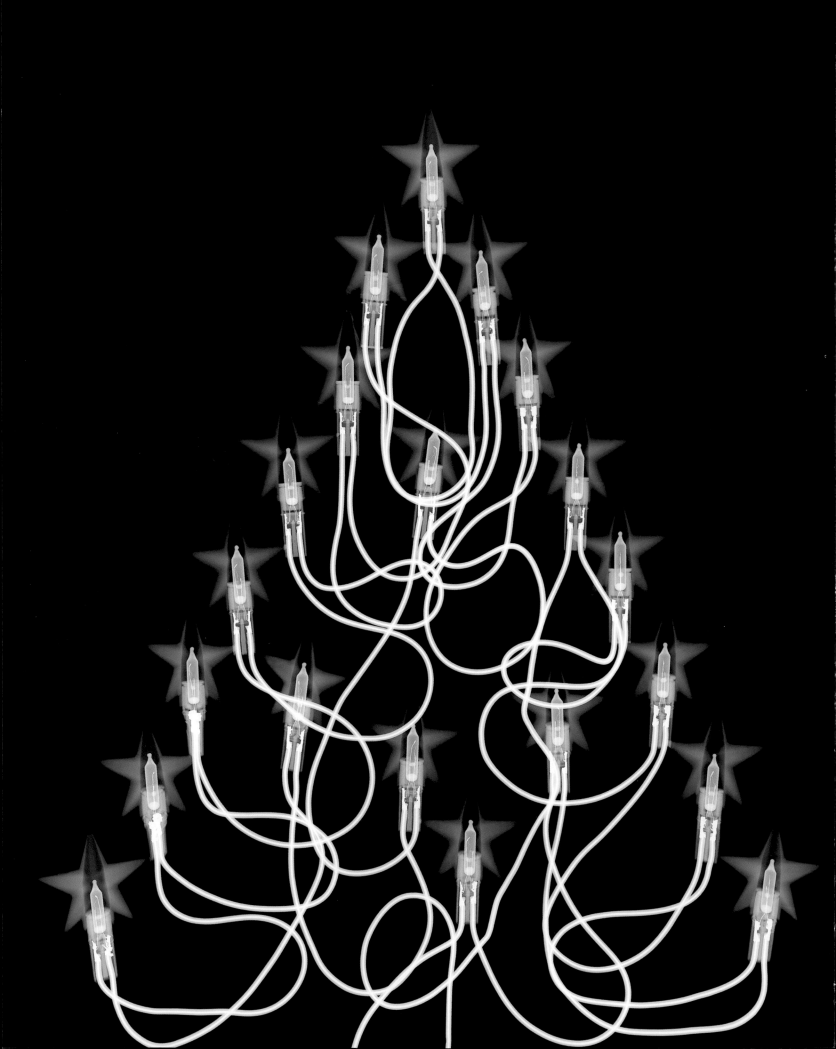

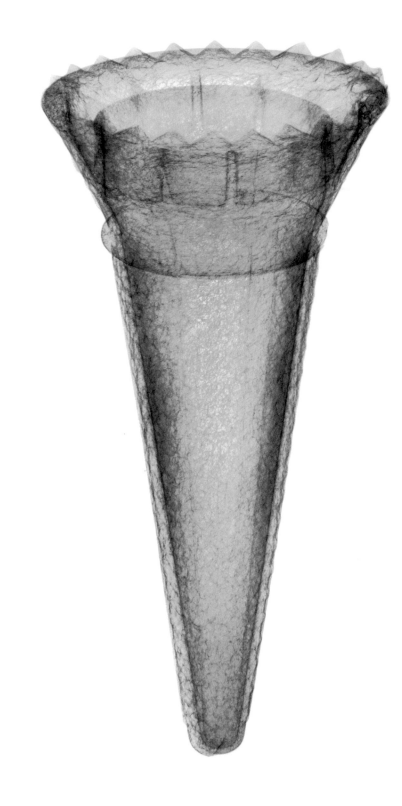

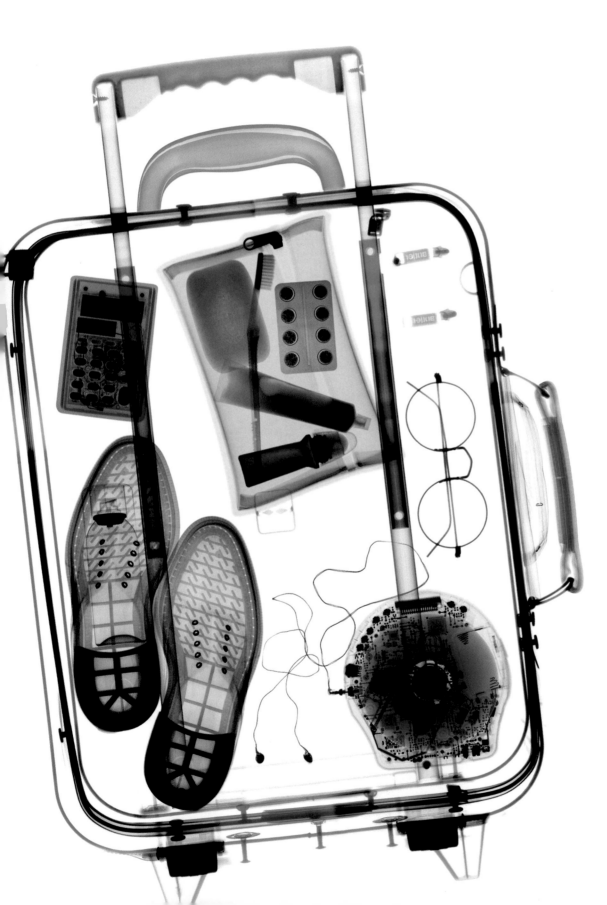

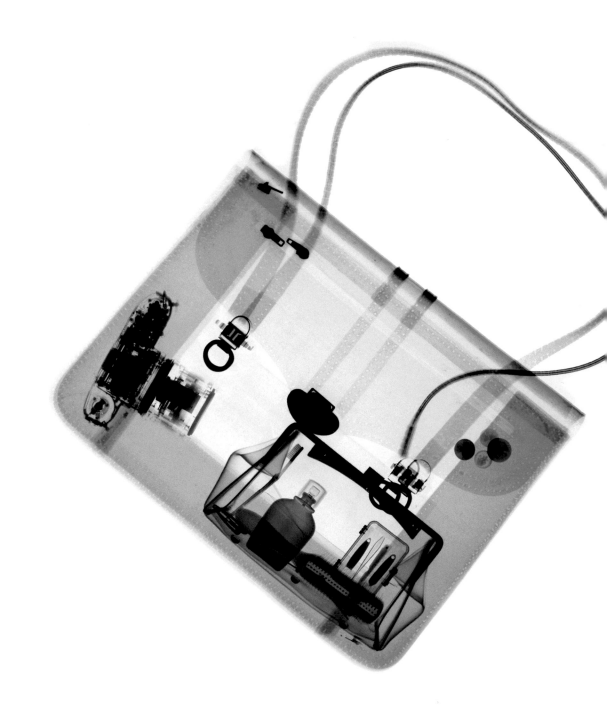

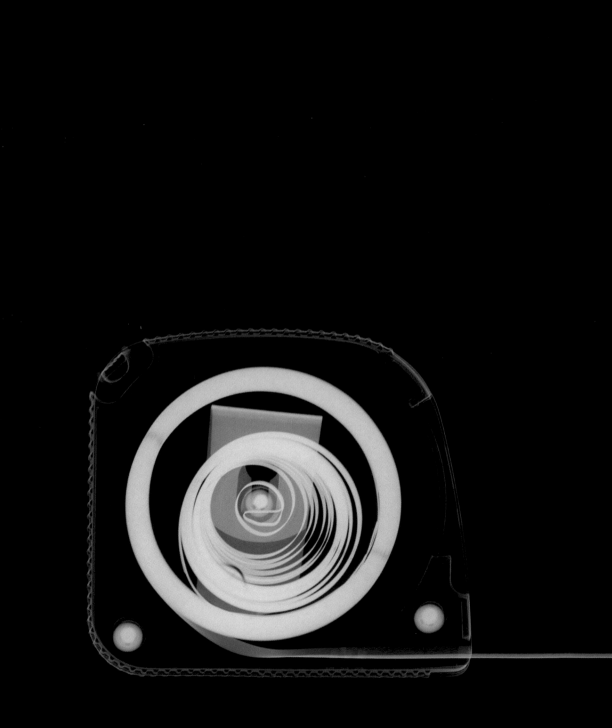

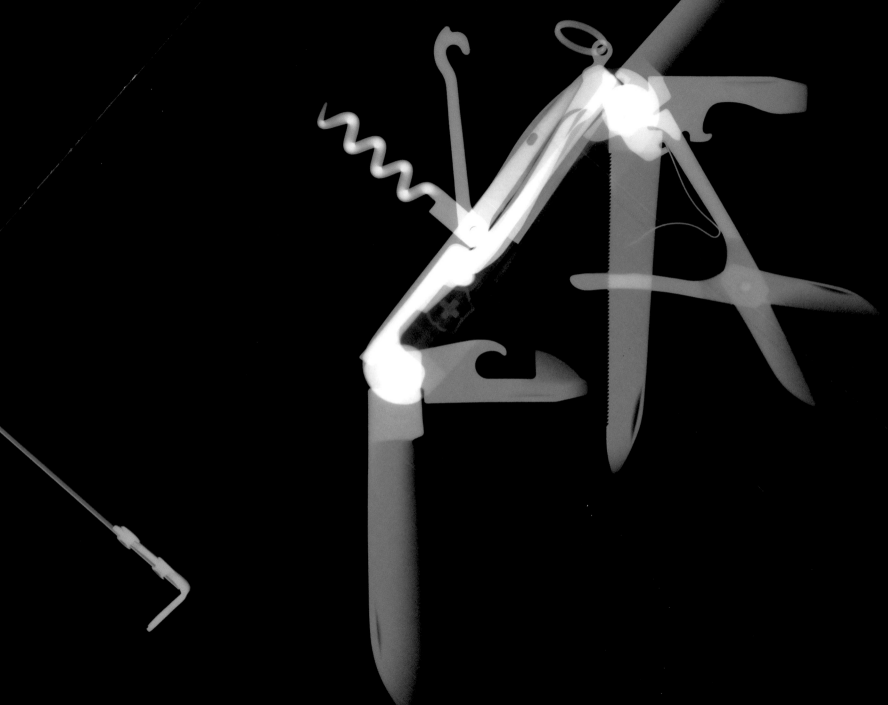

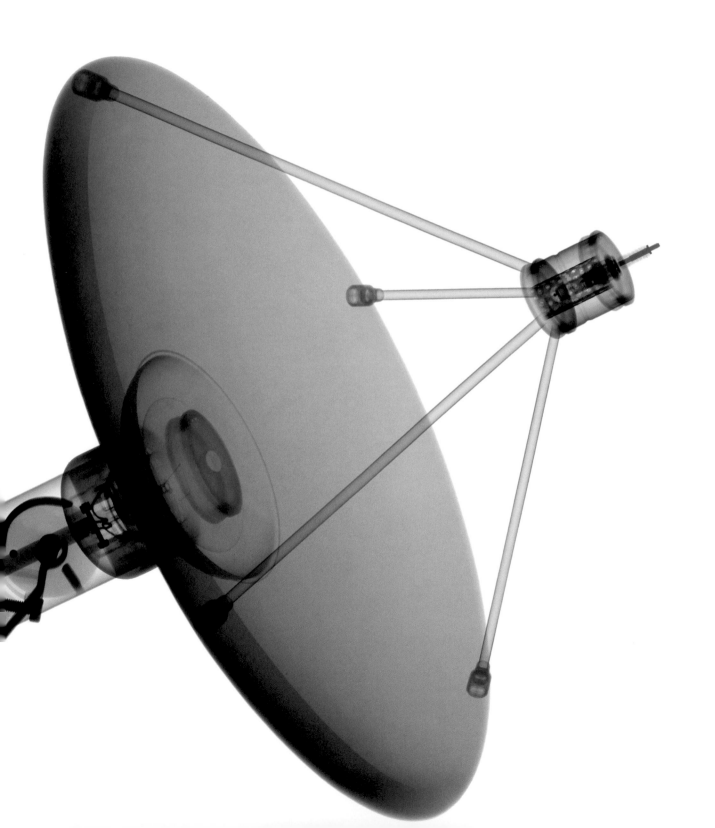

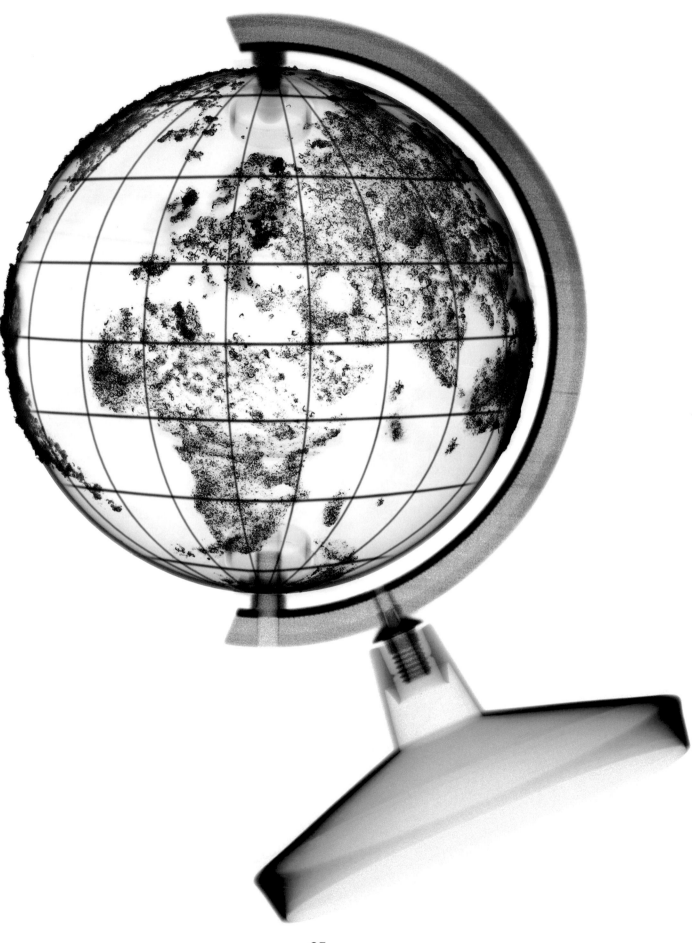

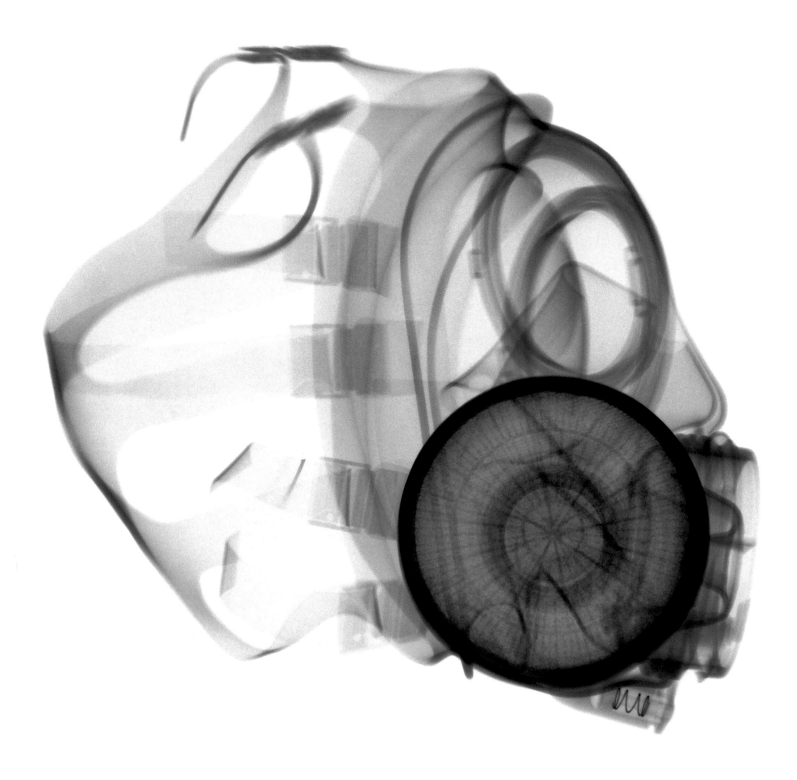

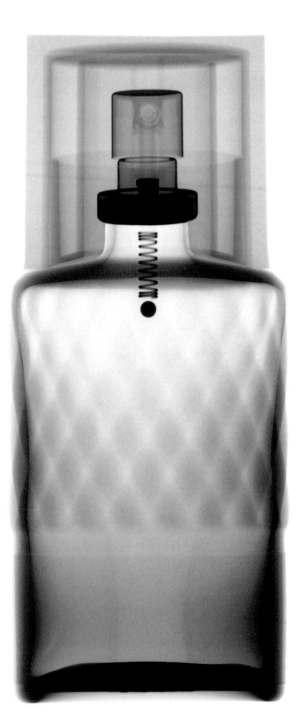

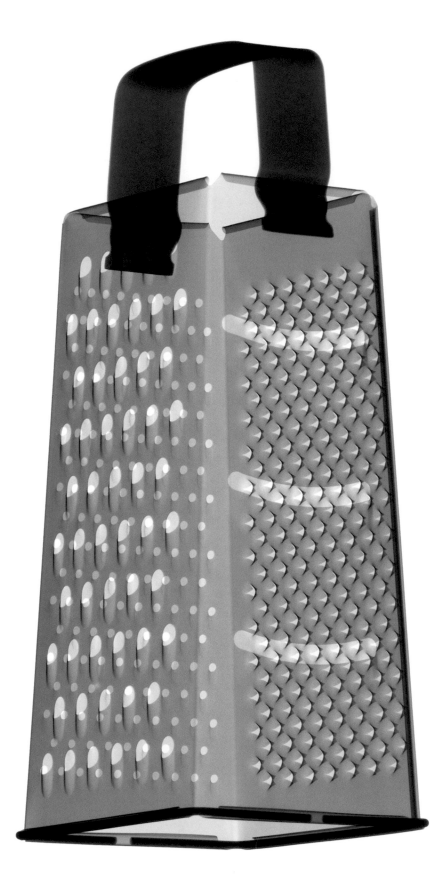

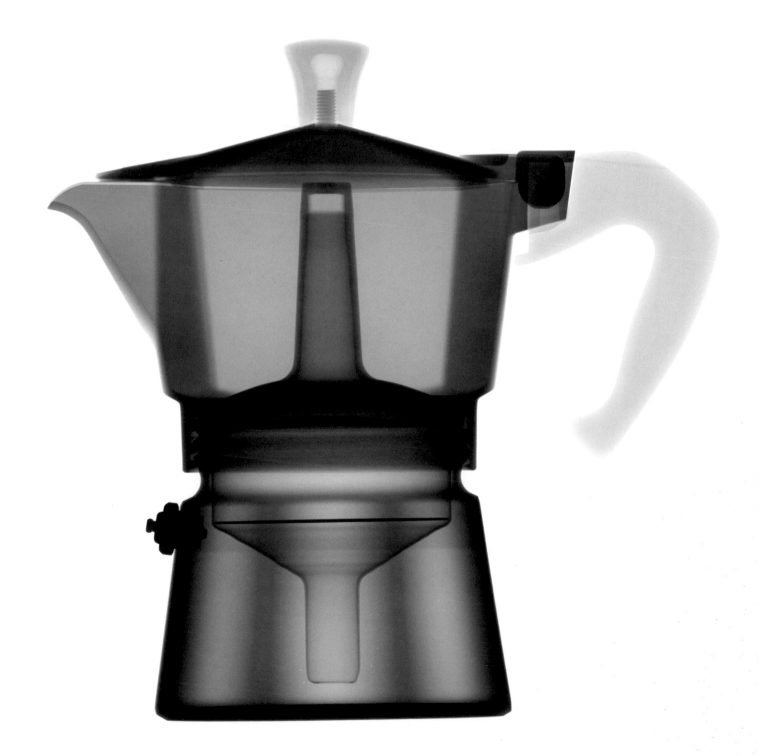

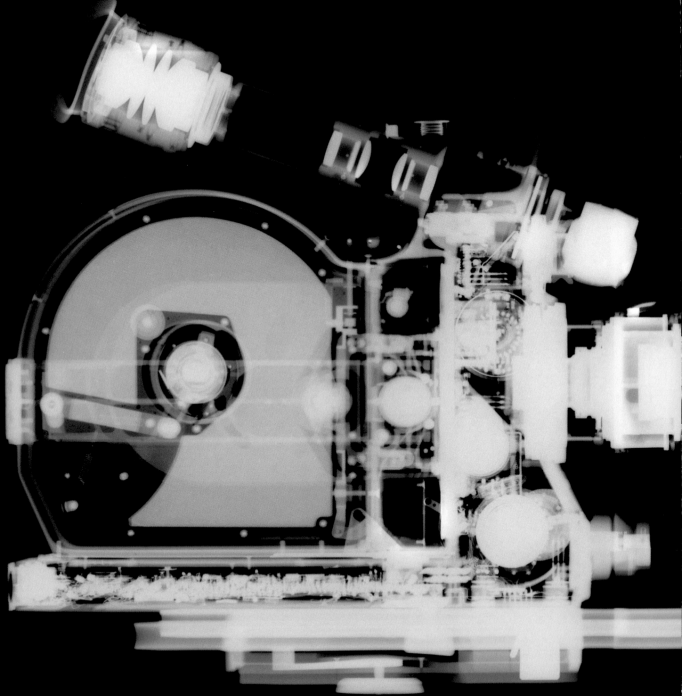

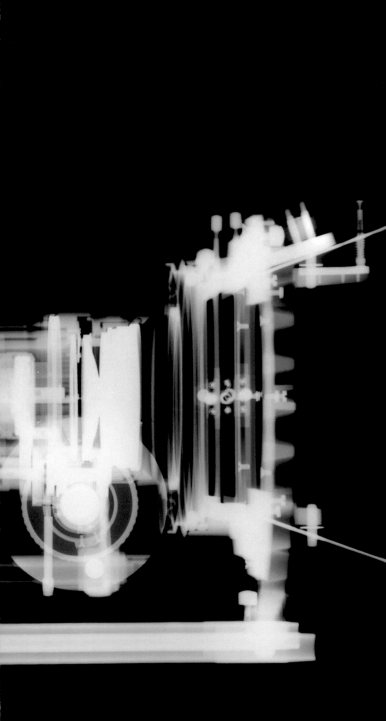

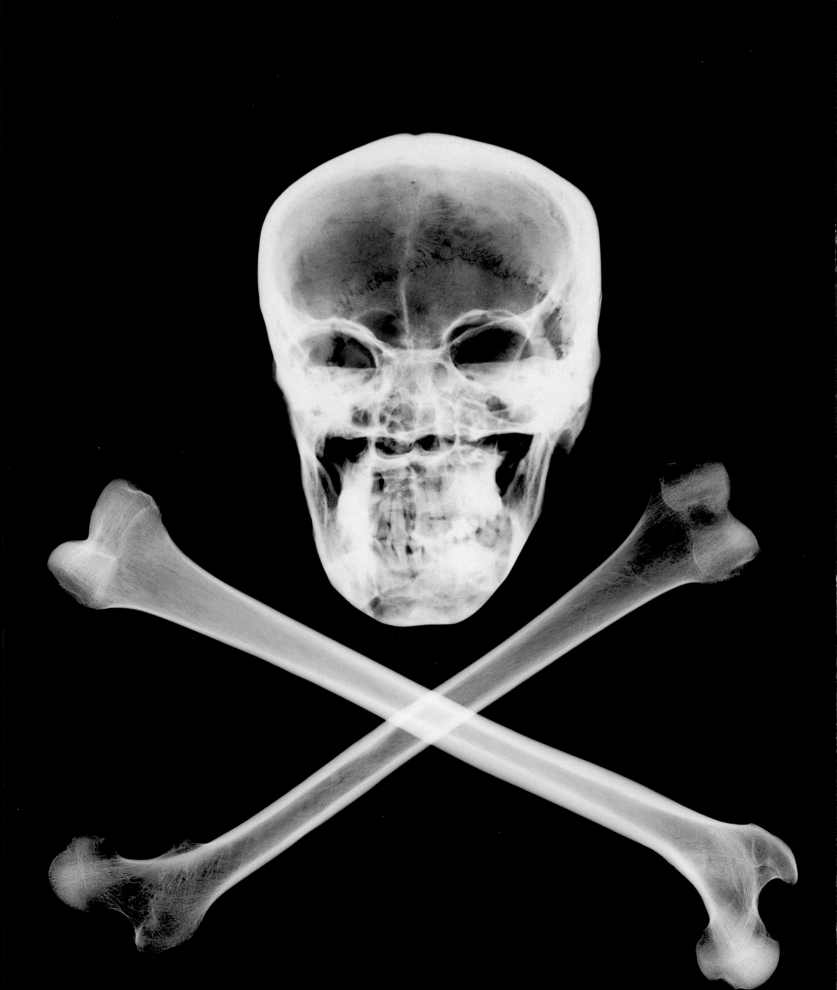

2 THE BODY

This is the area of my work that gives me the most problems. As x-raying a living person exposes them to radiation, I have to find another way to create human (and animal) images from other source material. I don't raid graveyards in the dead of night. Nor do I have a friendly undertaker. These images all start life as skeletons, or just bones and skulls, so "No humans or animals were harmed in the production of these pictures"! I am no anatomy expert either, I just gained basic knowledge of the human form while creating this part of my collection. I have been helped and guided by radiographers and doctors, but when they start getting too technical about the body, I just revert to what looks right to me.

The really difficult part is positioning the bone structure to match the pose of the "person". Often we do this bone by bone and it takes ages. The human skeleton is x-rayed in its constituent parts and then assembled back together.

Strangely, when you take into account our familiarity with x-rays of the human body, this area of my work gets the most extreme reactions. Comments received range from, "Looks too scary, like death" to "I never realised our bodies were so complex."

Stripping bare the human form emphasizes my earlier point about our fickle tendency to judge people by how they look. When skin and facial features are removed we all become equal. We are all flesh and blood – and bones!

This medical area of x-ray has the fastest growth in technological advances. Some of the equipment used costs several millions of pounds. Understandably it is difficult to get access to this equipment, as the state-of-the-art kit is being used in medicine, and sick people take priority. On the few occasions I do get my hands on such expensive technology, it is often just for an hour or so in the dead of night when most hospital business has ceased. Even then, there is always the all too frequent risk of being interrupted for a medical emergency. I would love to use this type of equipment to make a series of images not associated with the human form. Up to now my attempts have been unsuccessful, probably because those that have such cherished equipment at their disposal don't want to risk me breaking it.

The pictures that have the most impact for me in this section are the ones that have the added drama of the scale of the human body when placed in a certain situation. Compare the size of the people servicing the plane to the plane itself, or lose yourself inspecting the people on the bus. The complexity of the human form when you can see through it has added organic qualities. When placed in some kind of context, there is something uncomfortable in the relation of the body to man-made surroundings. The "people" in my x-ray situations are all saying "Hey, look at me!" but in fact, we are looking right through them.

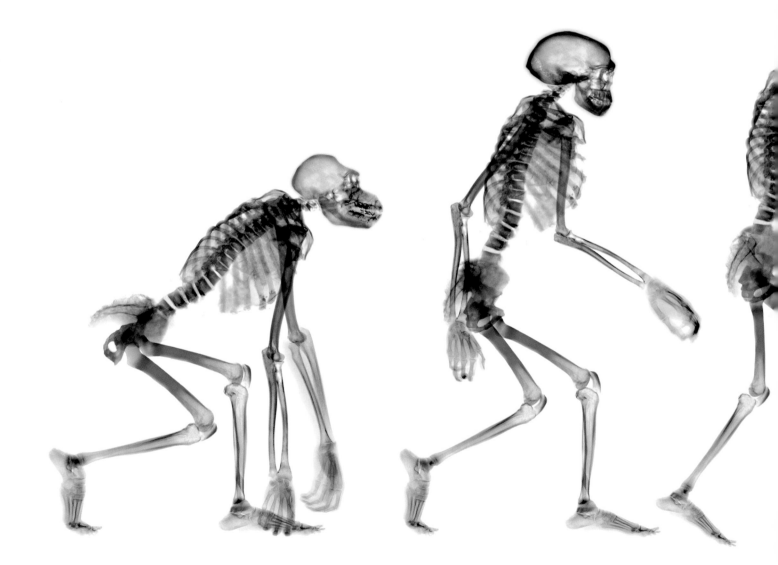

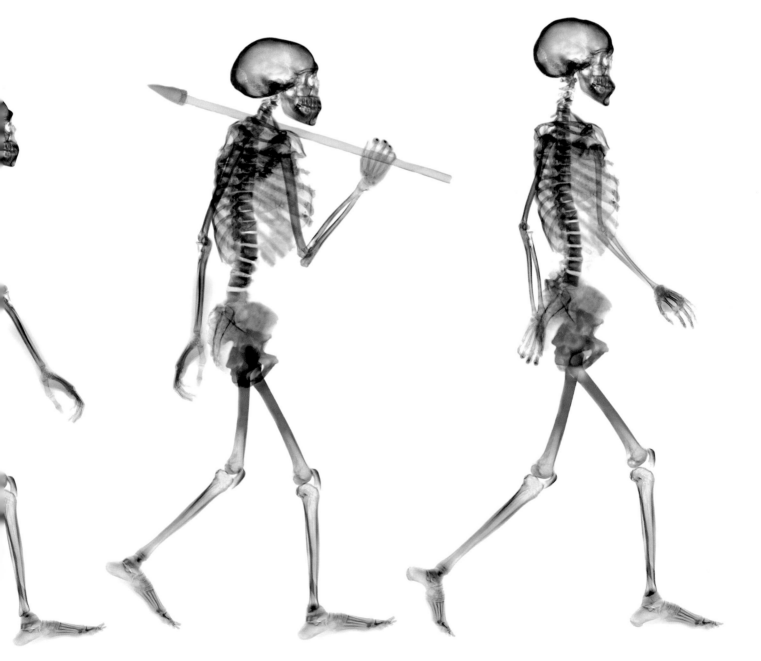

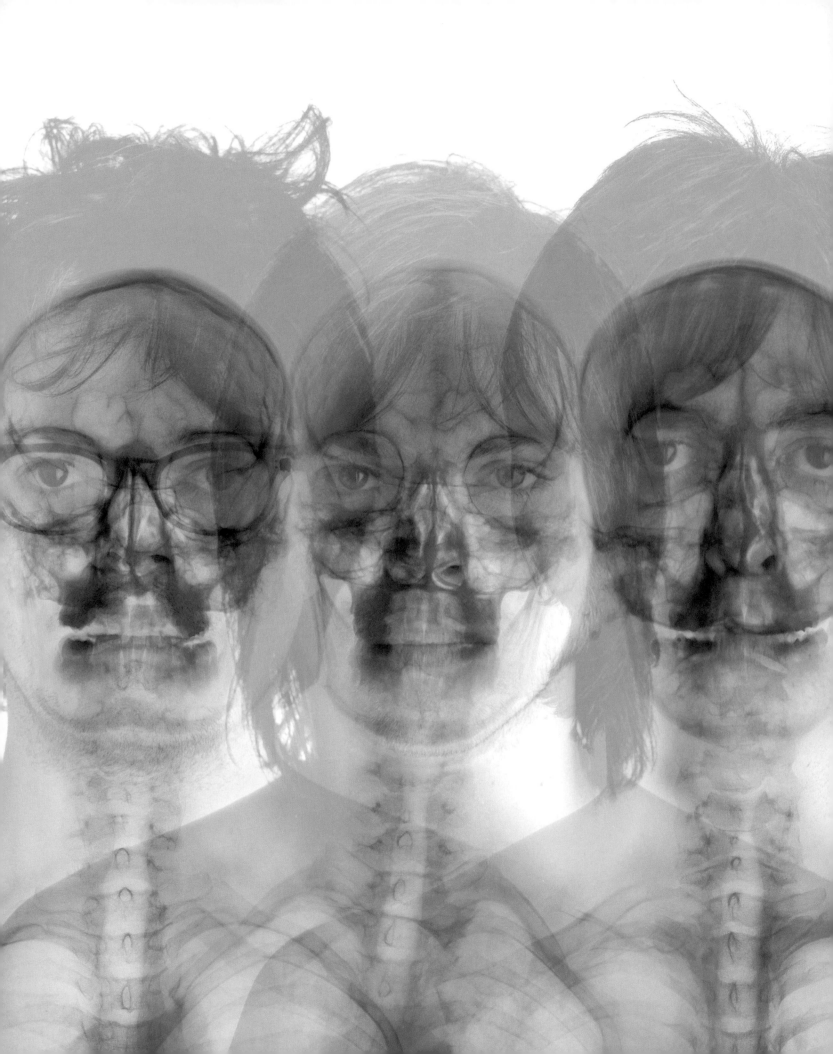

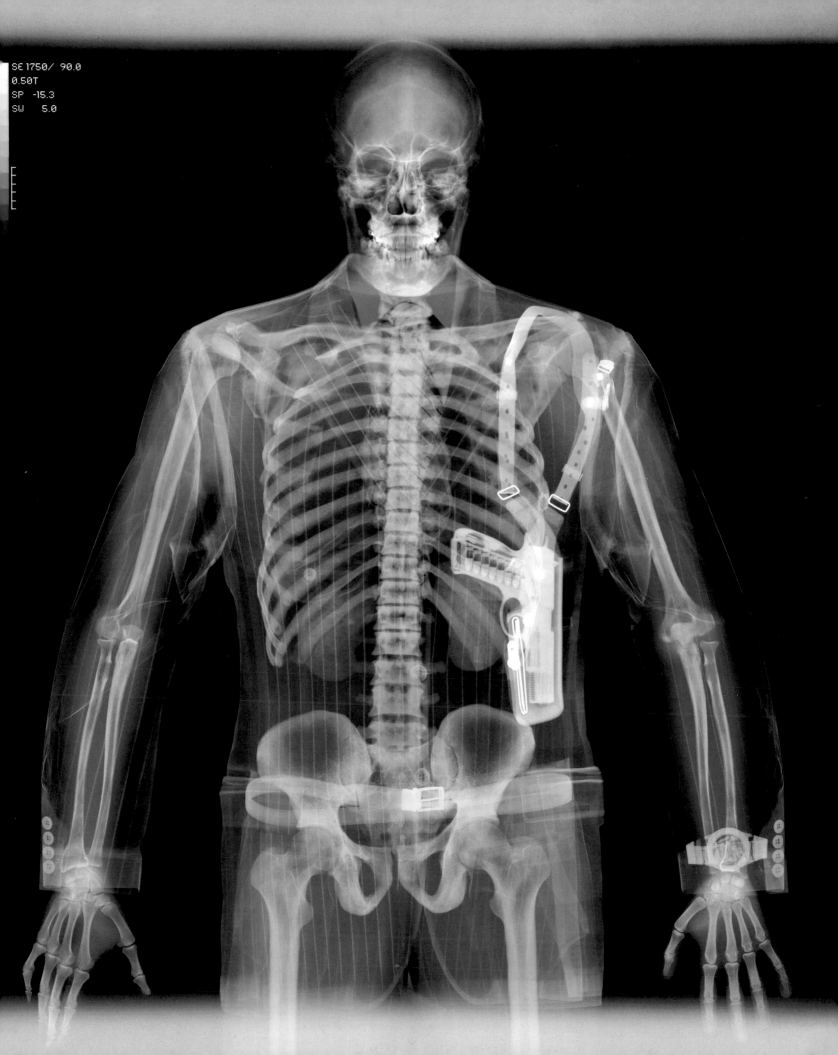

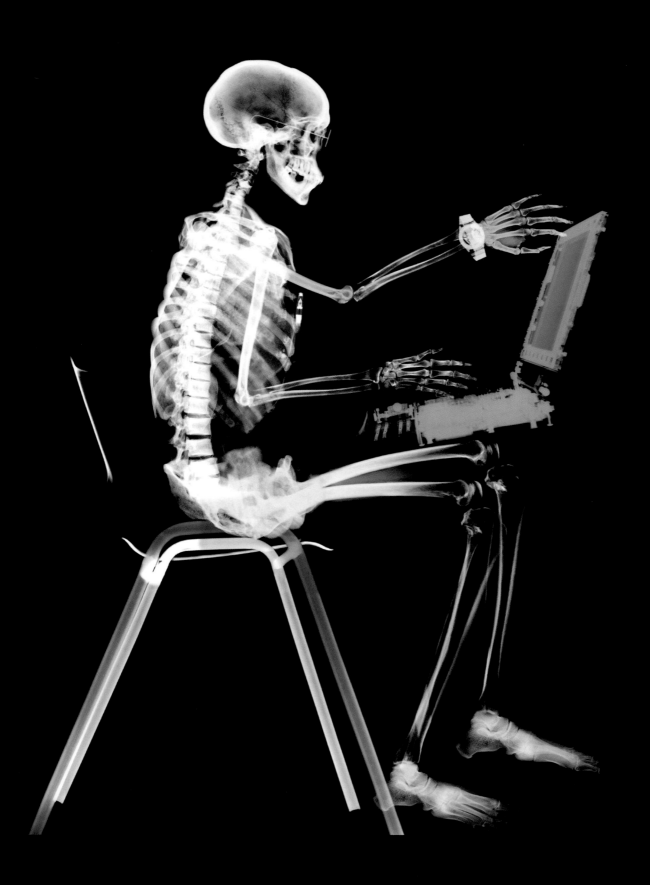

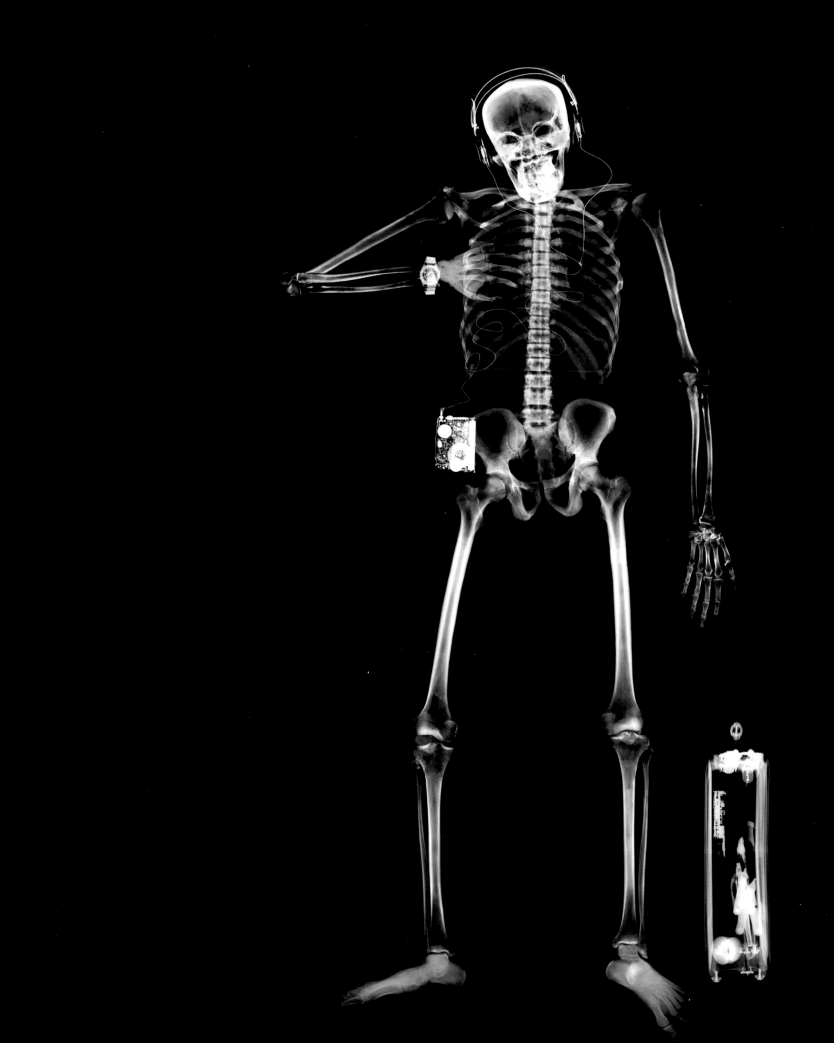

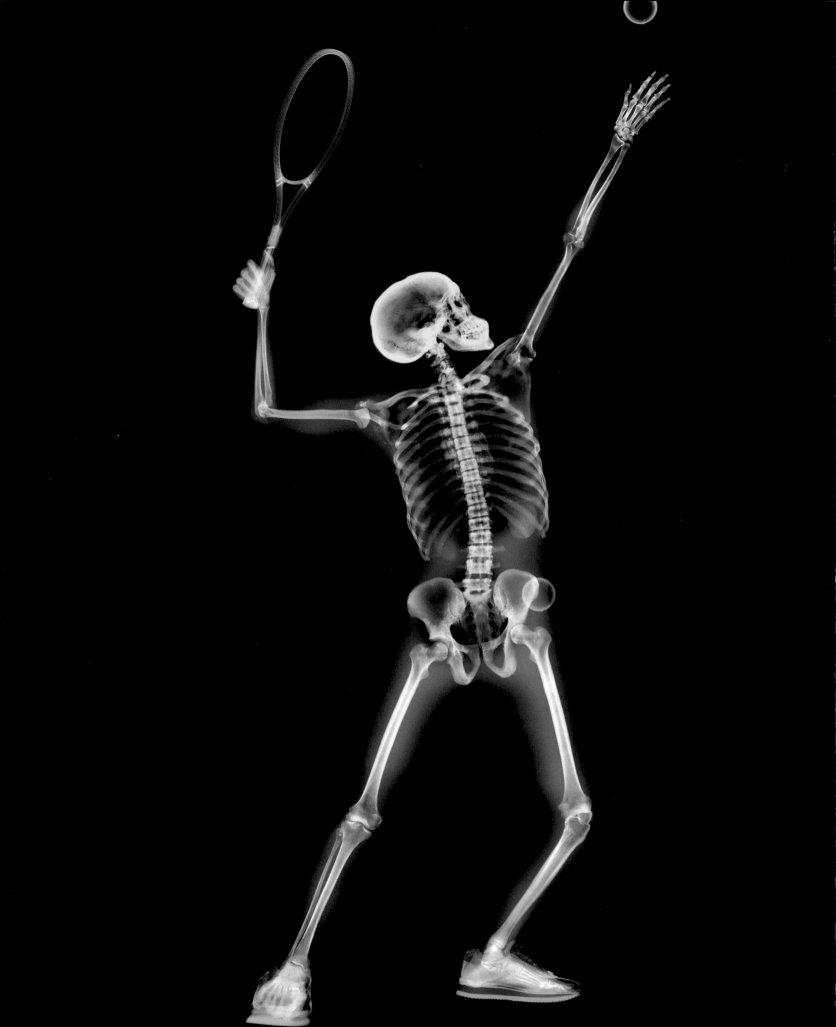

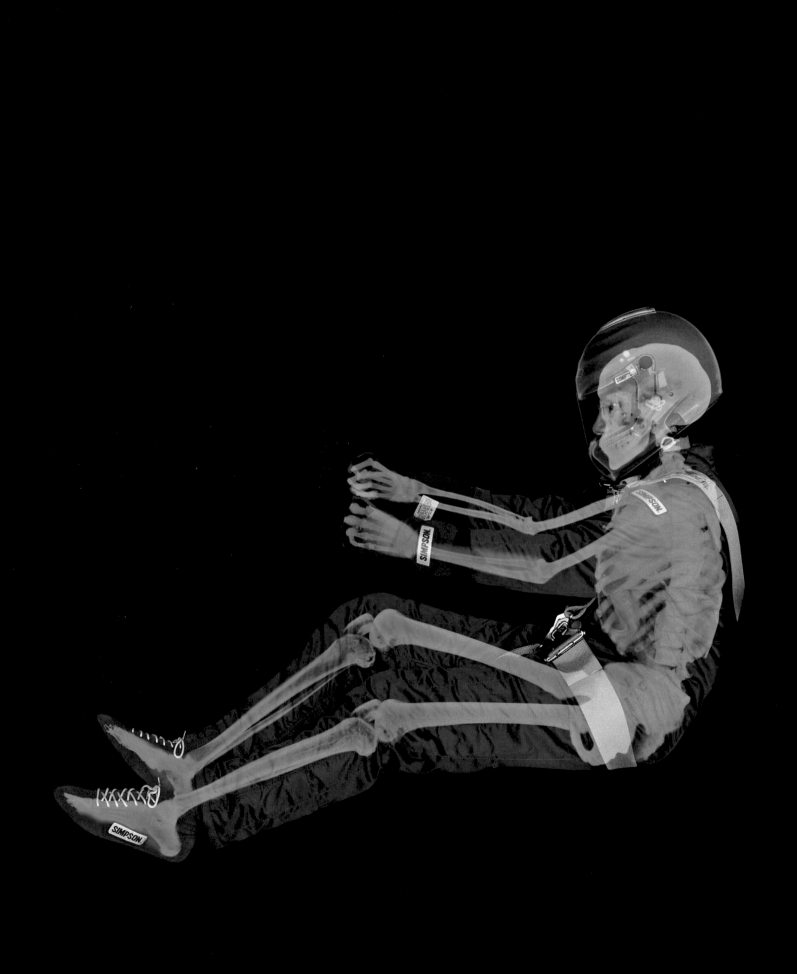

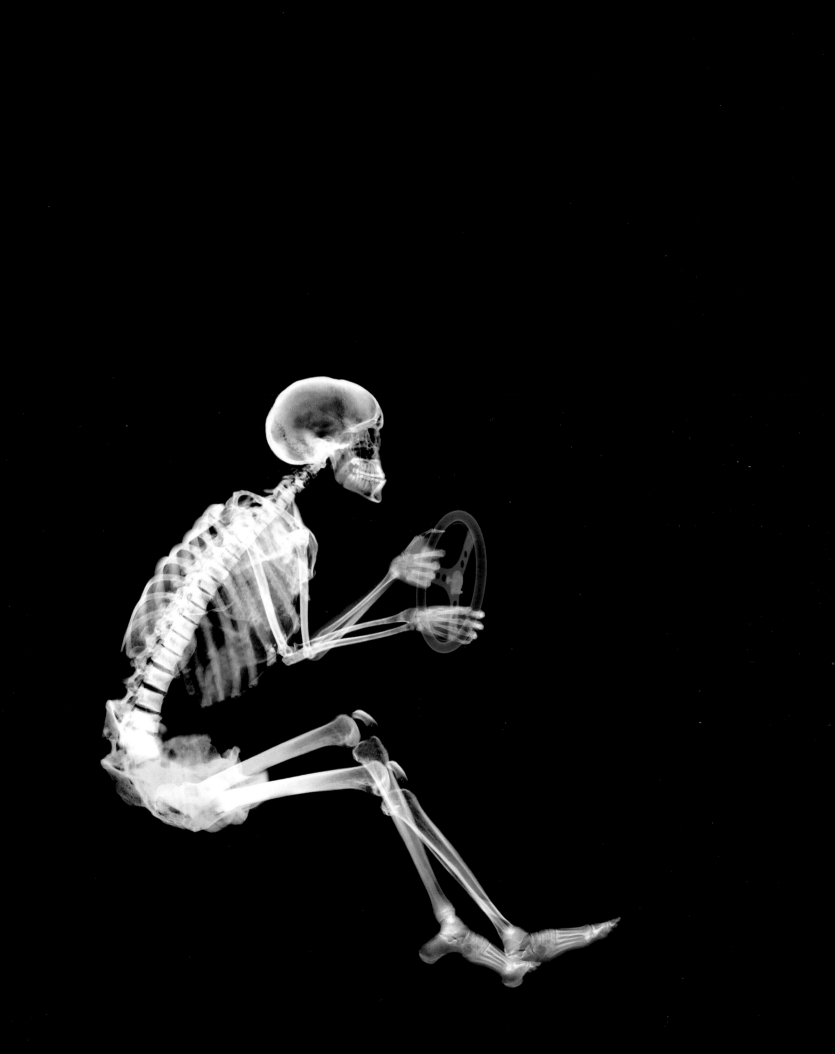

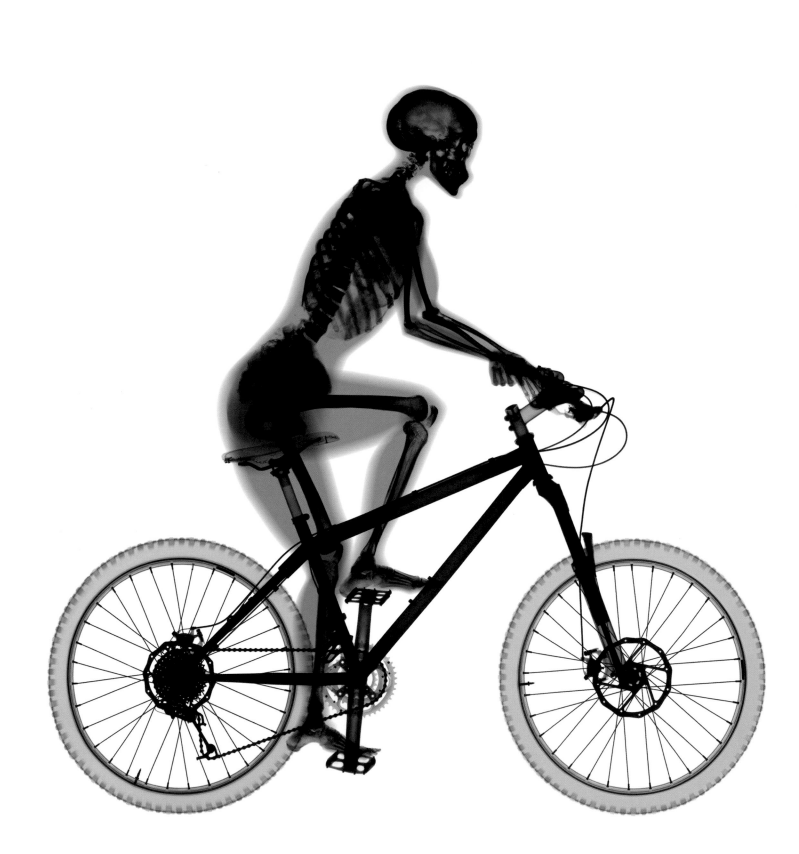

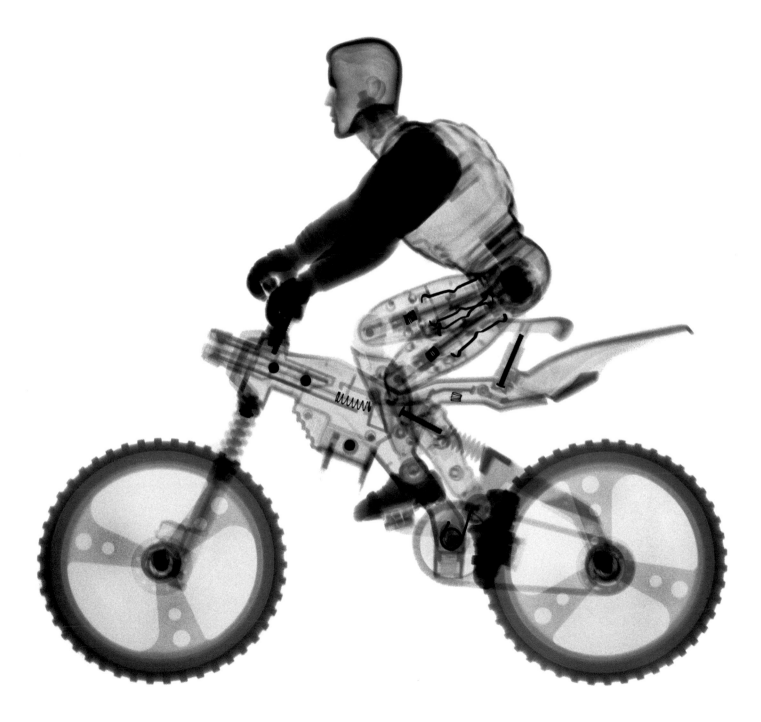

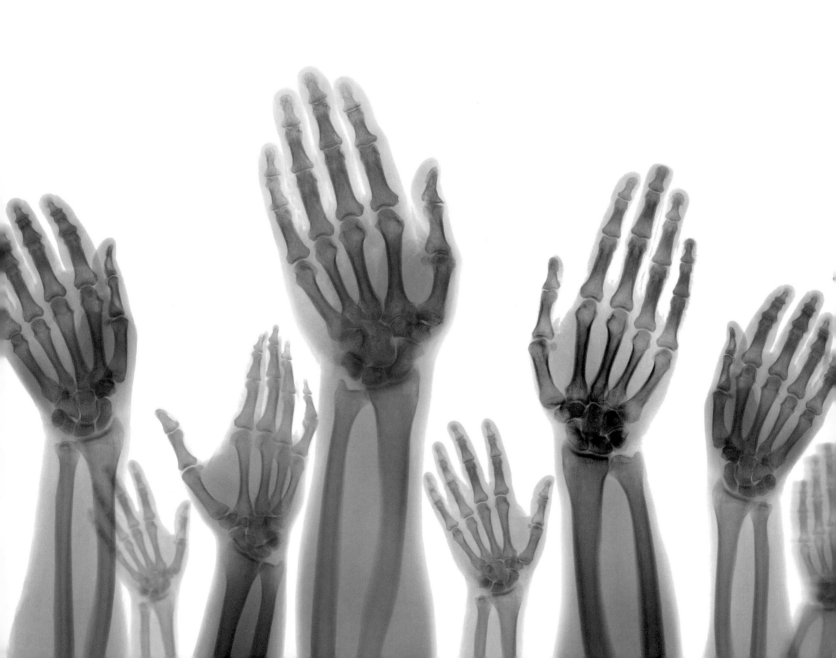

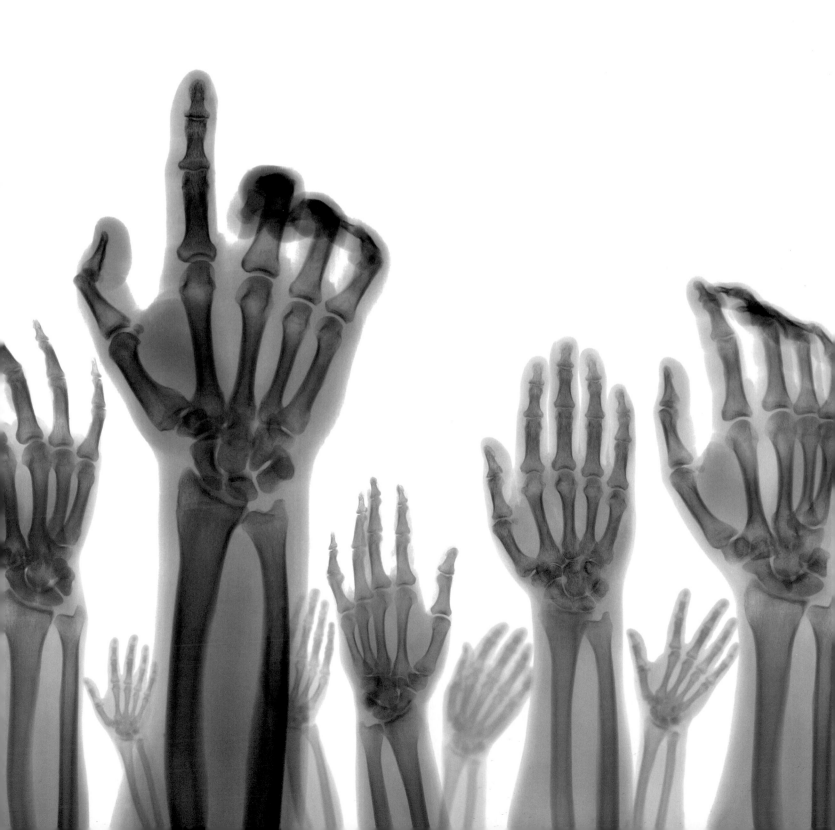

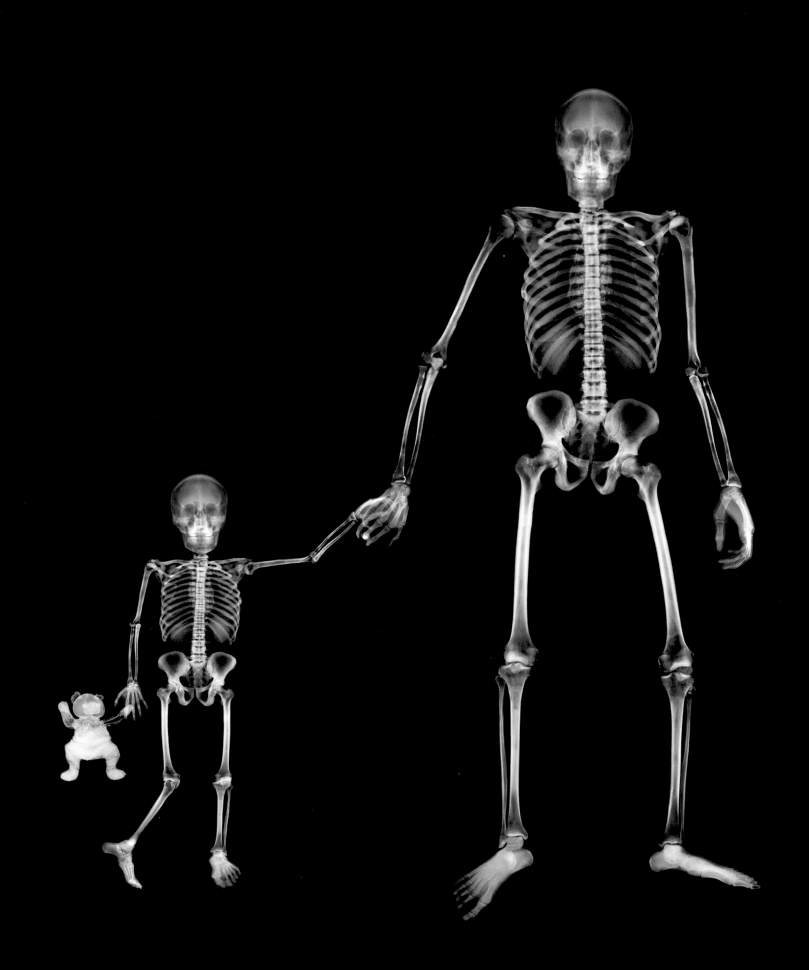

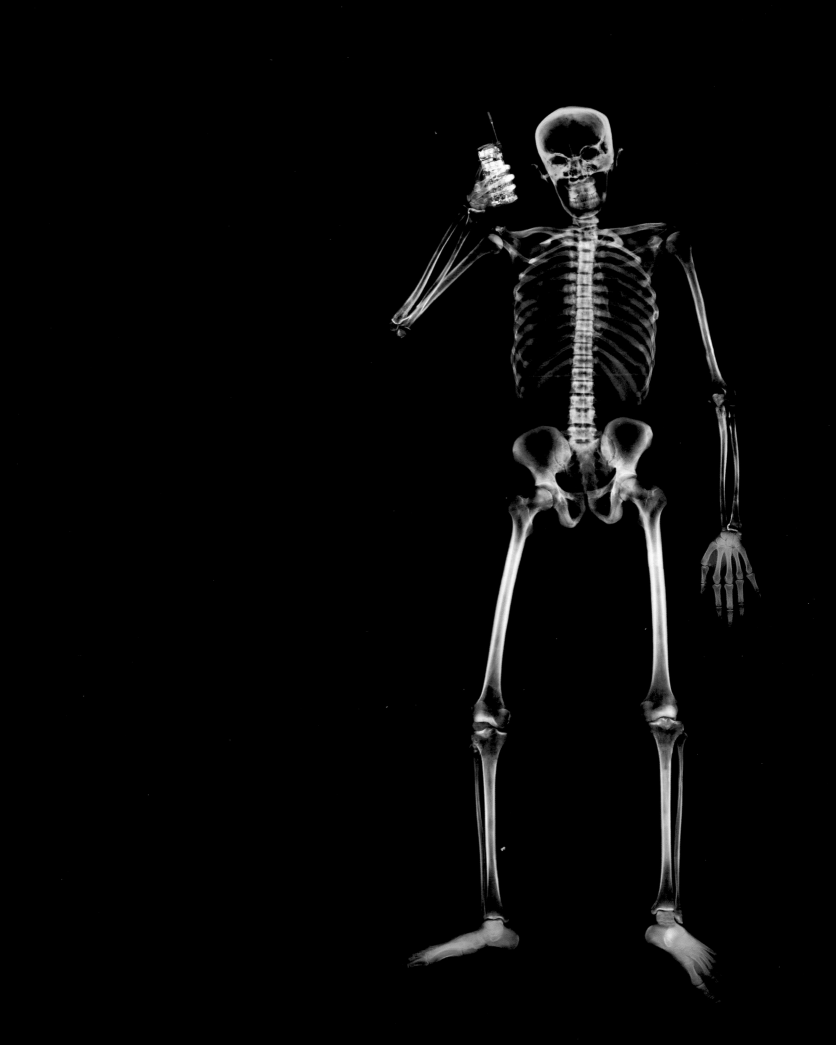

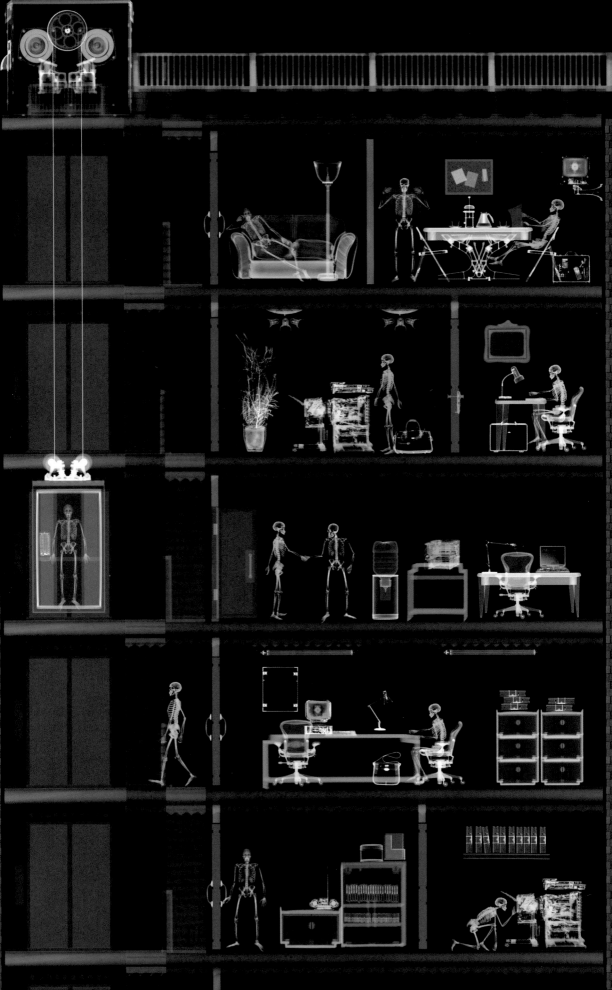

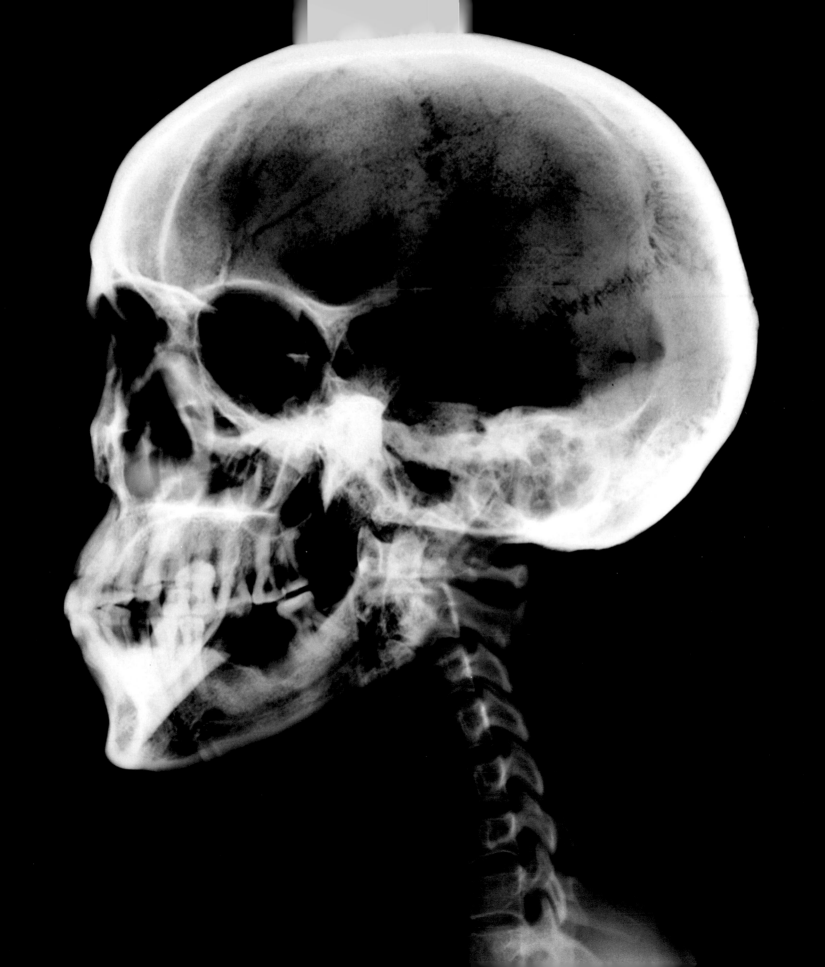

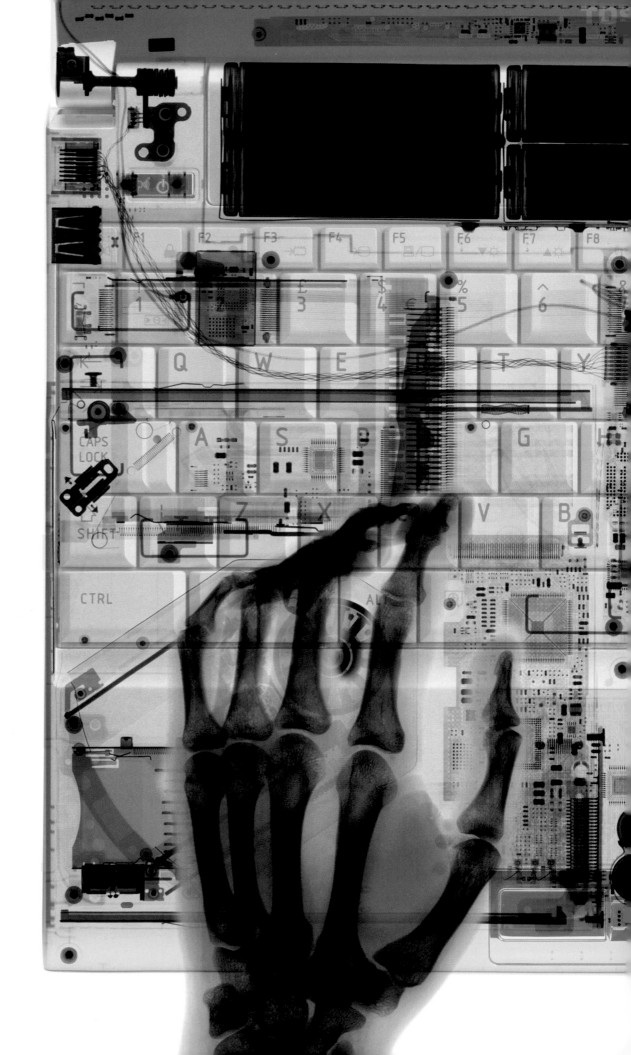

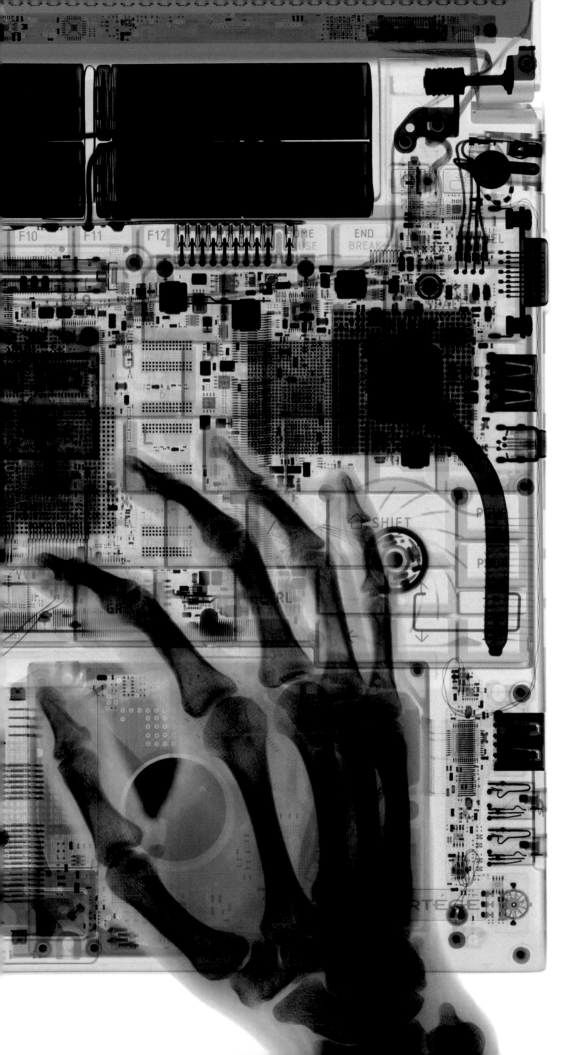

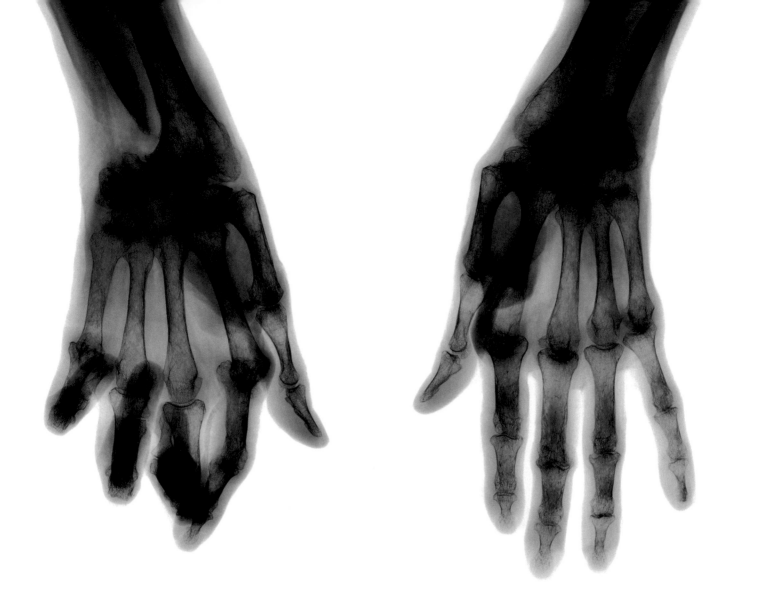

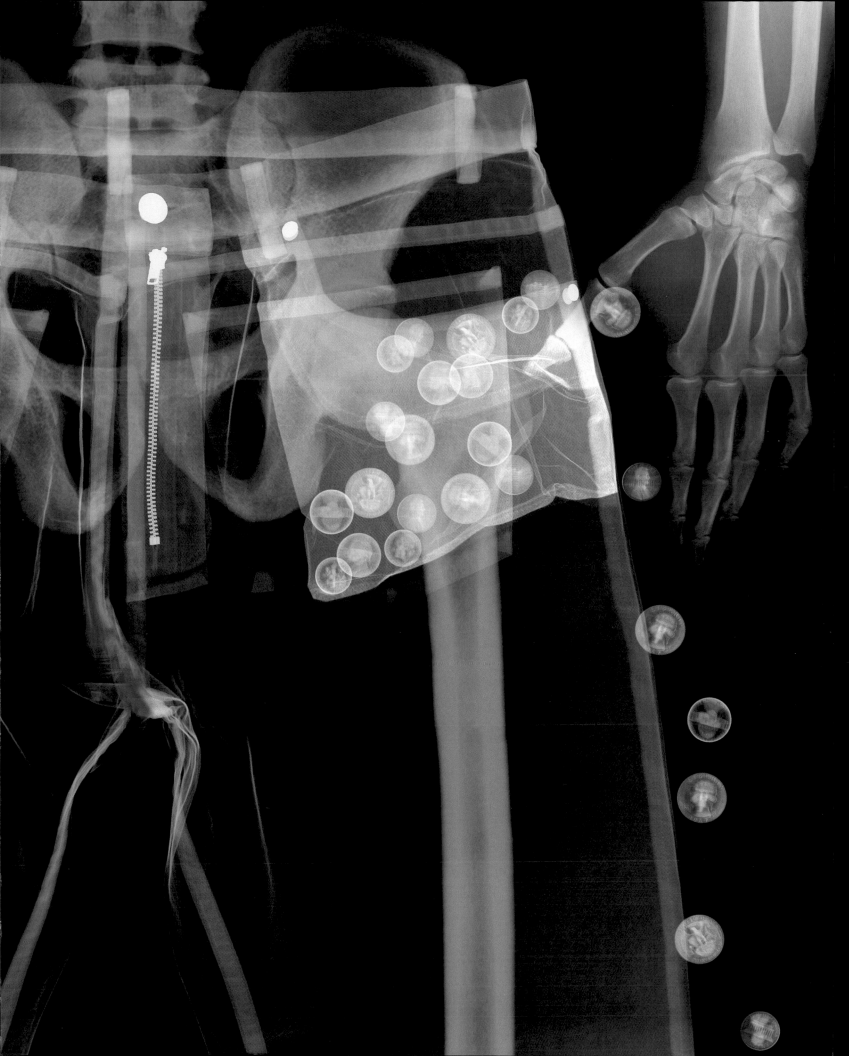

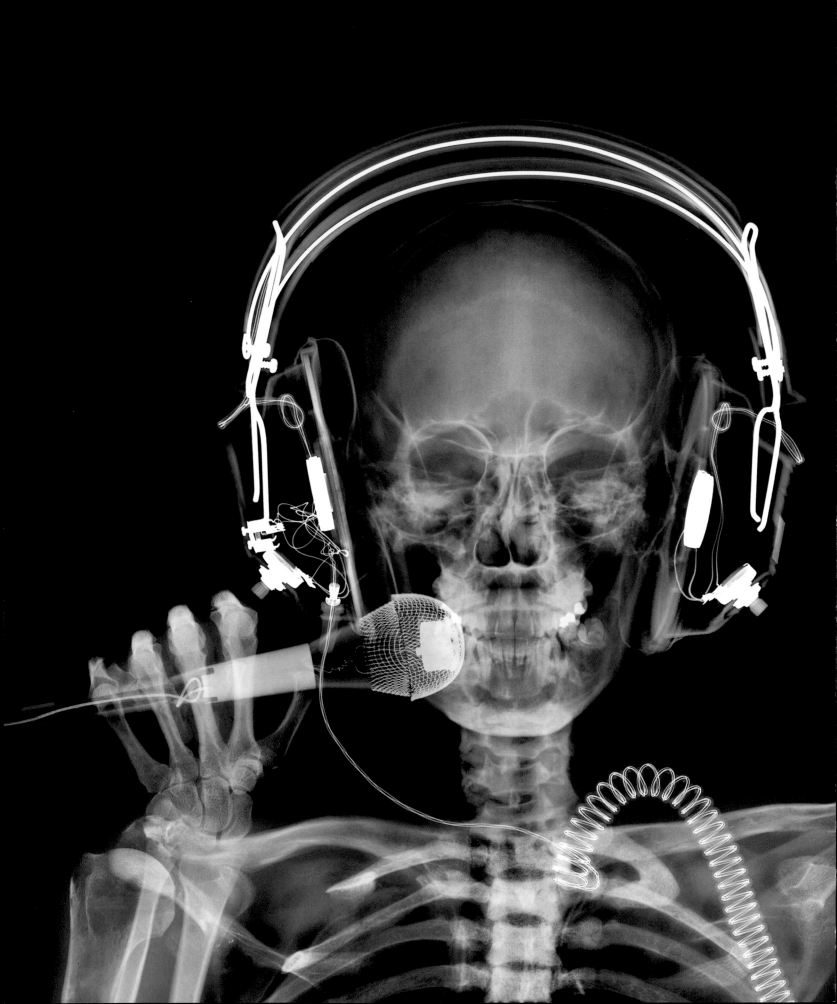

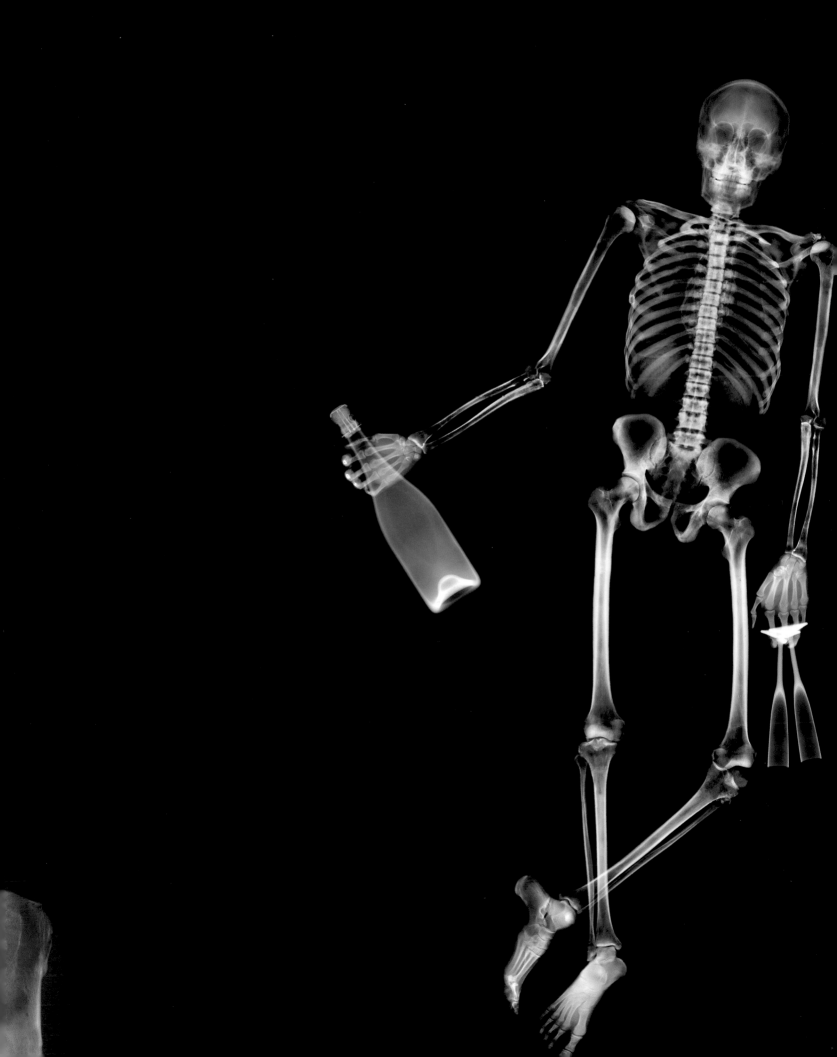

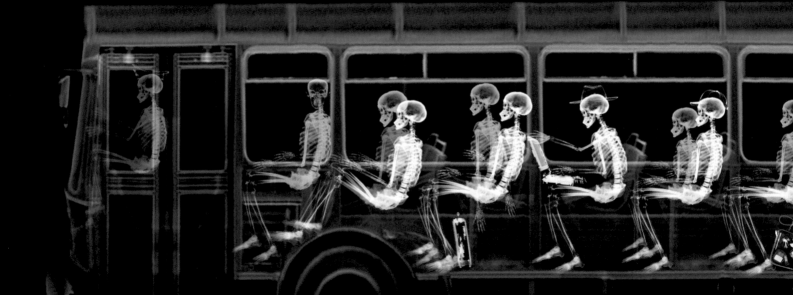

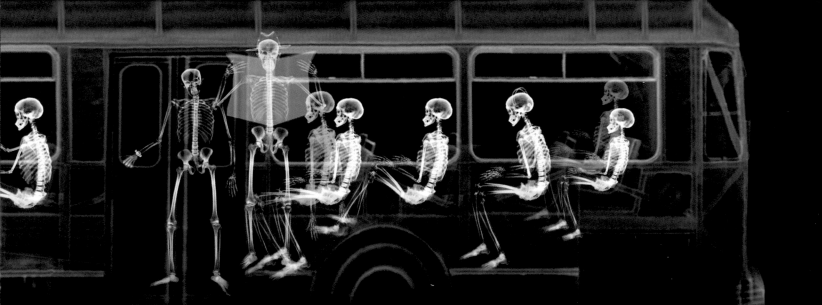

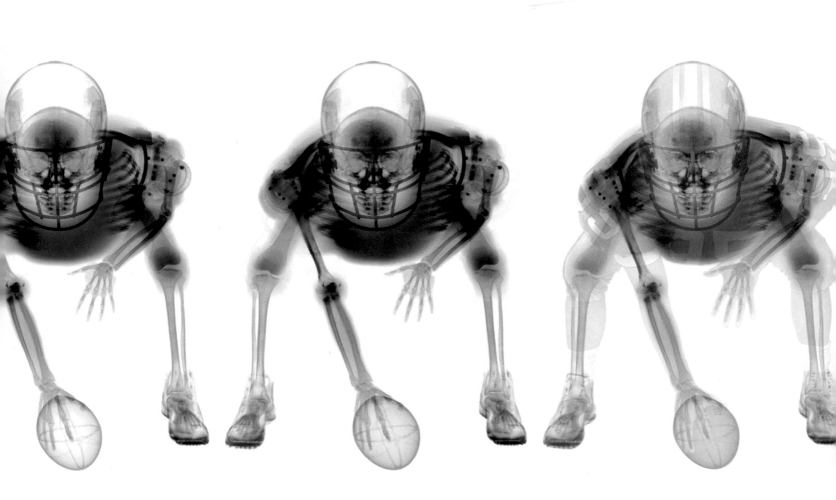

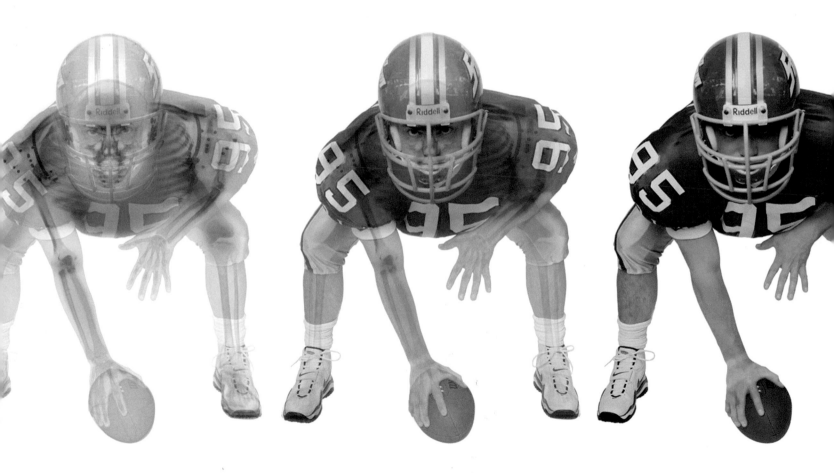

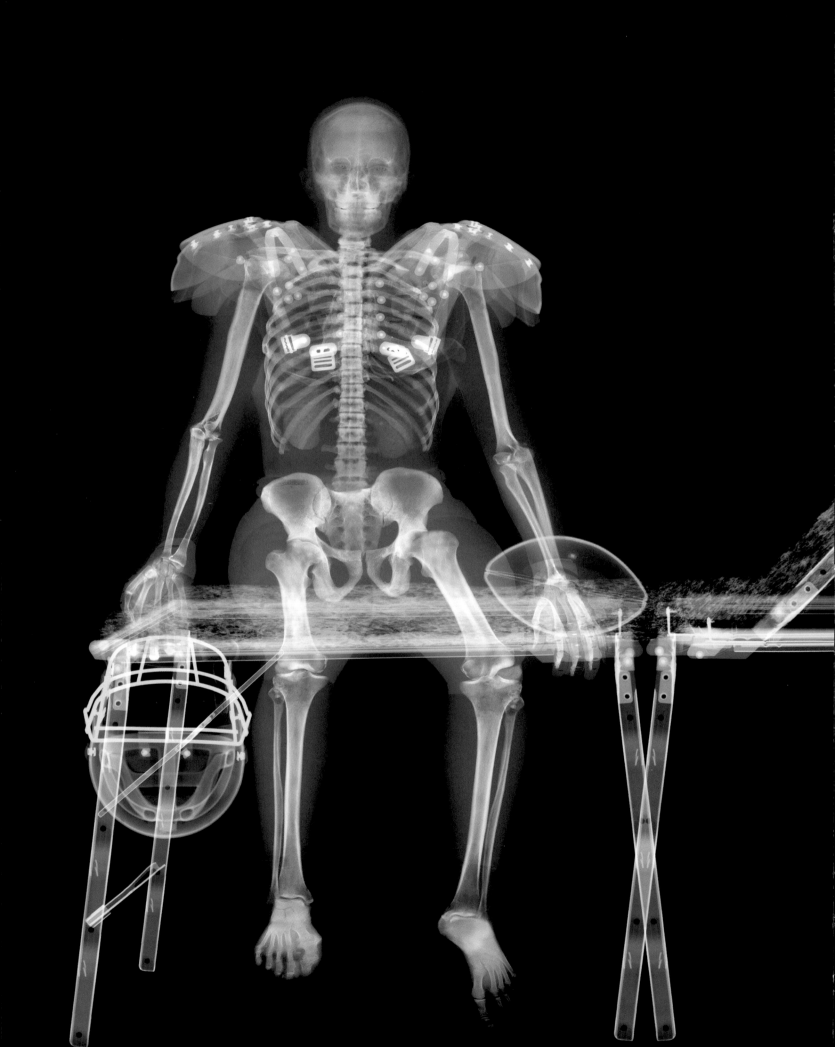

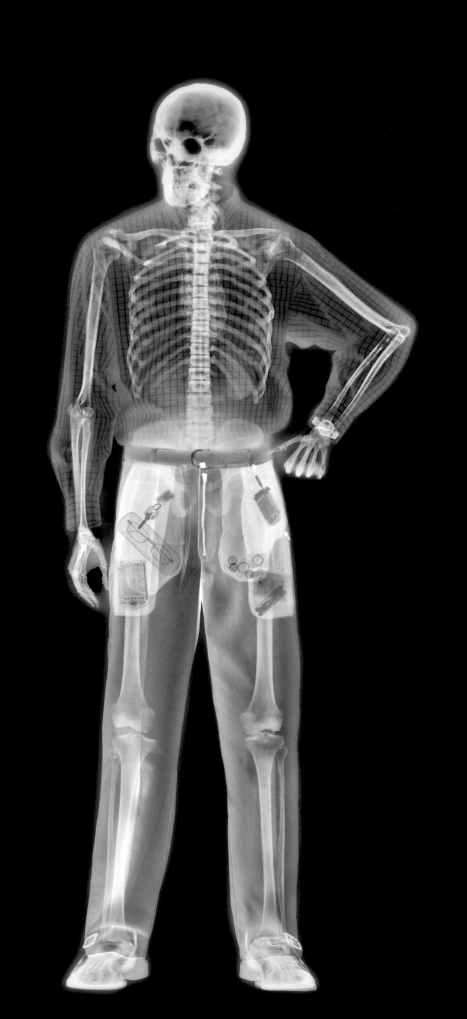

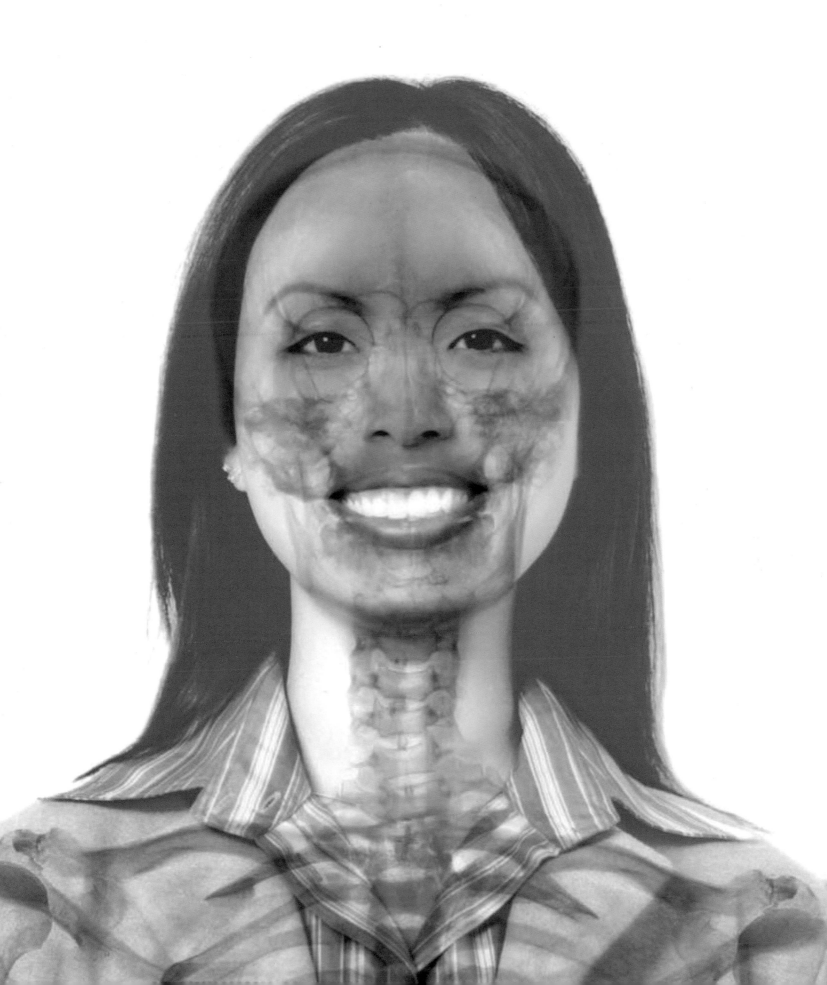

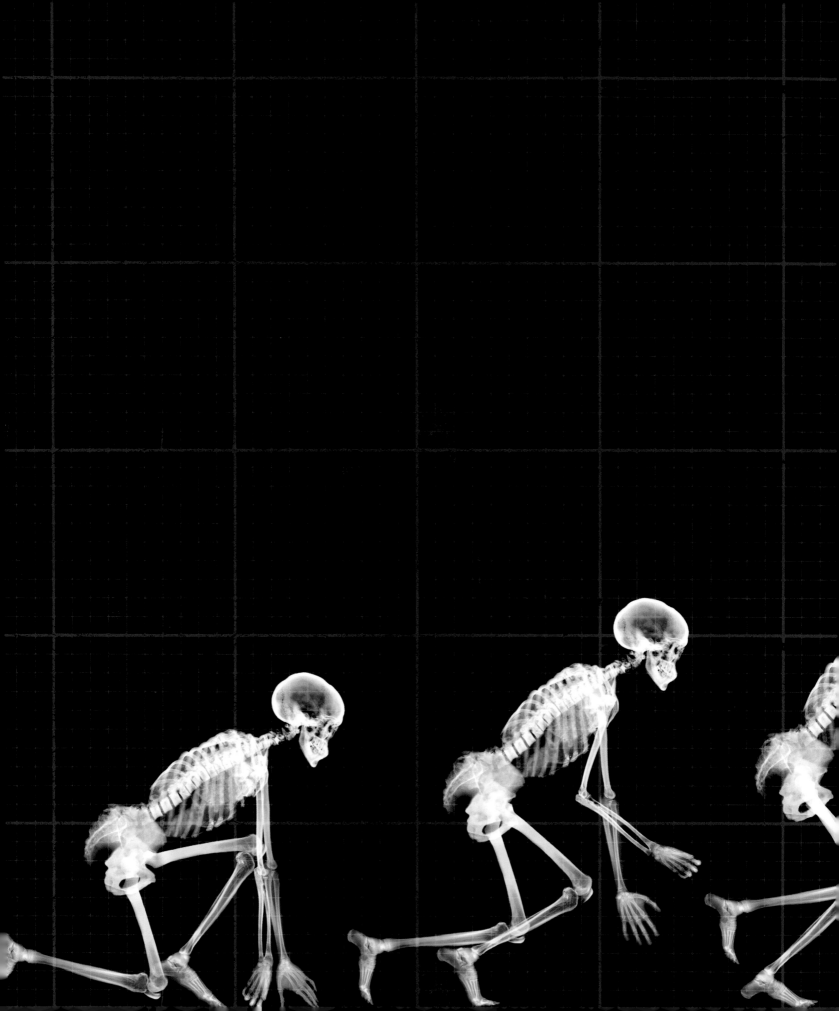

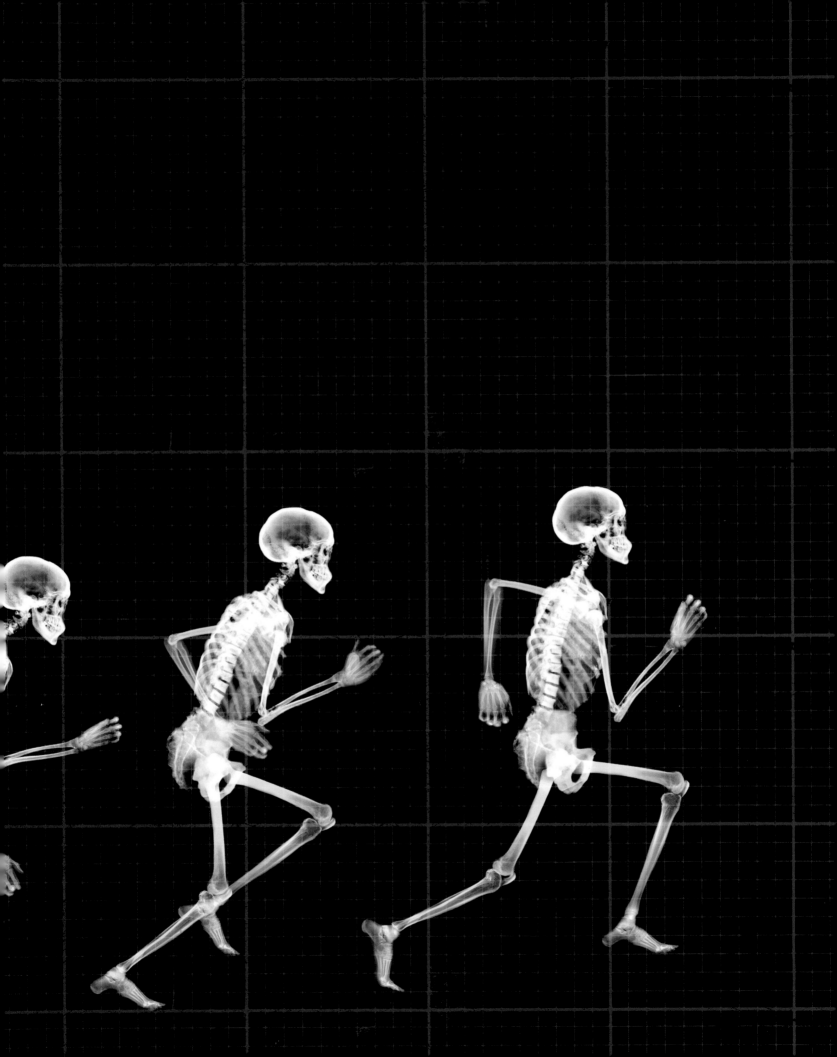

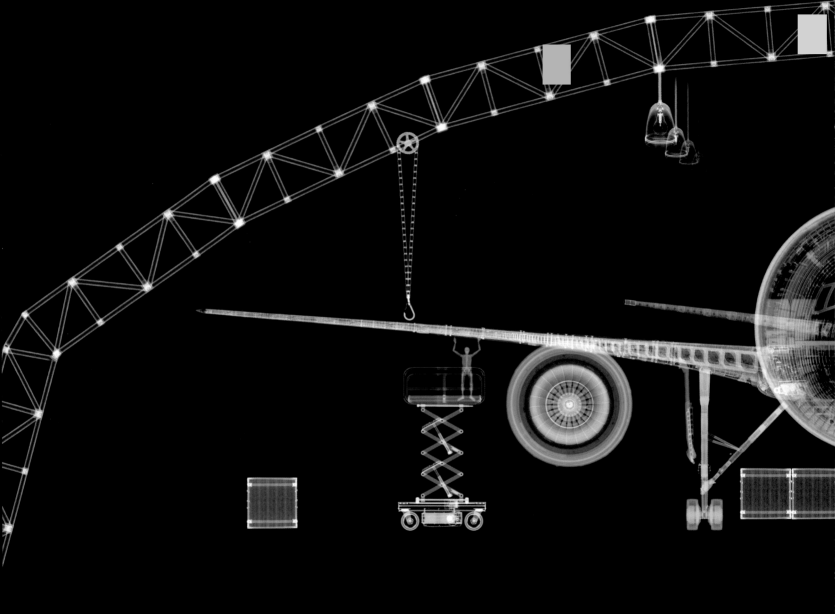

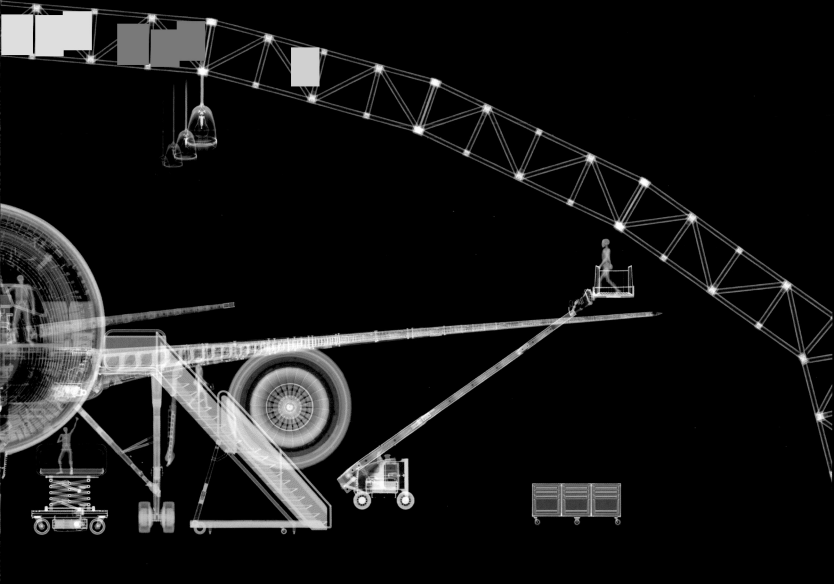

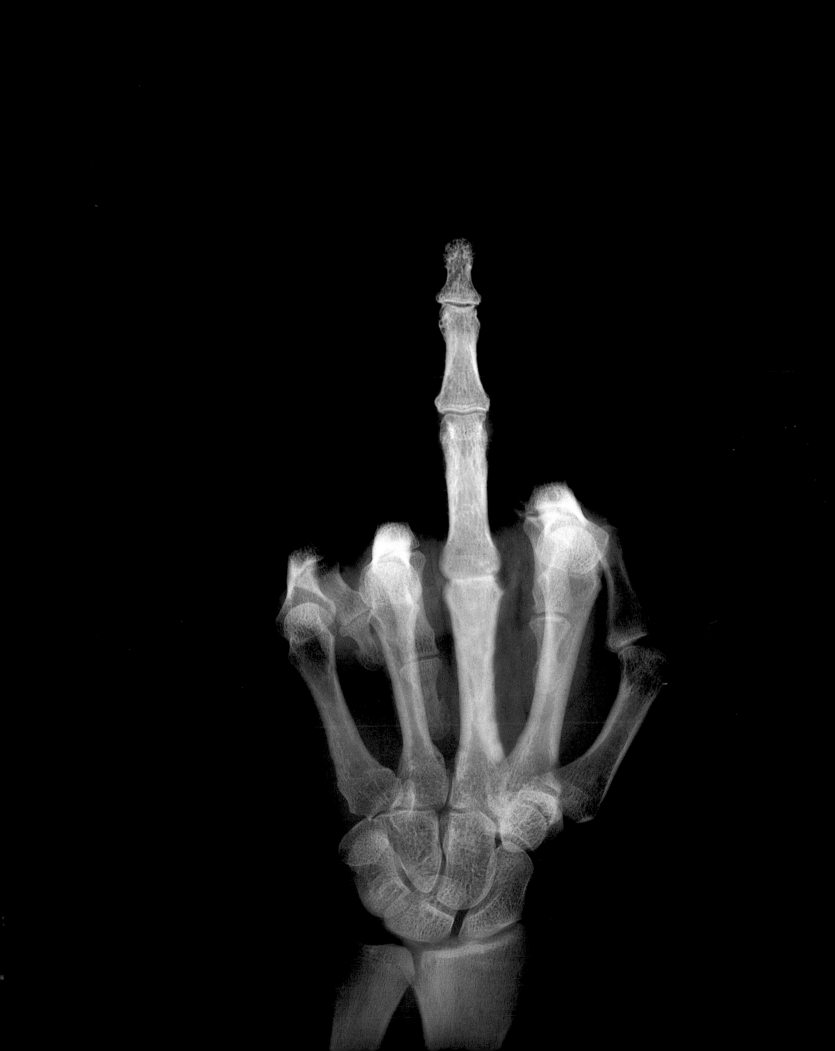

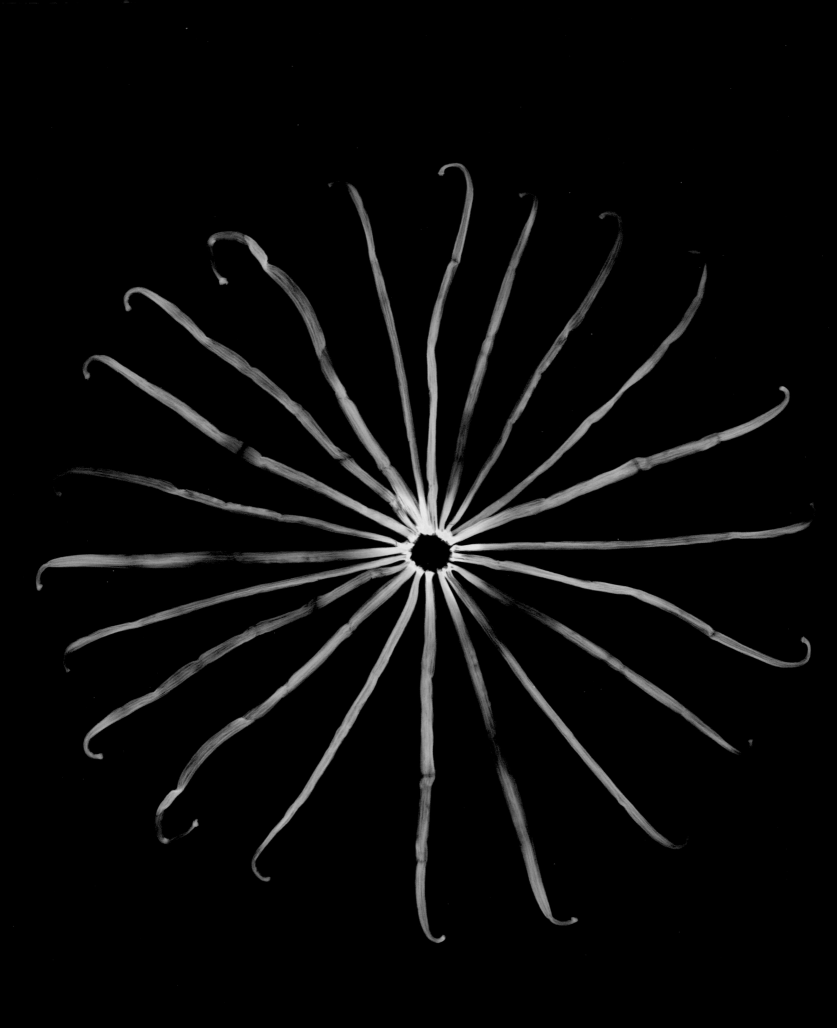

3 NATURE

Working with nature is impossible to top, and I'm privileged to have had the experience. Just looking at detail in the natural forms this world has created always inspires me to keep going. I also really like the way nature dictates, through seasons and locations, what is available. You have to work with nature.

As I'm working with a collection of natural specimens, the excitement builds. In most sessions there is always one image that stops me in my tracks. I've seen many beautiful x-rays of natural forms, but still I'm regularly blown away by the way nature creates such detail and interest.

Working with plants and flowers has given me a passionate interest in botany and horticulture. Flowers are stunning things in their own right, but I love to bring out their structure and I enjoy revealing how many layers these dainty things actually consist of. My garden is full of plants that I've obtained over the years and it's nice to look at the plant and visually recall the x-ray image.

Foliage can often be as interesting as flowers, although generally speaking it is a bit more unruly. Foliage does its own thing and that is how I like to capture it: bending and curling. I have also started working with plants as they decay (you will find a few images of seed heads and dried leaves) and would like to expand this to follow a complete life-cycle of a plant in an x-ray journey, starting with microscopic x-rays of seeds bursting into life, then regular x-rays as it buds, foliage appears, flowers bloom, flowers fade, seeds form and then decay sets in.

When I go "pruning" (raiding other people's gardens with secateurs) the available specimens are wide and varied. My studio always has some plant or other being carefully tended as we wait for it to move into the stage required. As my studio is surrounded by glorious Kent countryside, I have many images that have resulted from walks in the lanes and woods, but I'd also love to get my hands on some exotic species from the Caribbean.

Working with the insects in this section wasn't quite so pleasant as working with fragrant flowers. I've never handled anything as brittle as a dried insect specimen. Open a door and a wing falls off! And I'd prefer not to remember the bats, as they give me nightmares. To me, bats are one subject that looks scarier in the flesh than when x-rayed. The shells and coral weren't scary, and were begged and borrowed from collectors and museums.

Obtaining the necessary detail on x-ray film of fine petals is technically challenging. I've had to invest in a special x-ray machine that is so sensitive that when I x-ray a bank note you see what is on both sides of the paper. It is useless for forgery, but just the job for revealing the beauty in nature that is everywhere. I just hope these images help you see and appreciate that beauty.

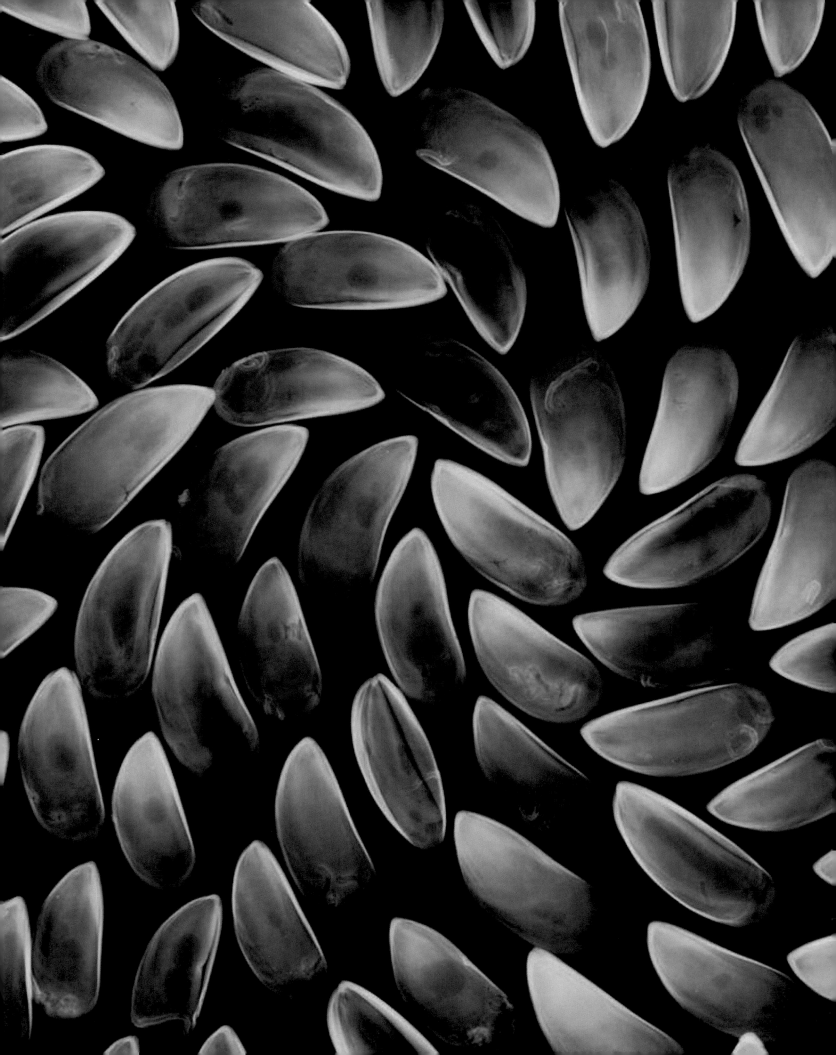

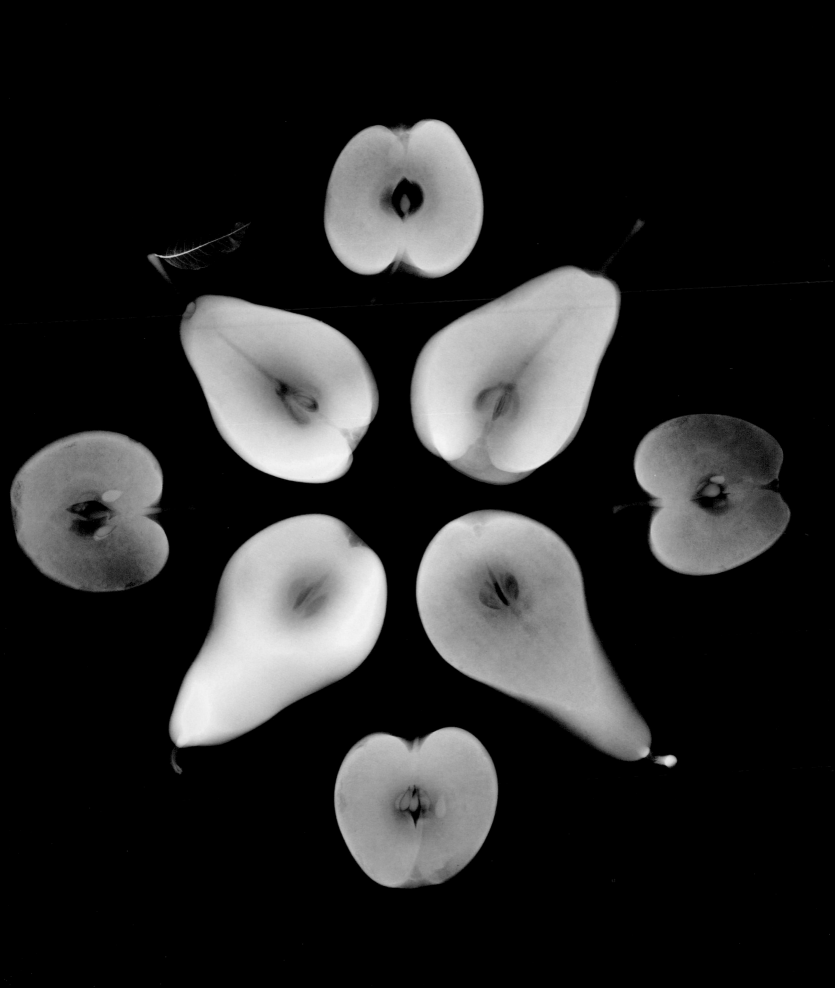

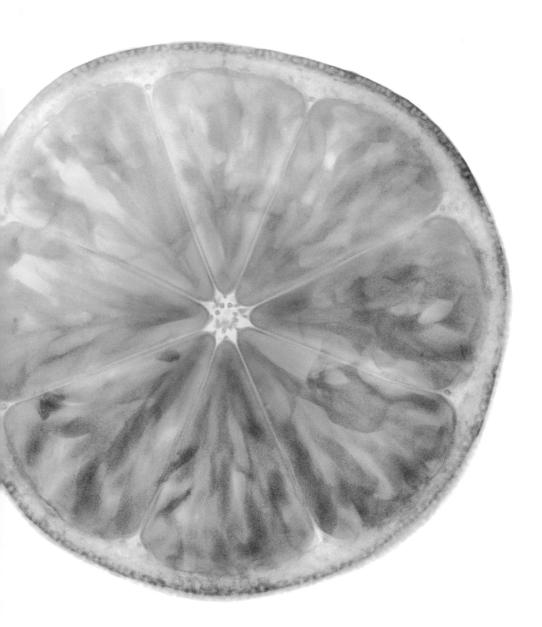

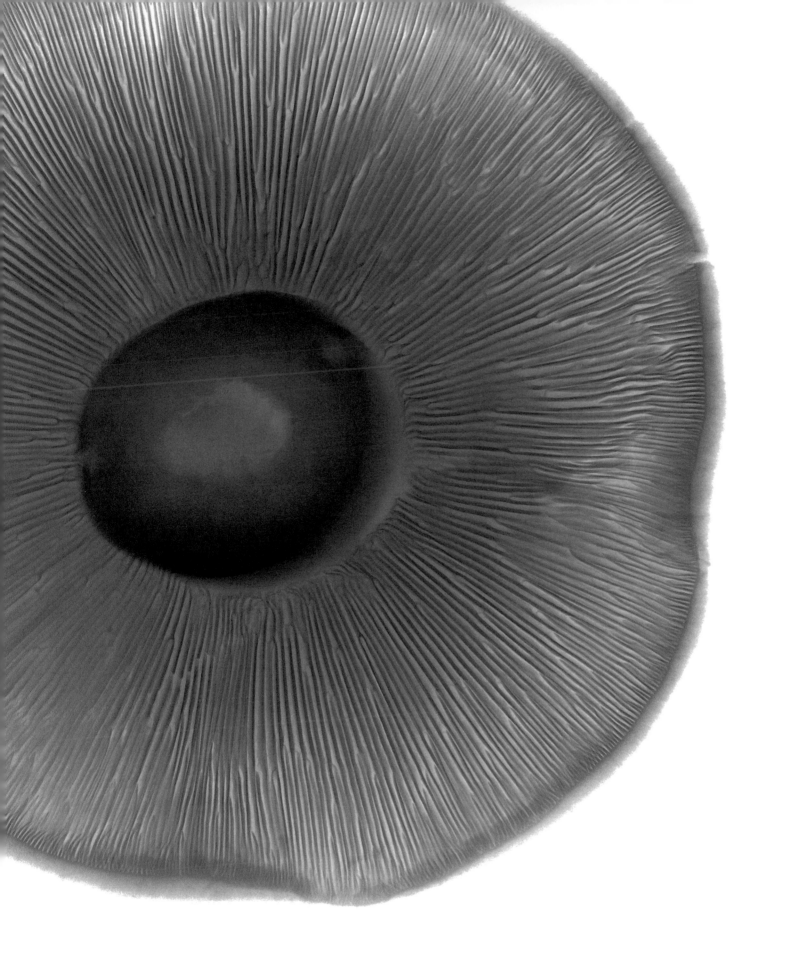

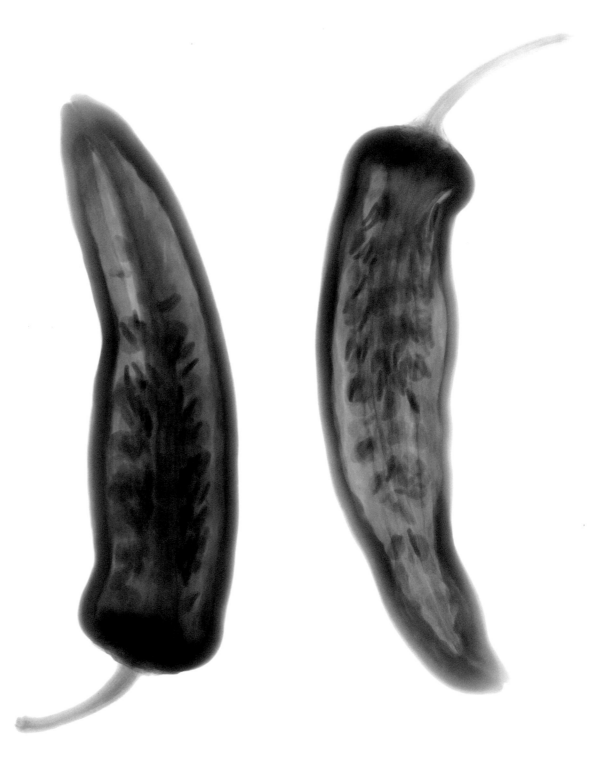

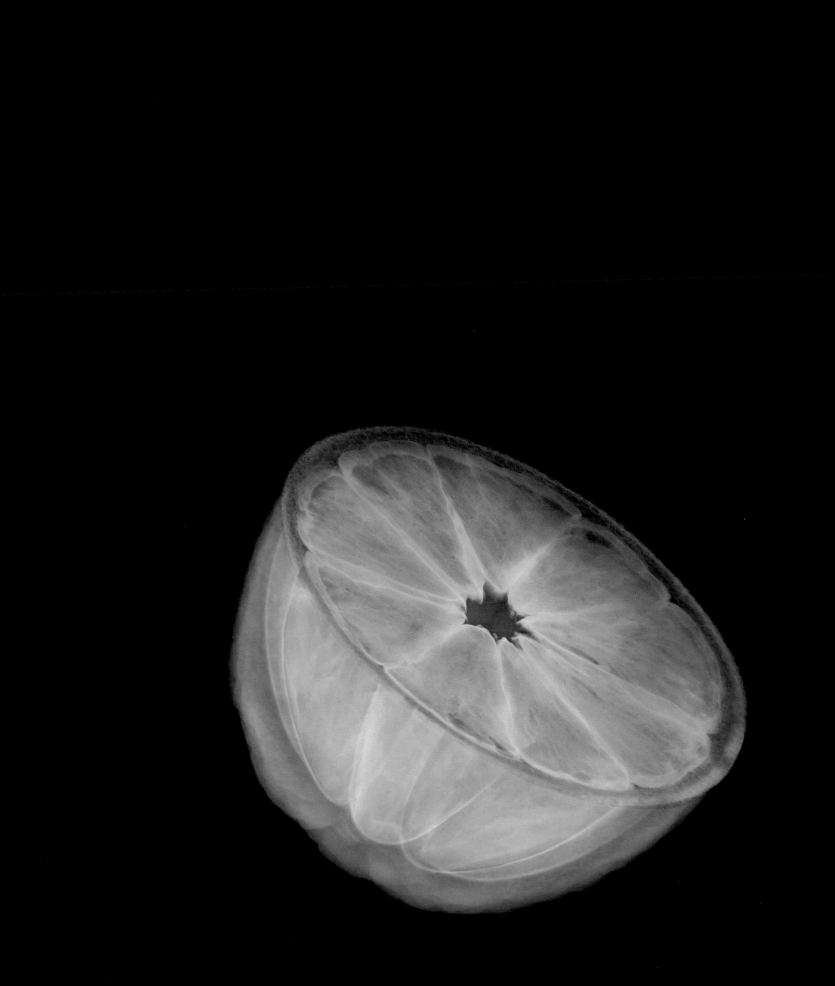

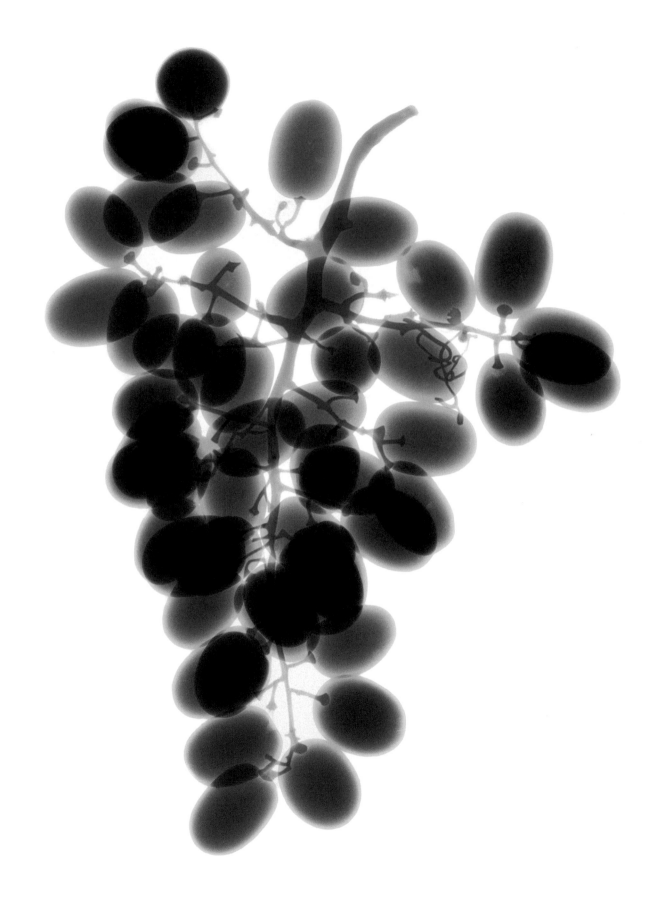

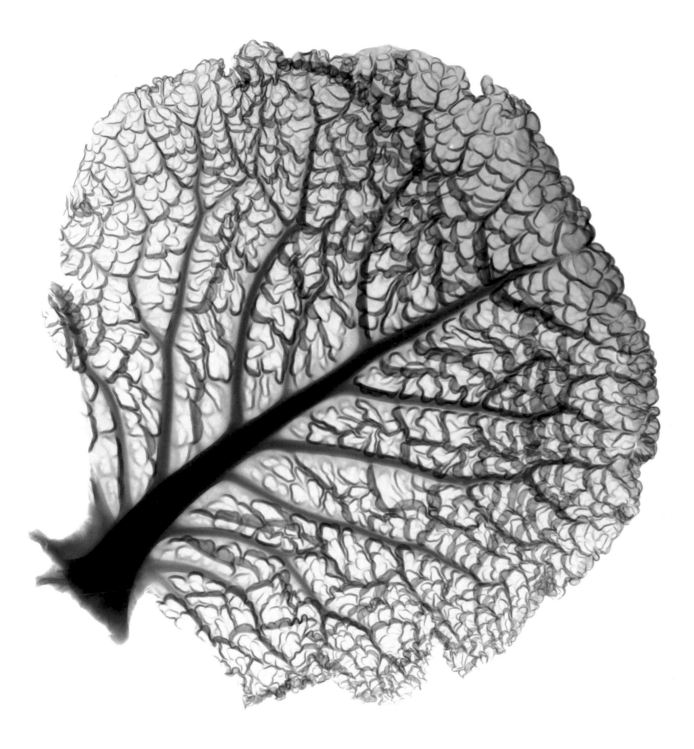

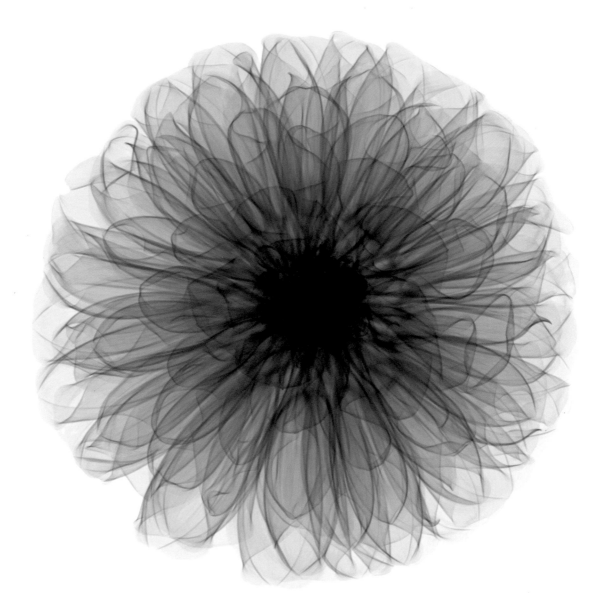

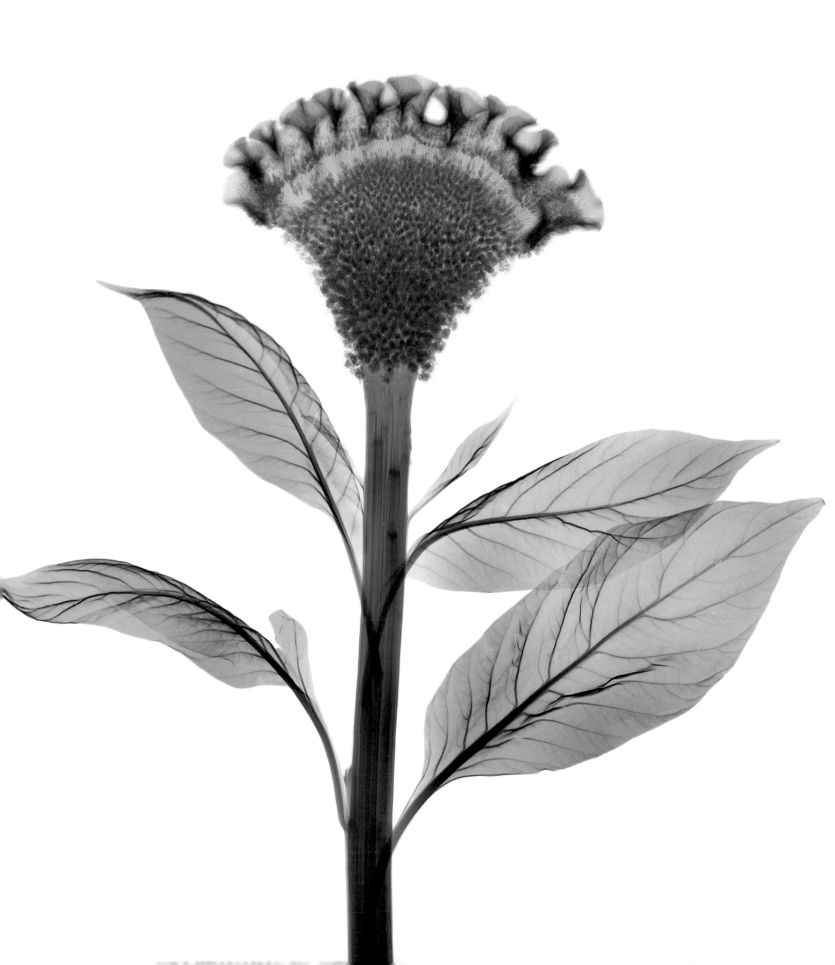

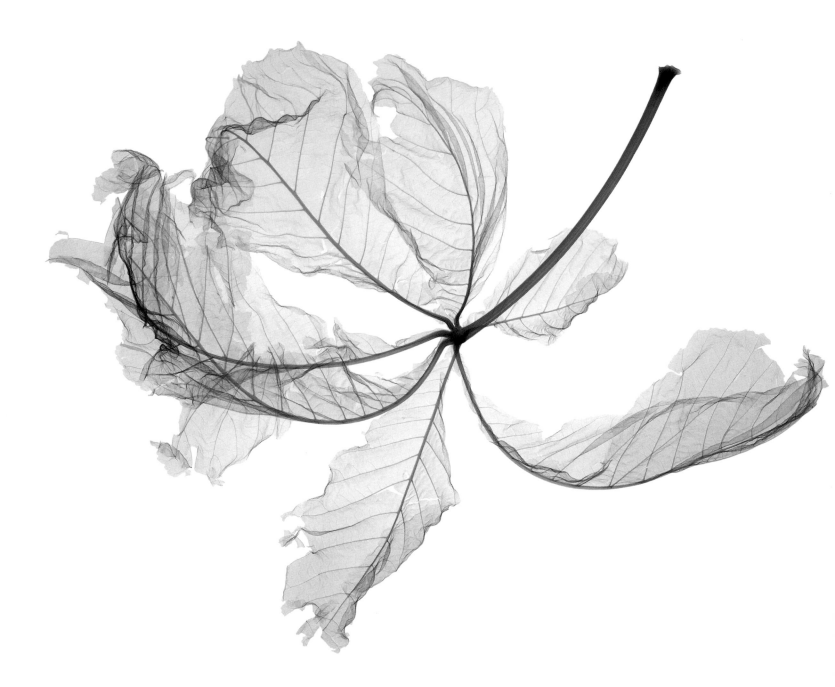

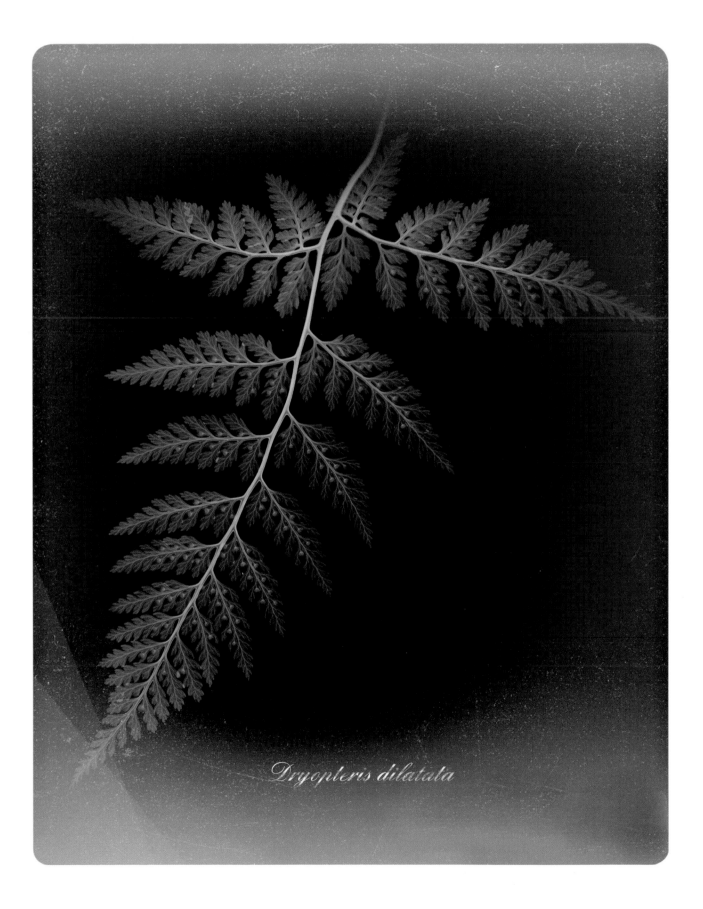

Dryopteris dilatata

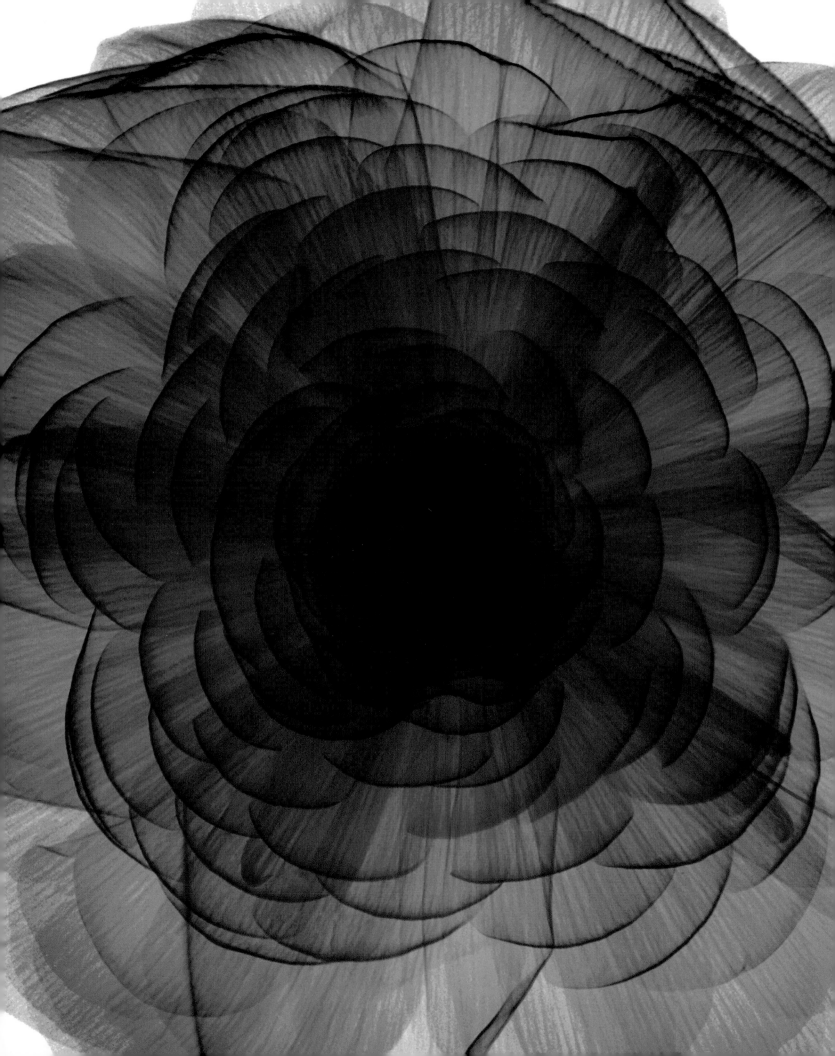

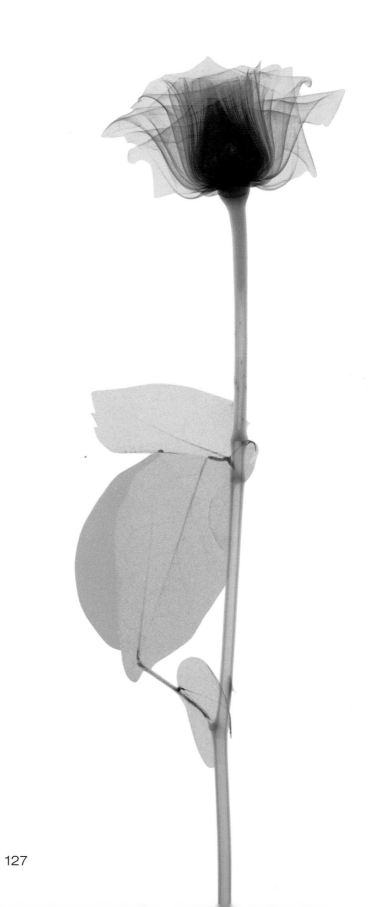

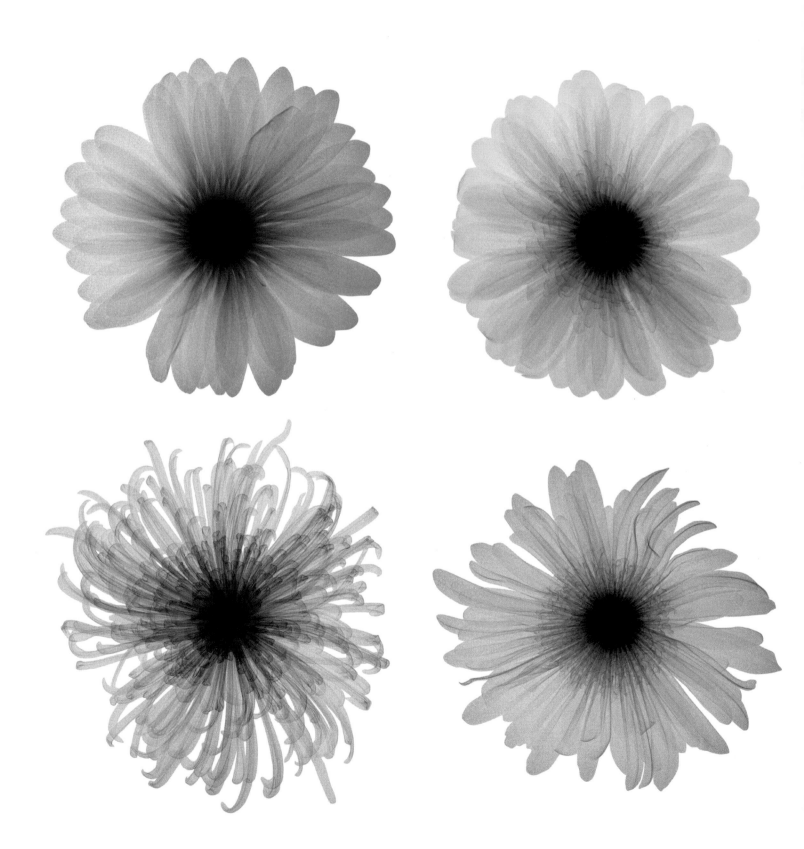

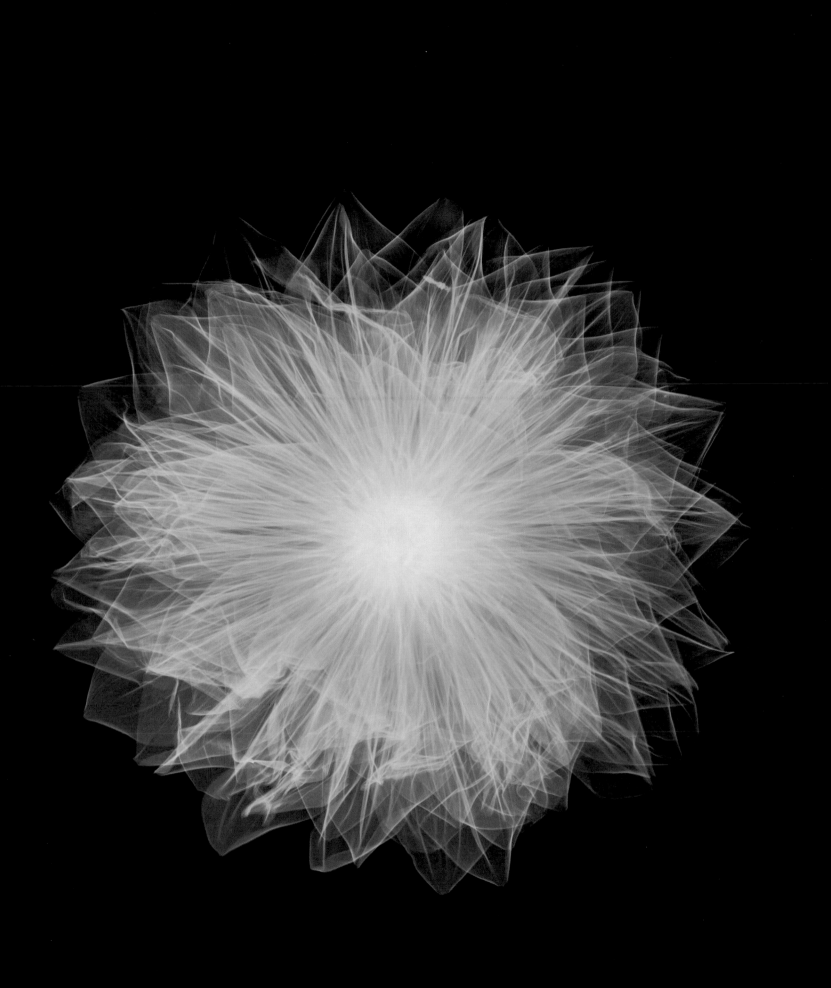

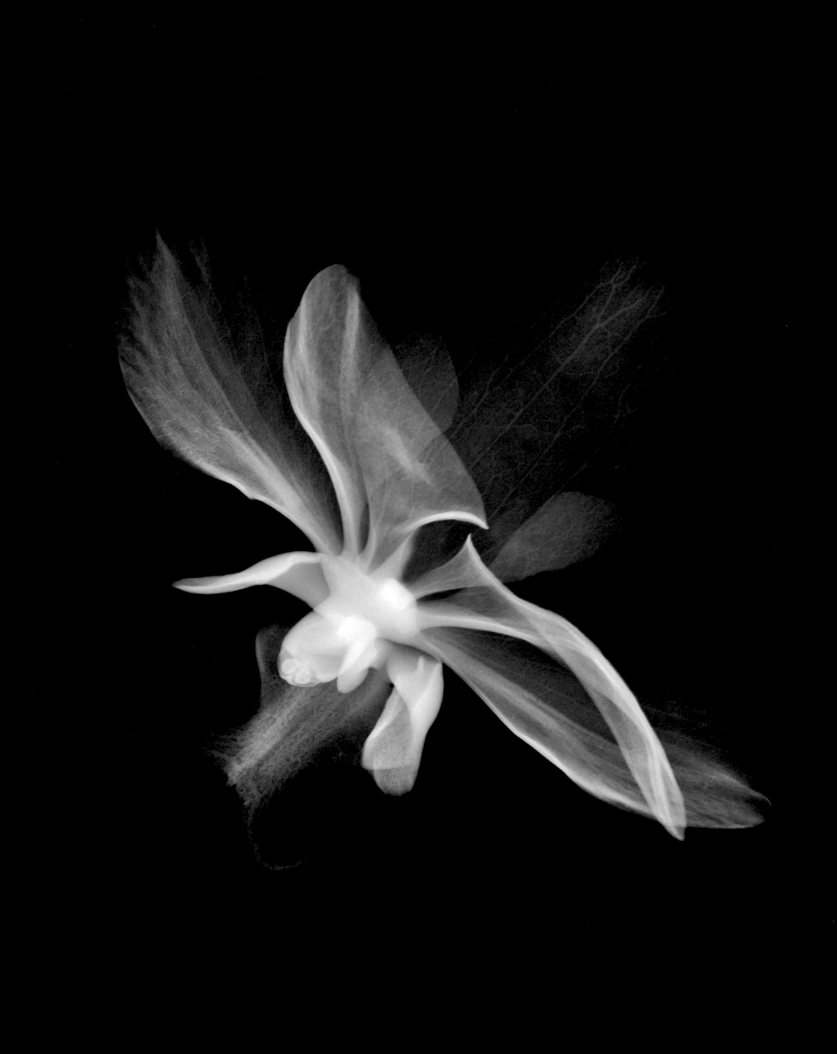

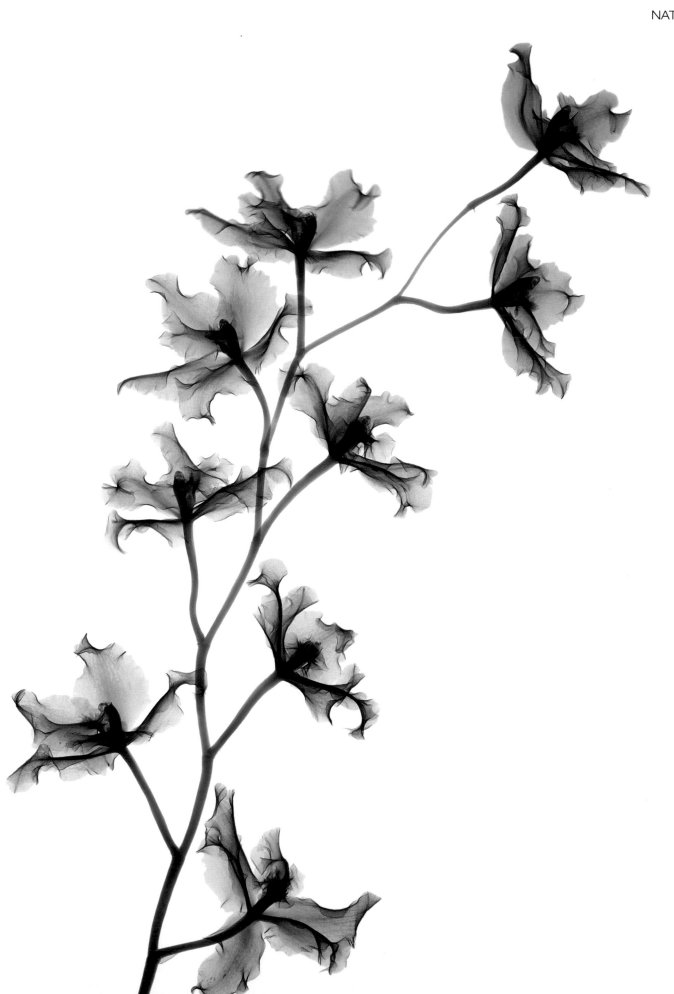

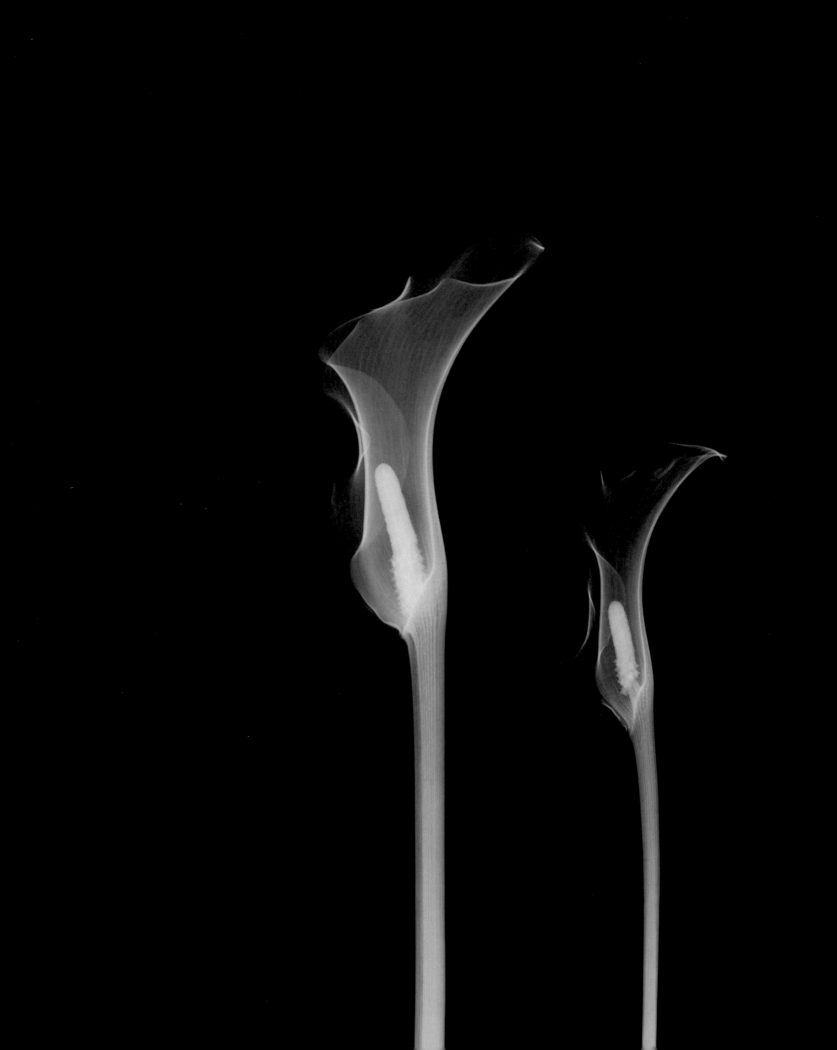

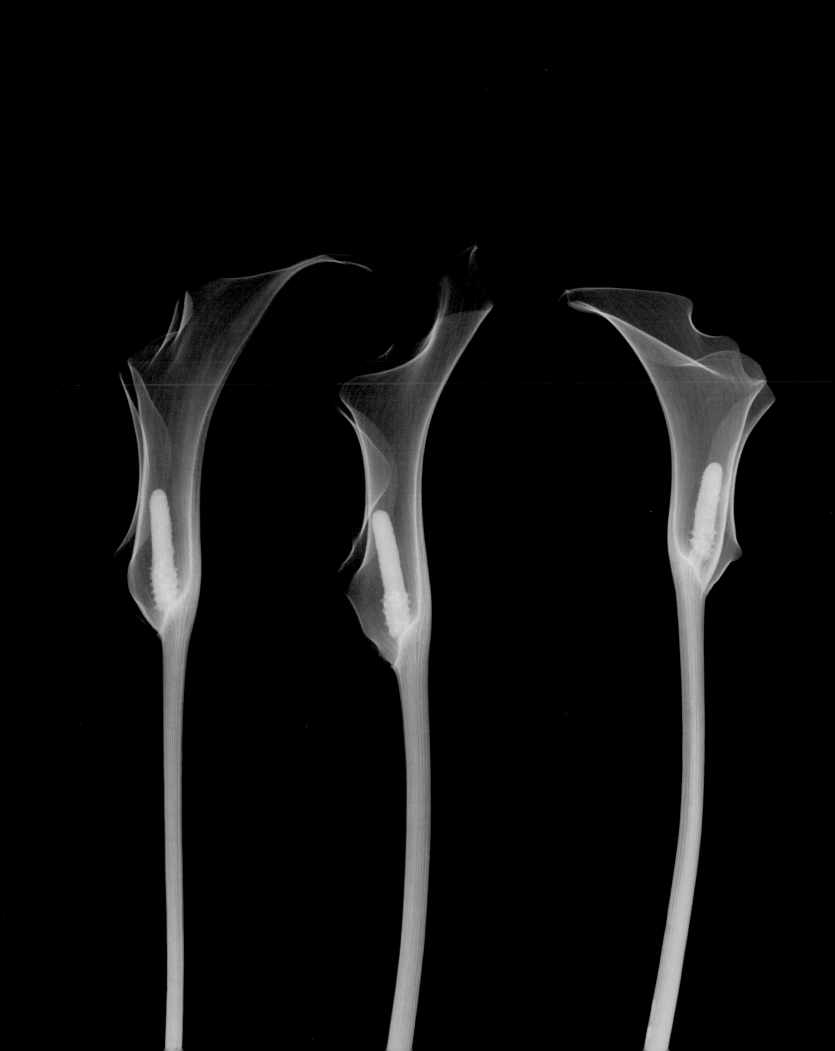

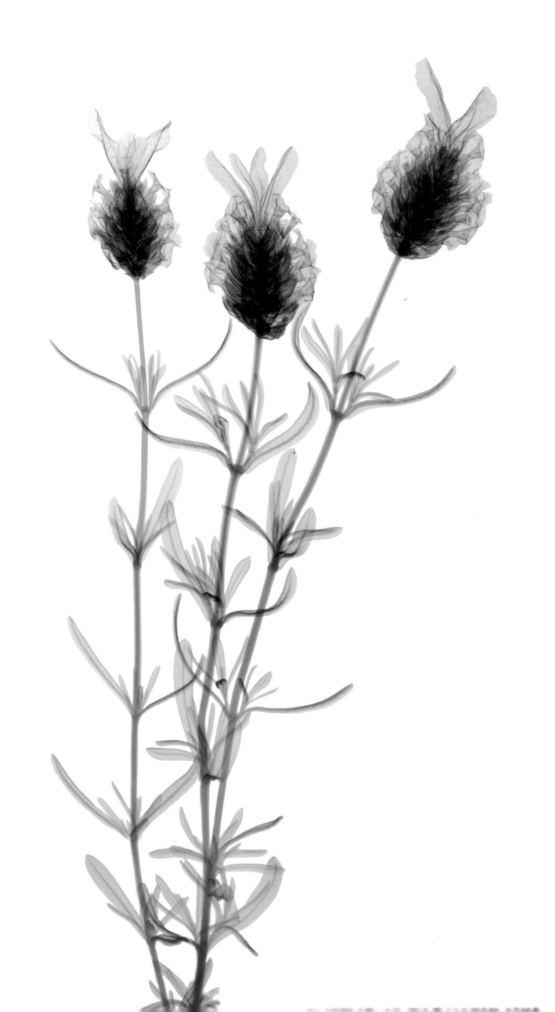

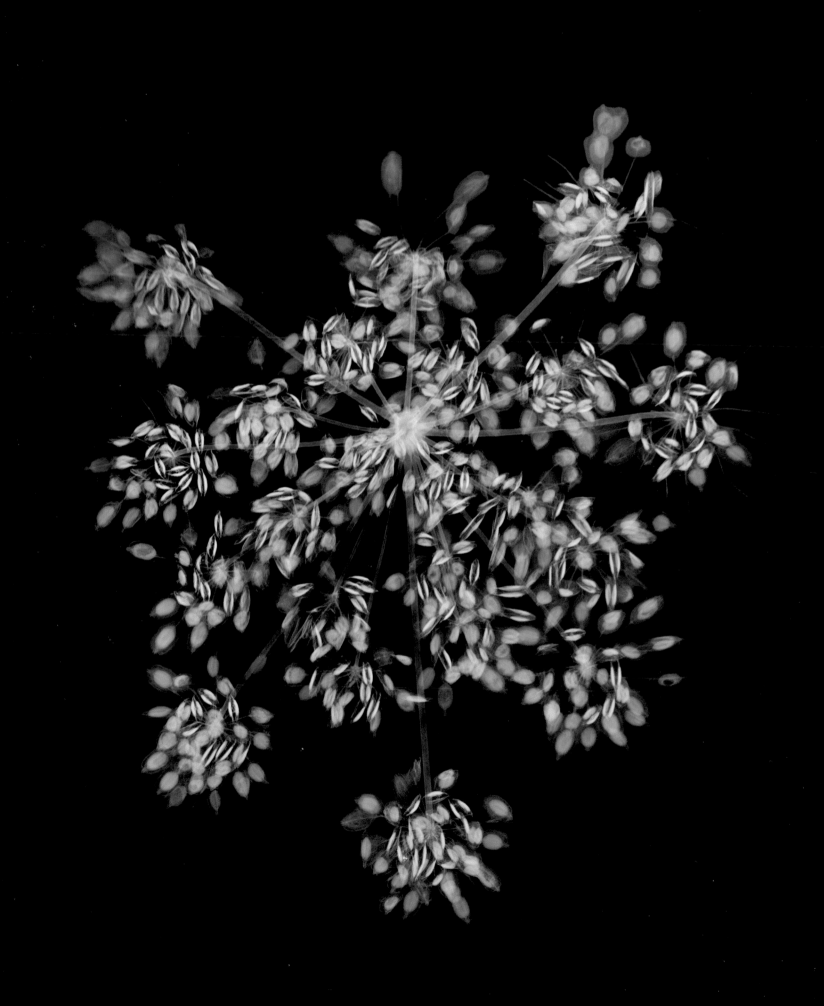

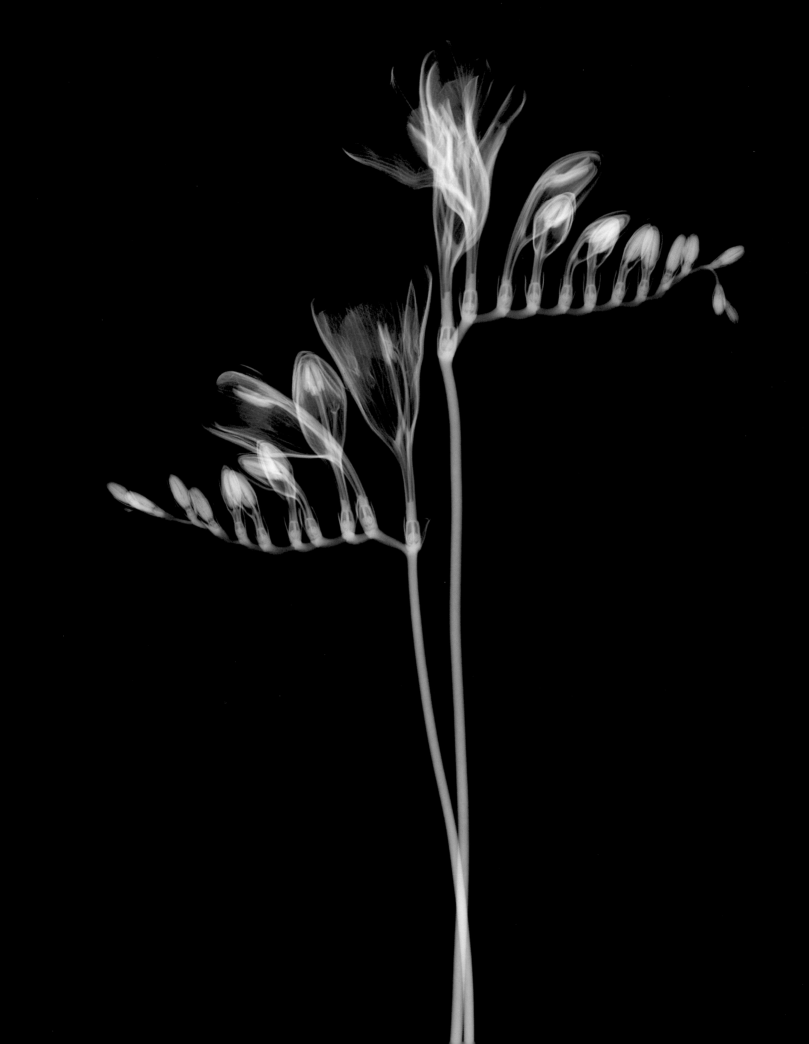

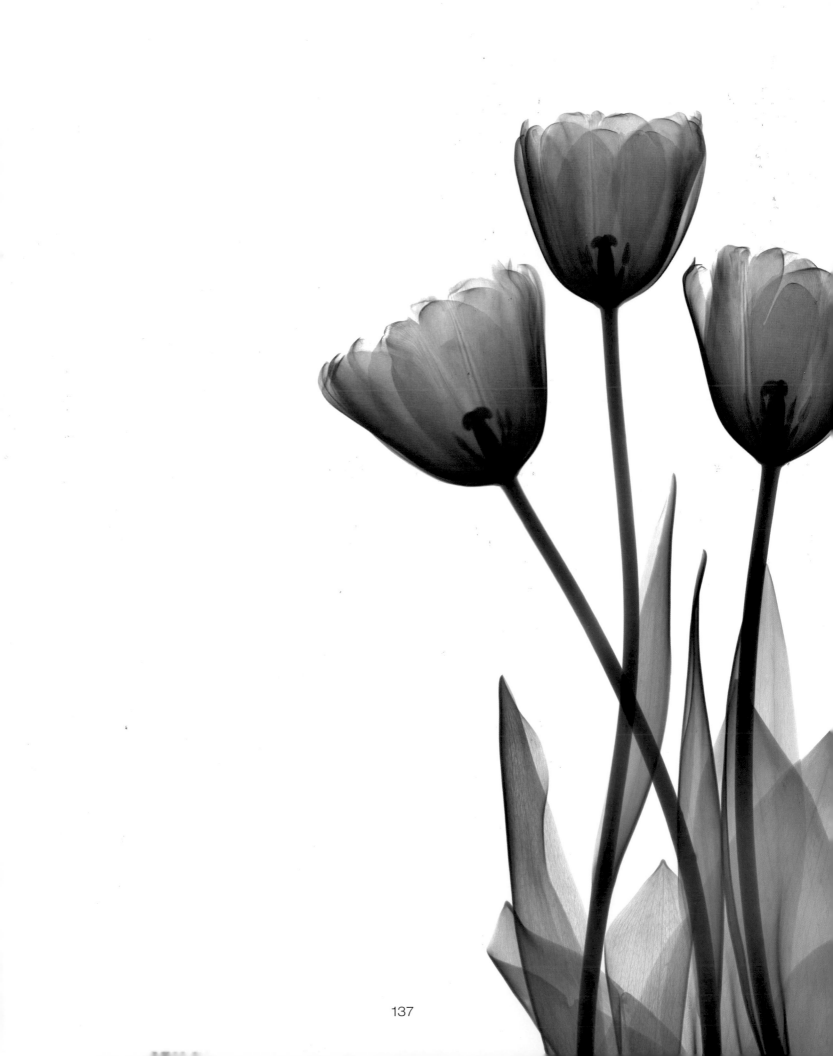

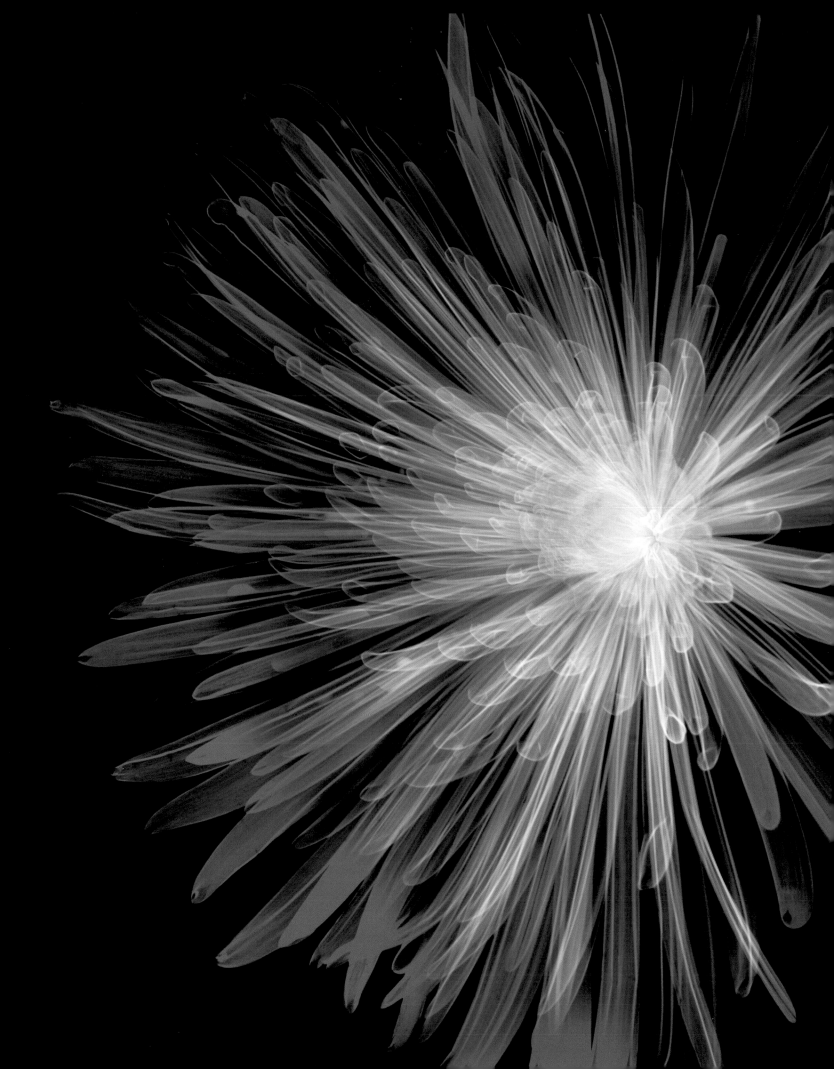

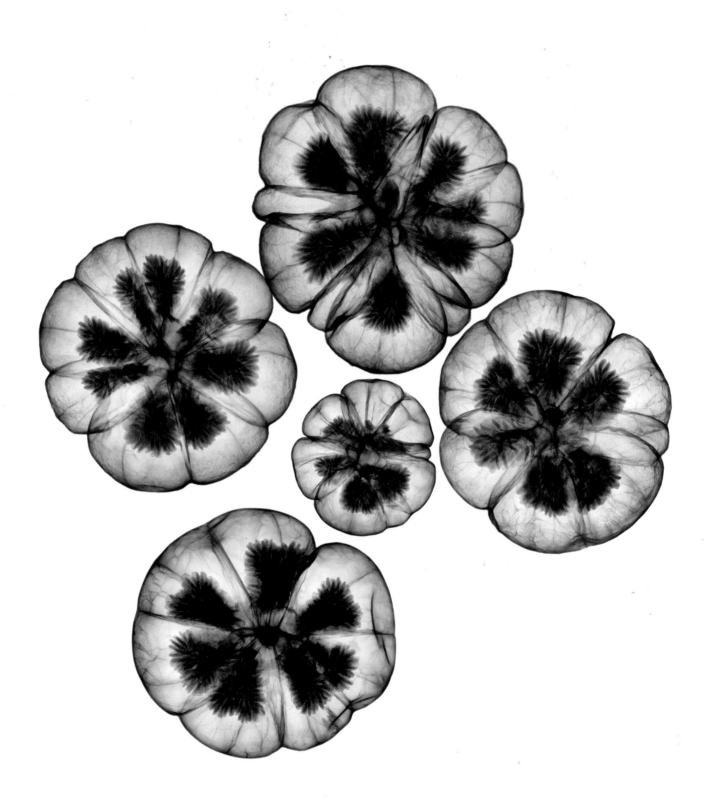

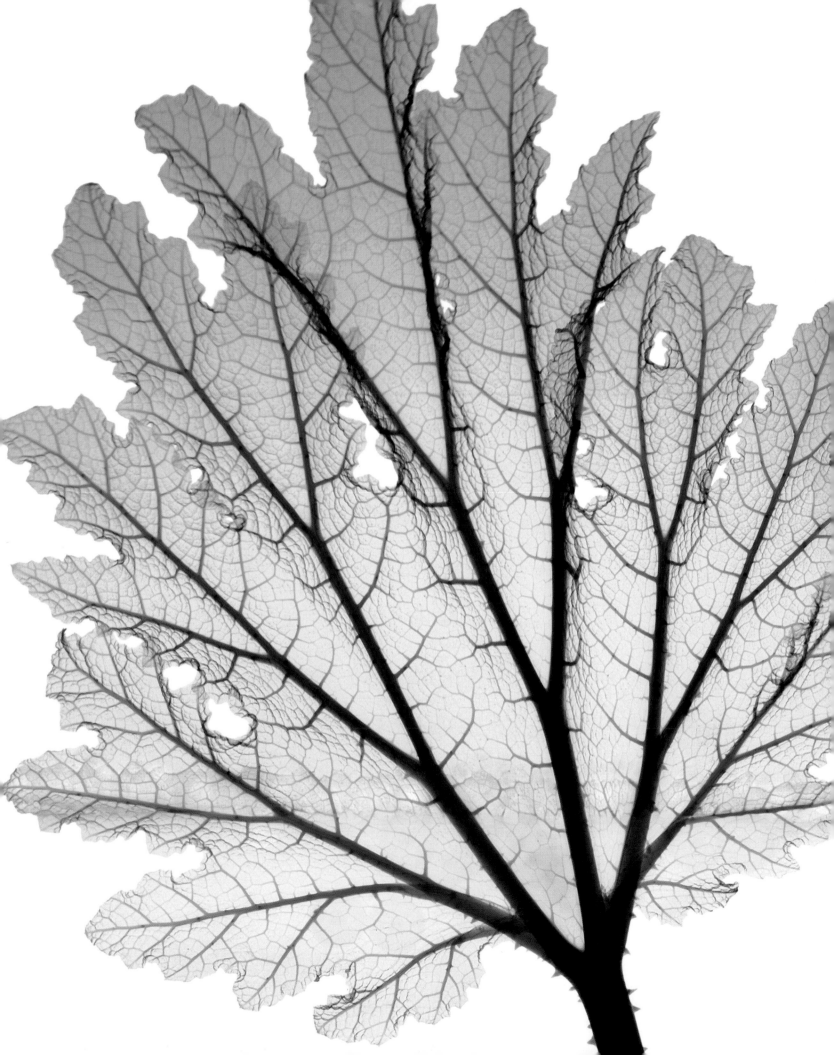

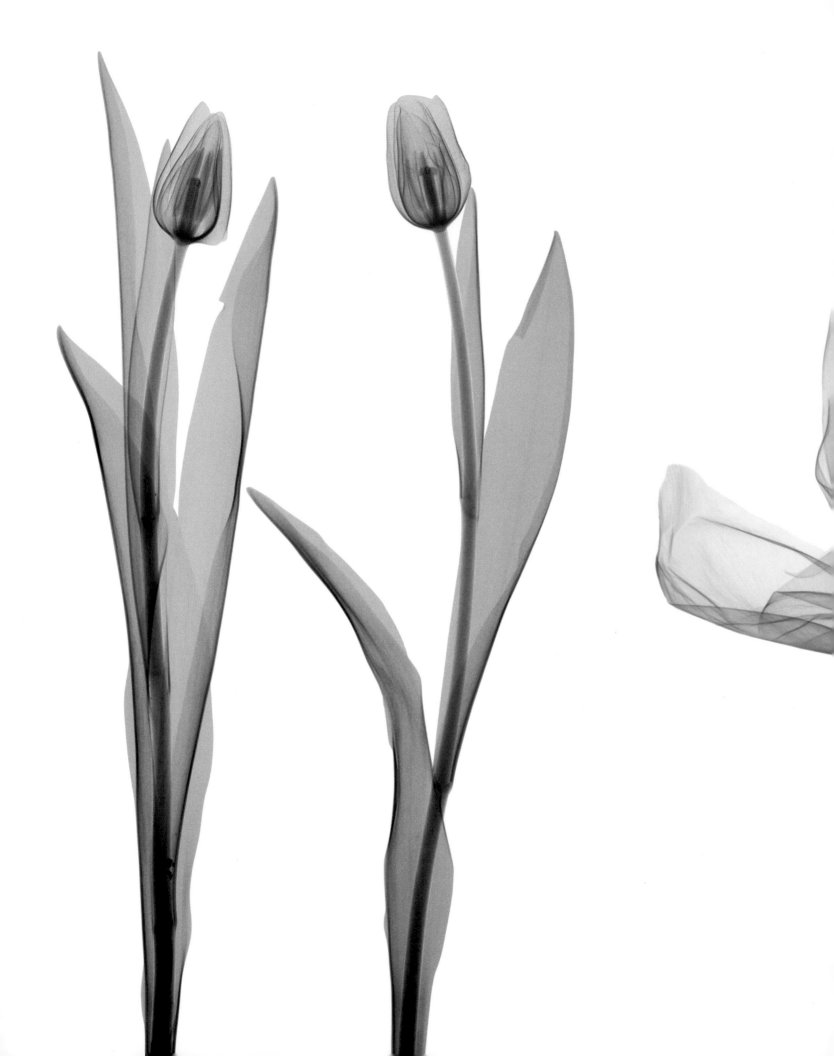

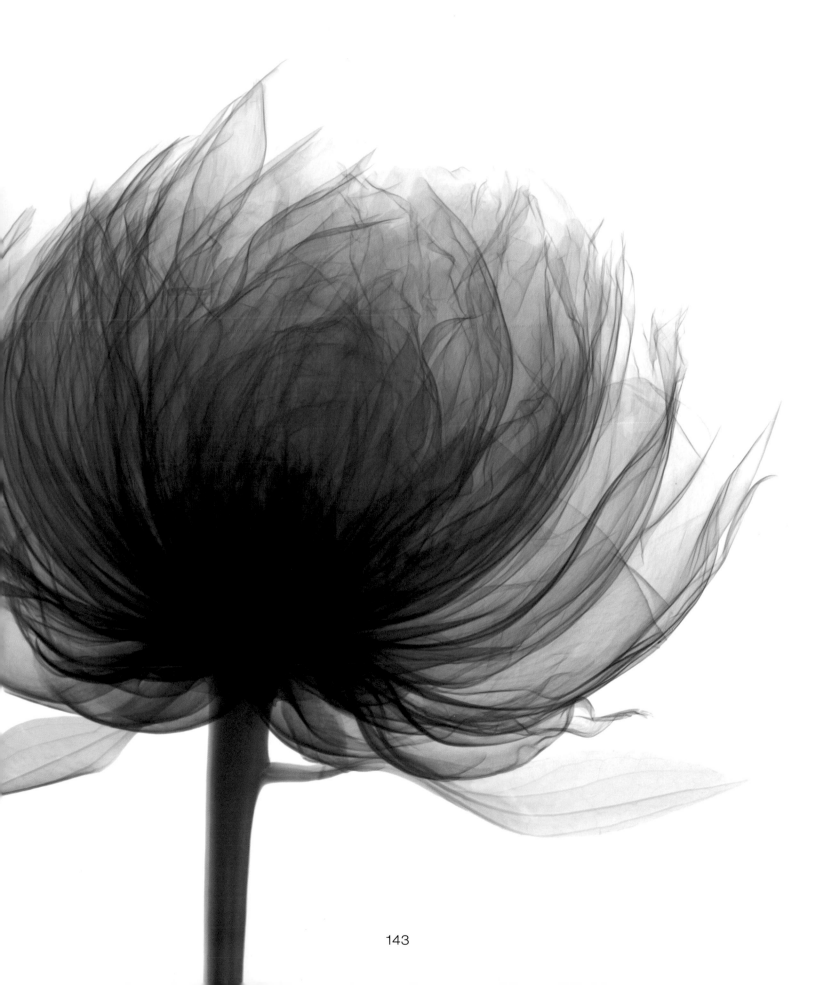

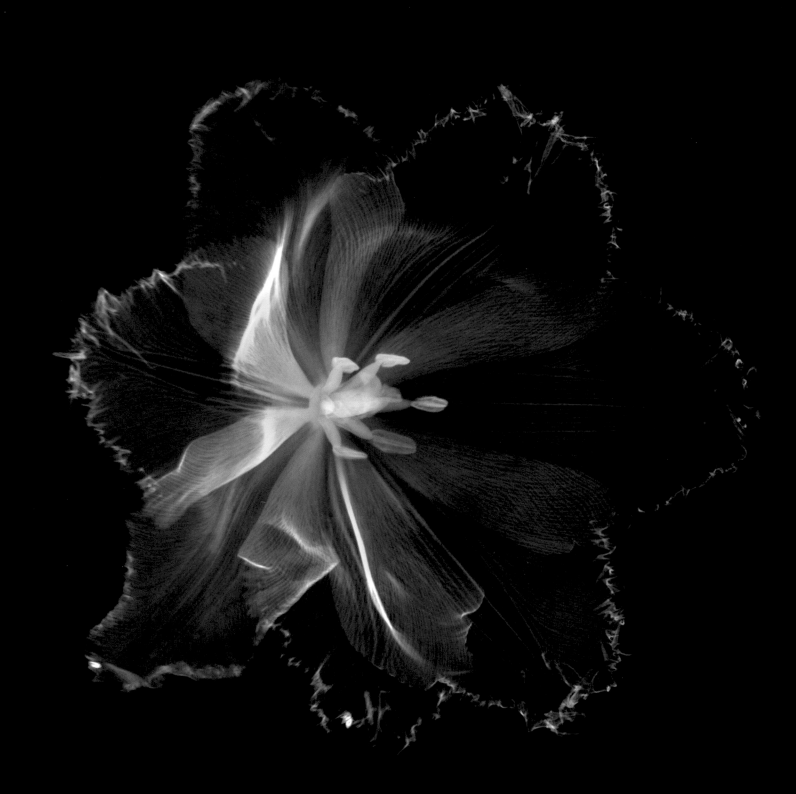

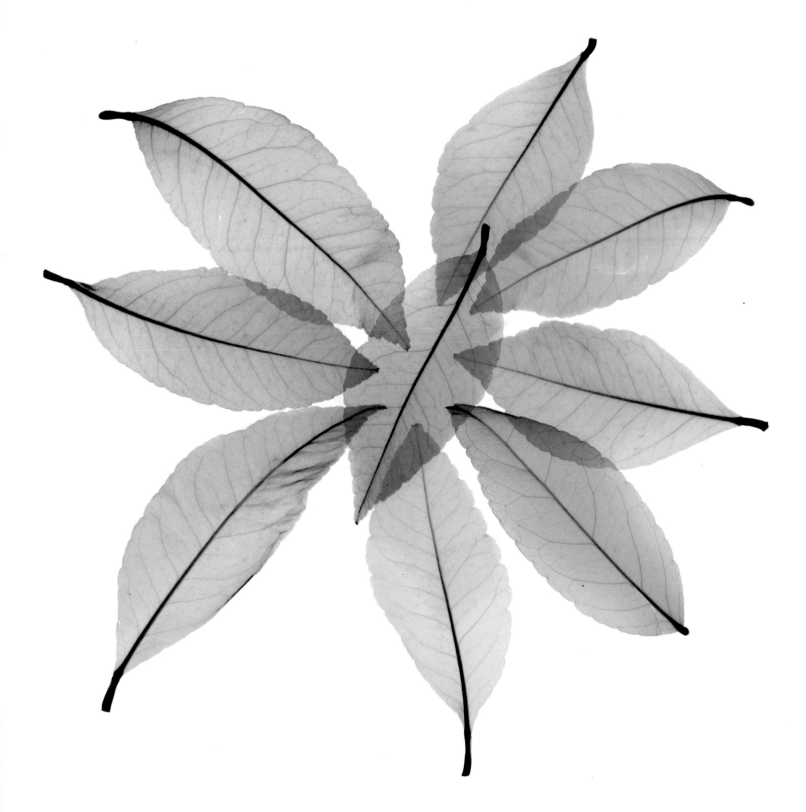

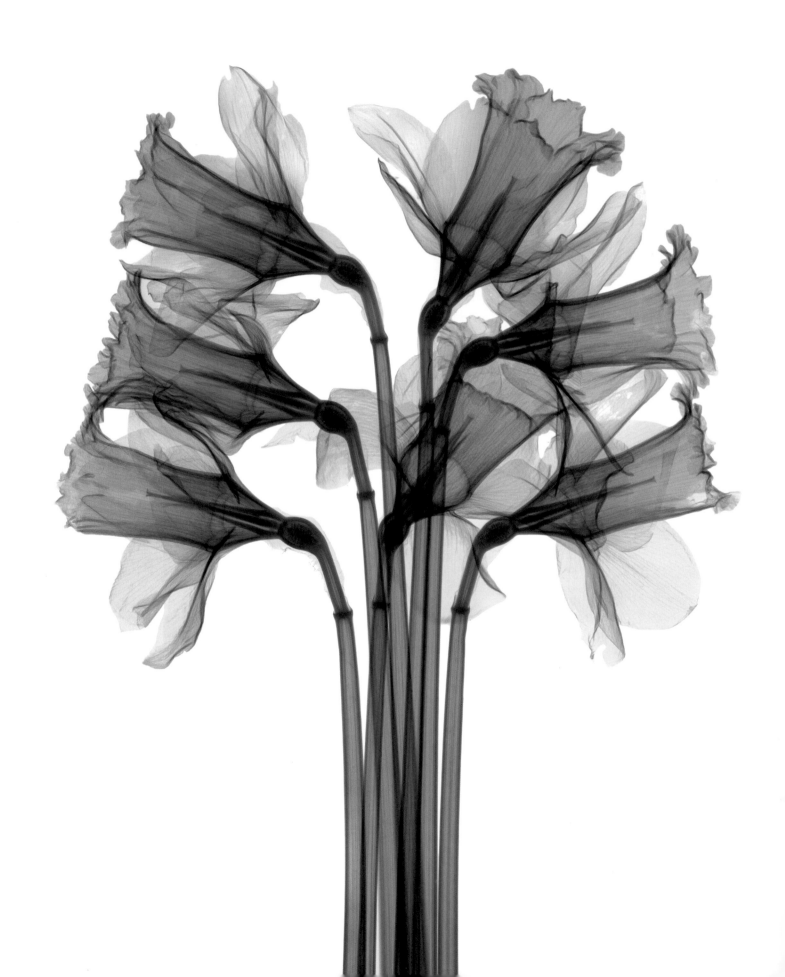

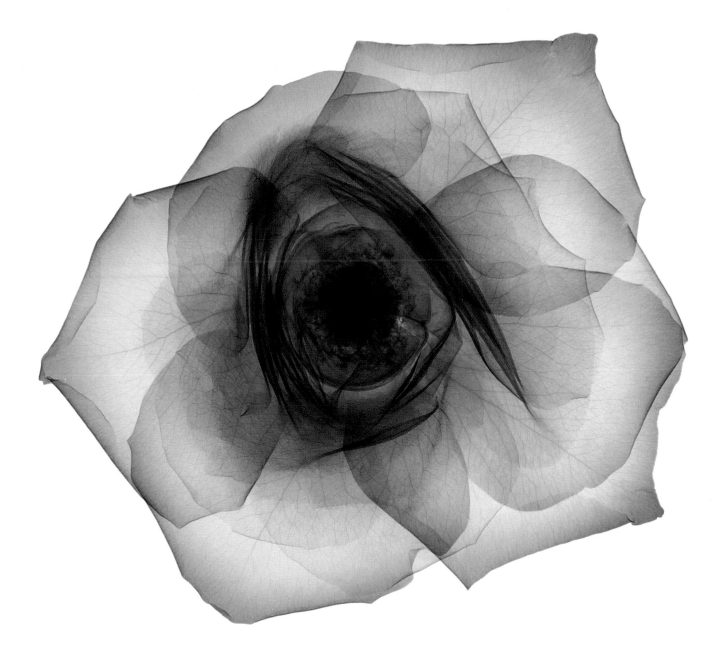

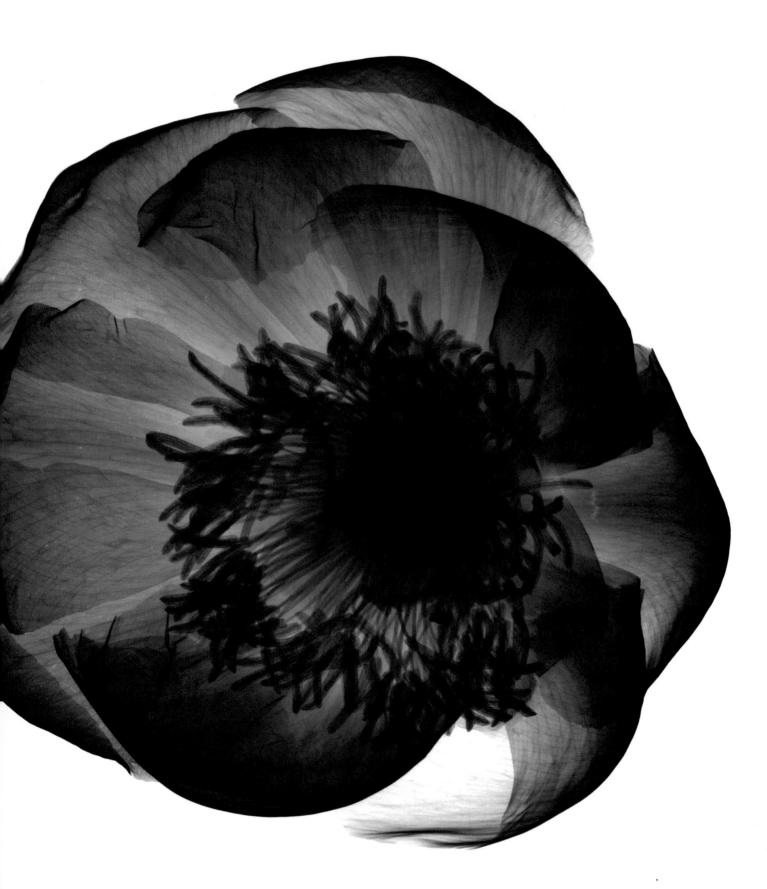

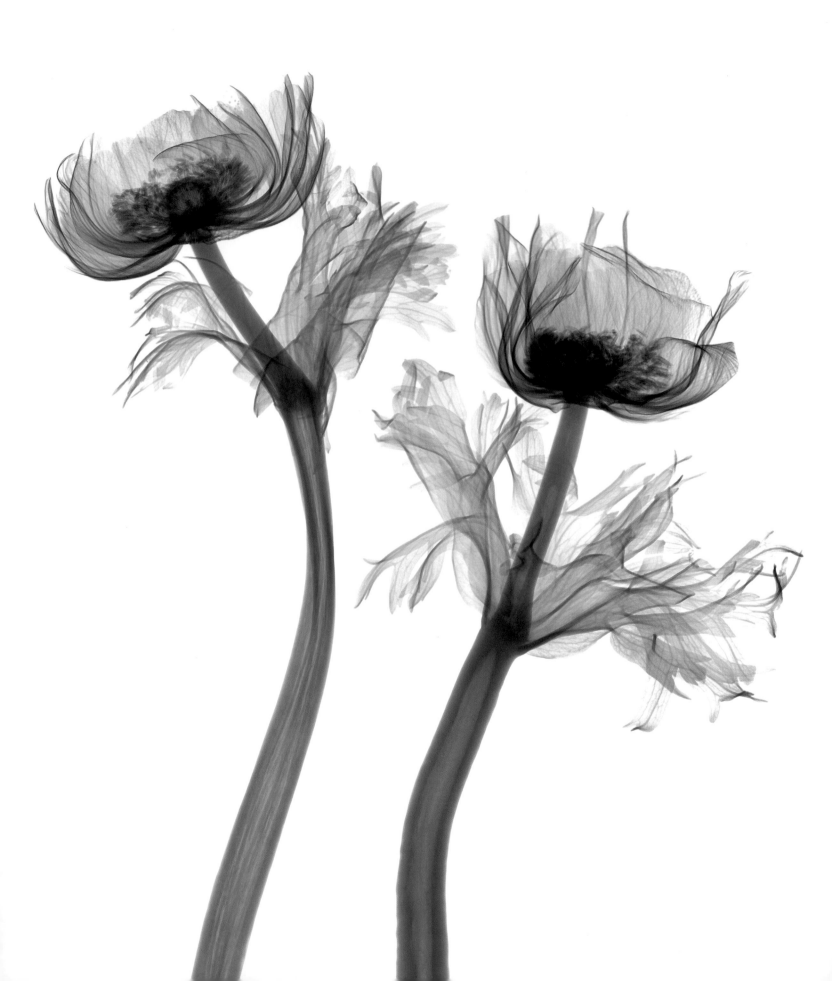

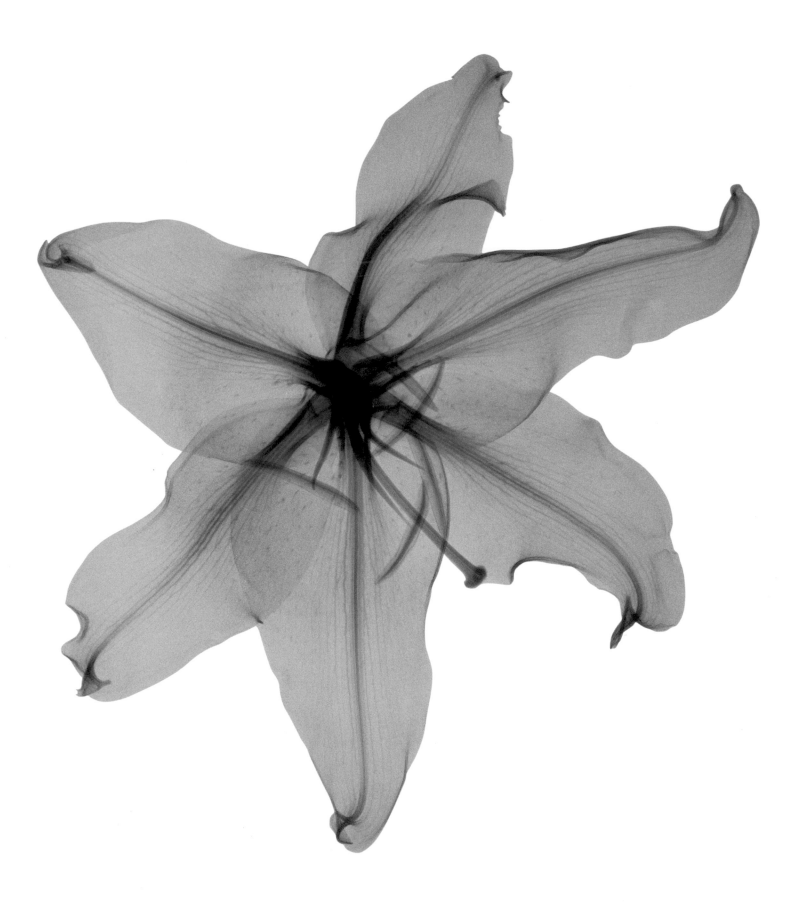

NATURE

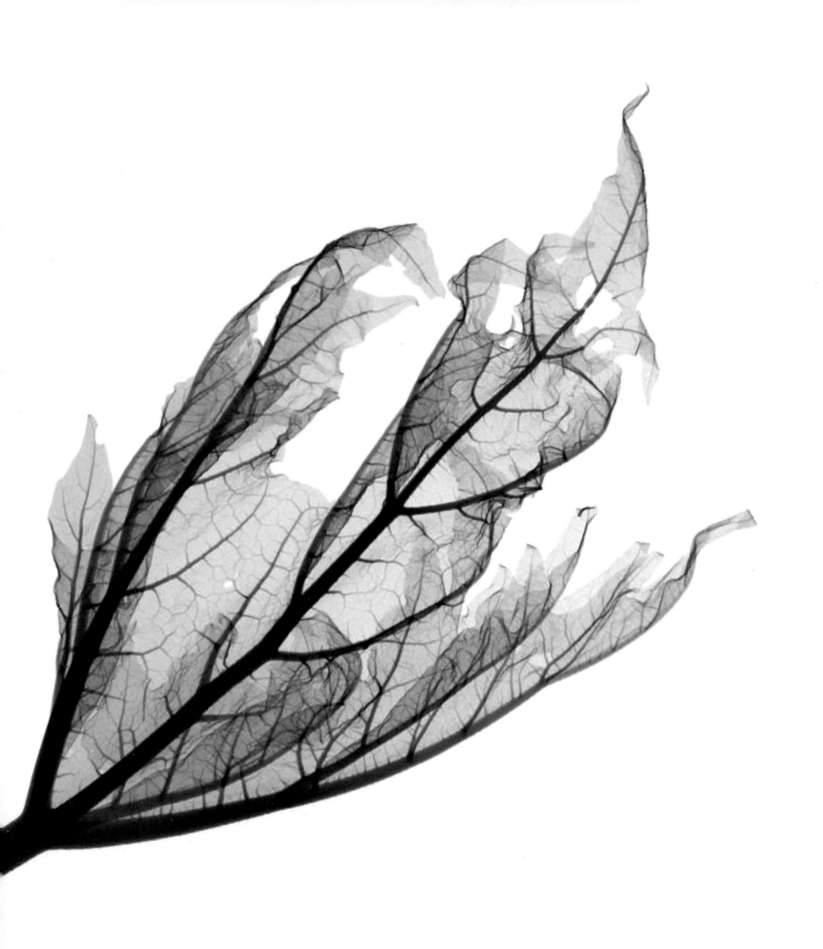

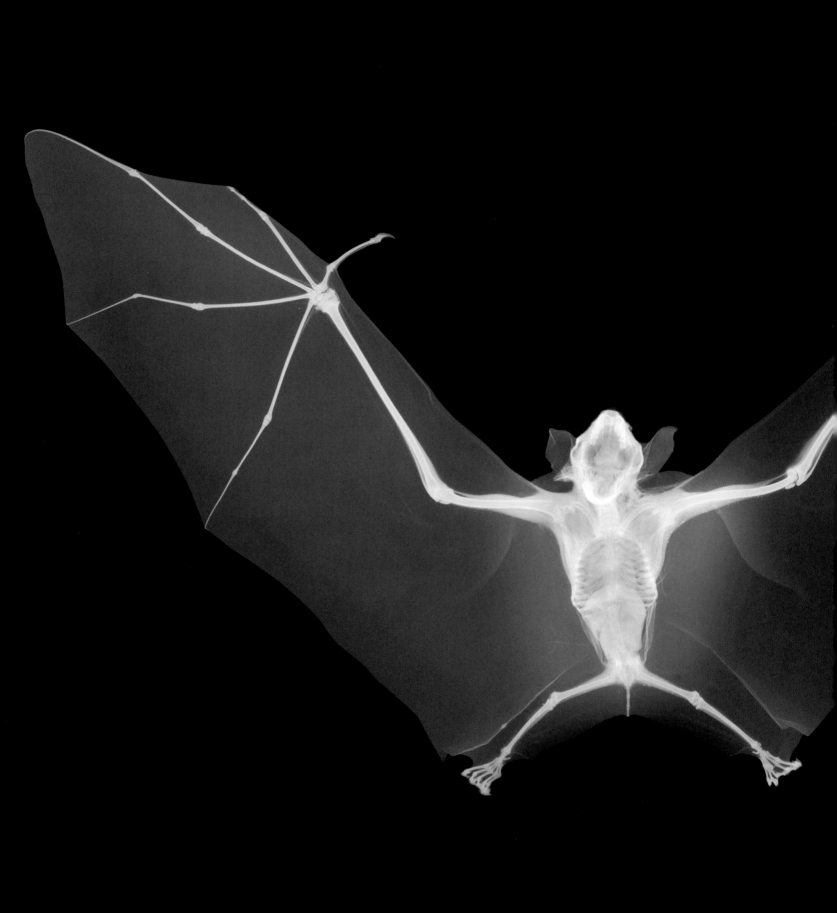

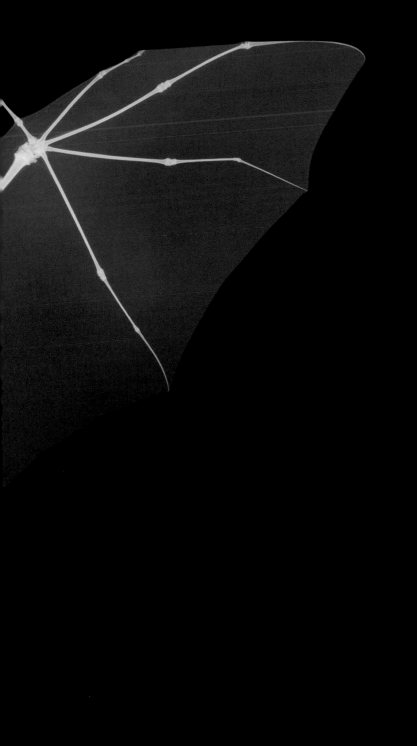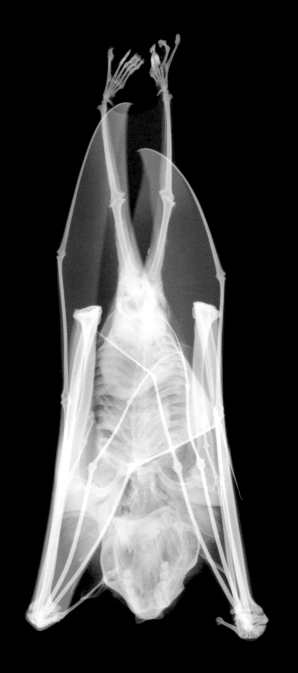

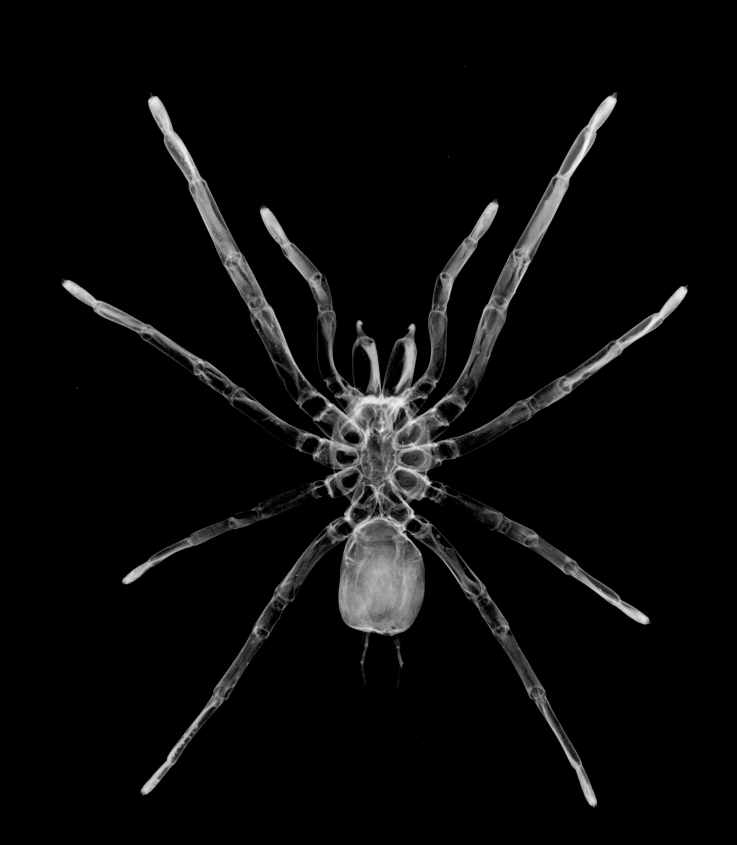

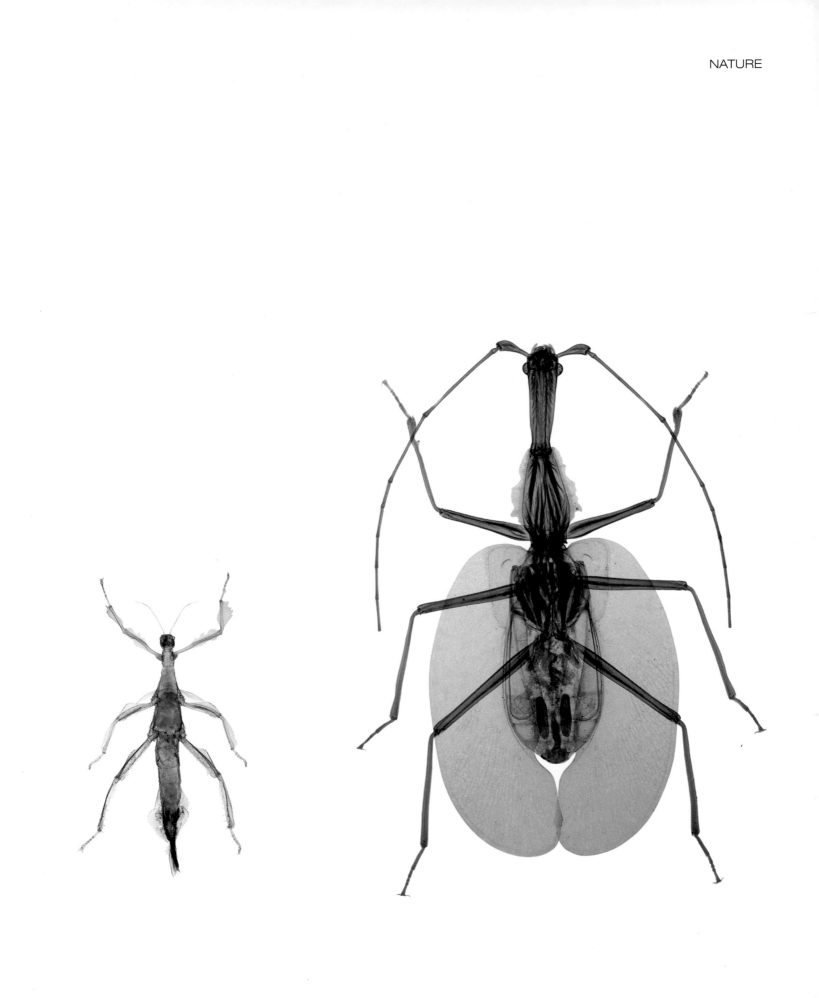

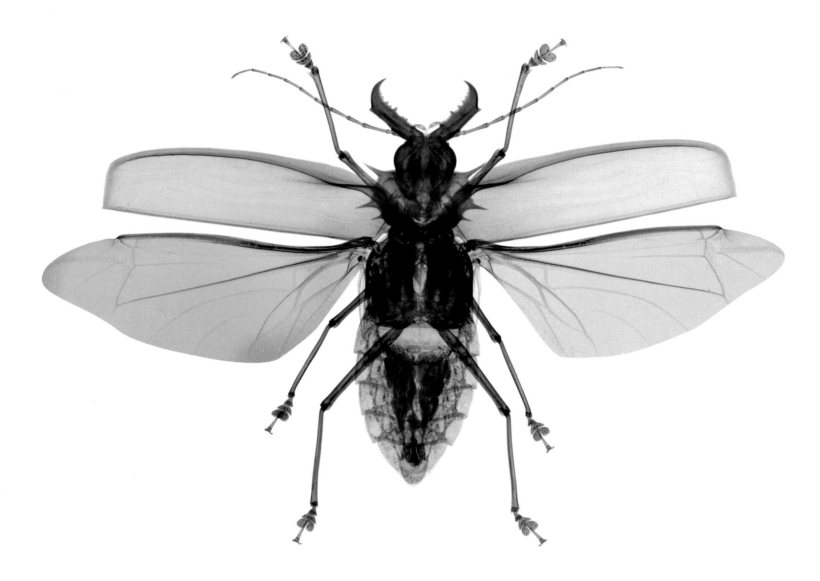

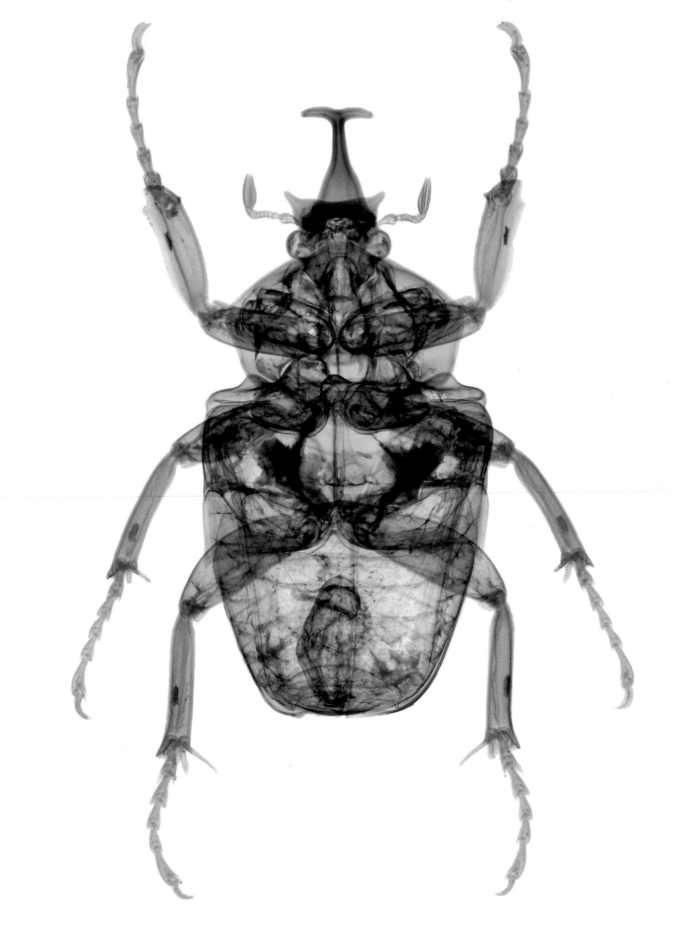

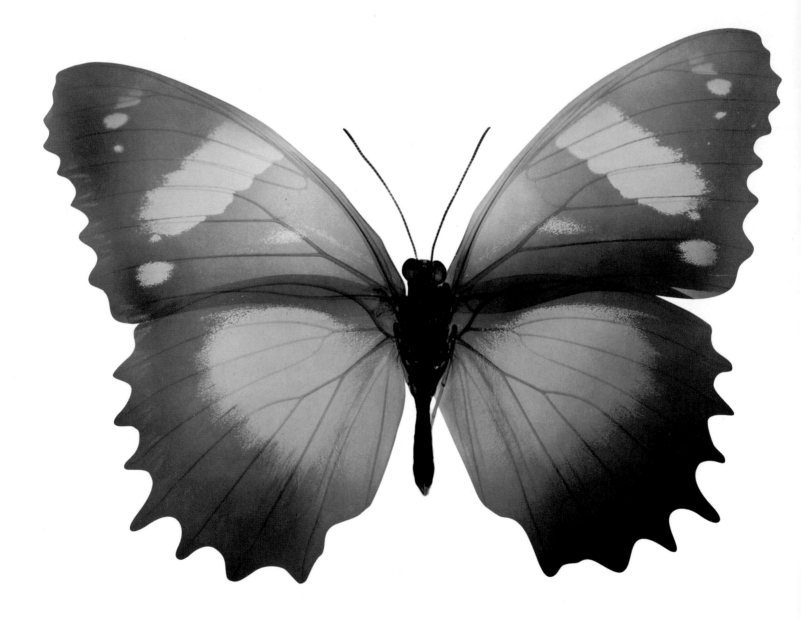

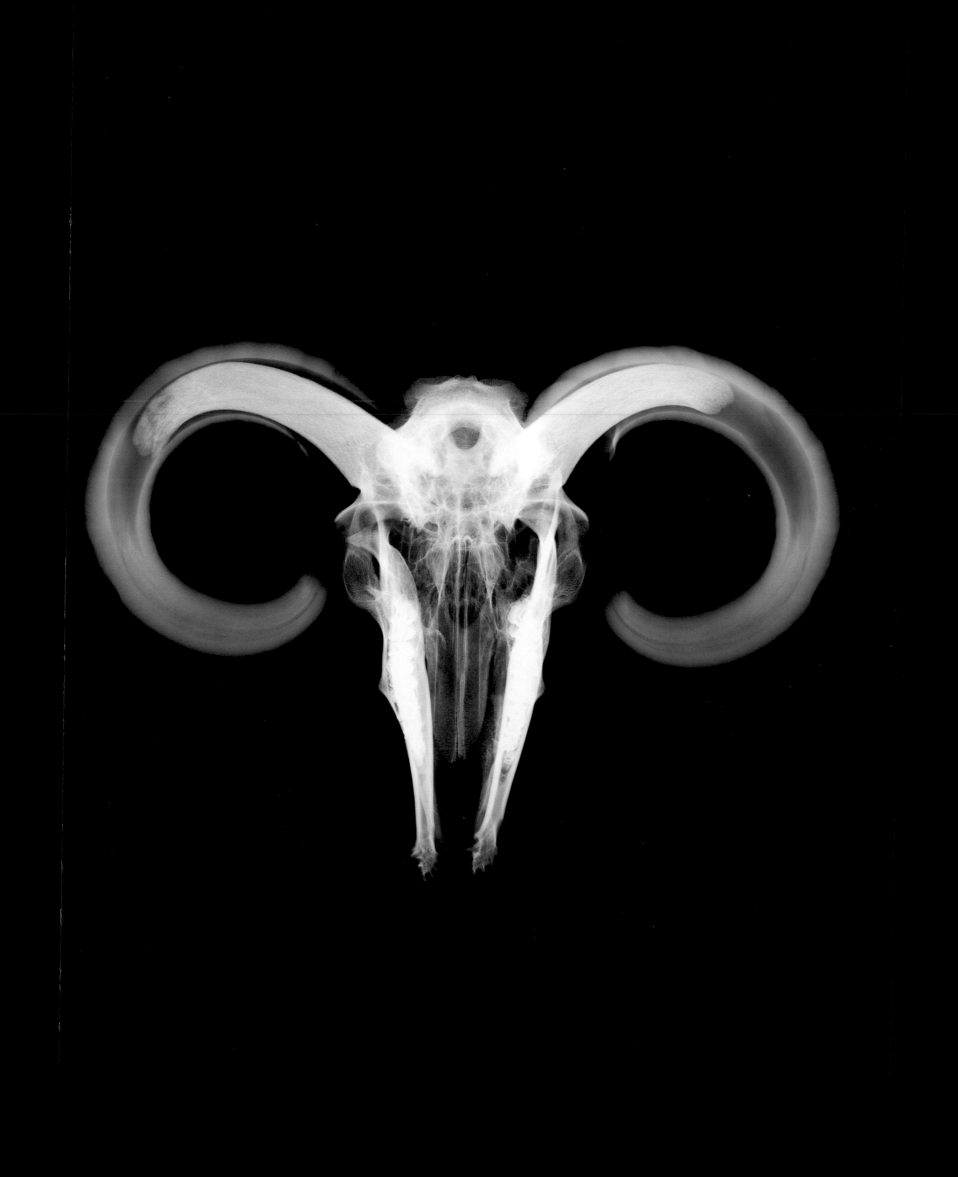

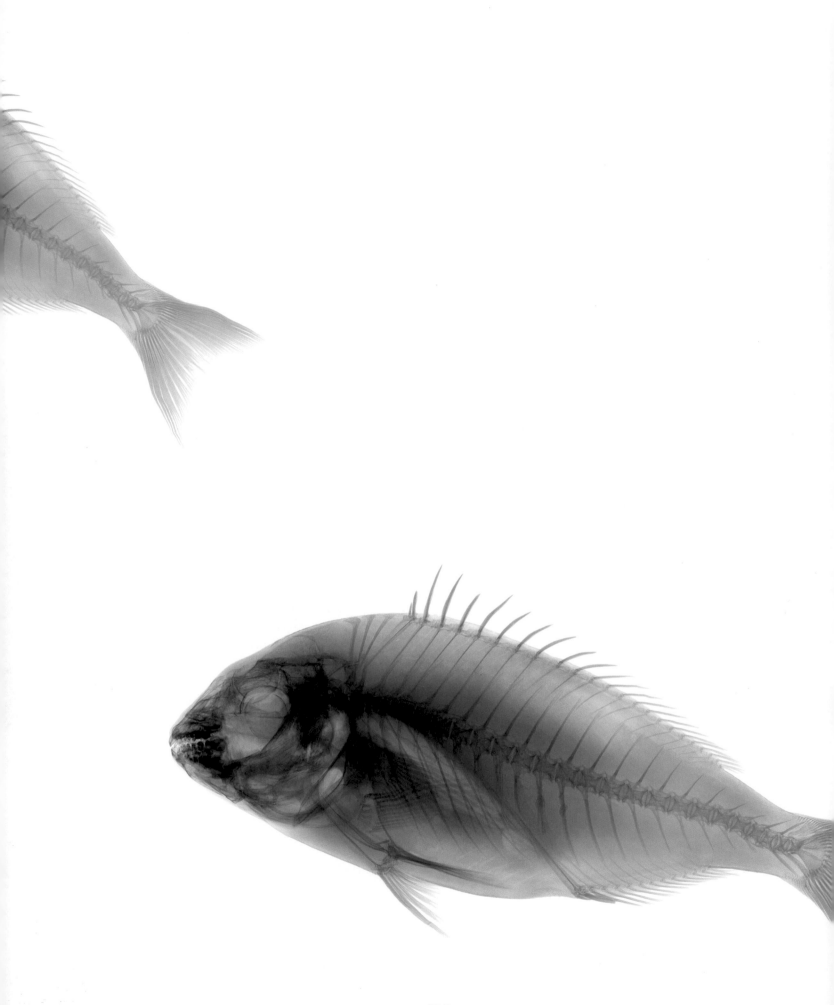

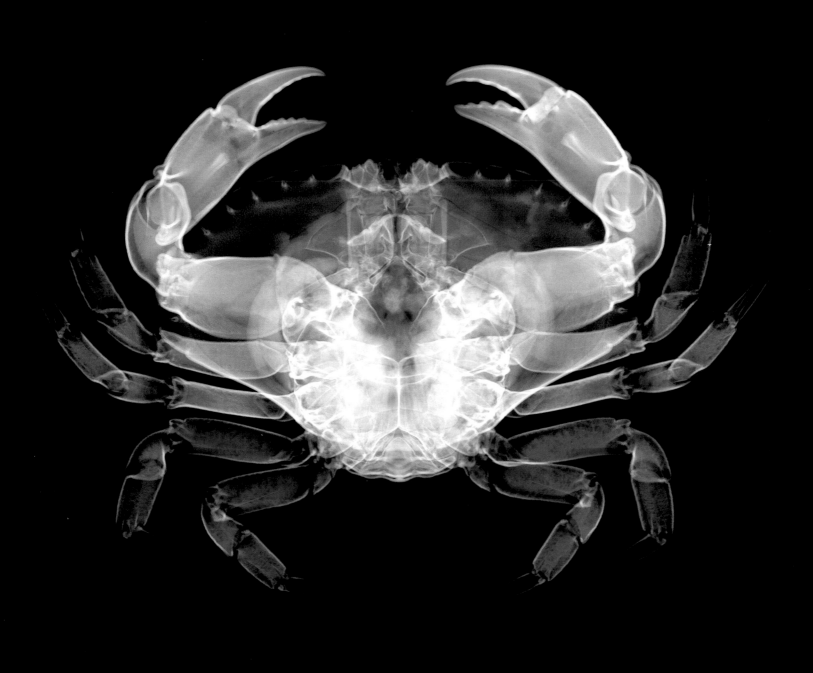

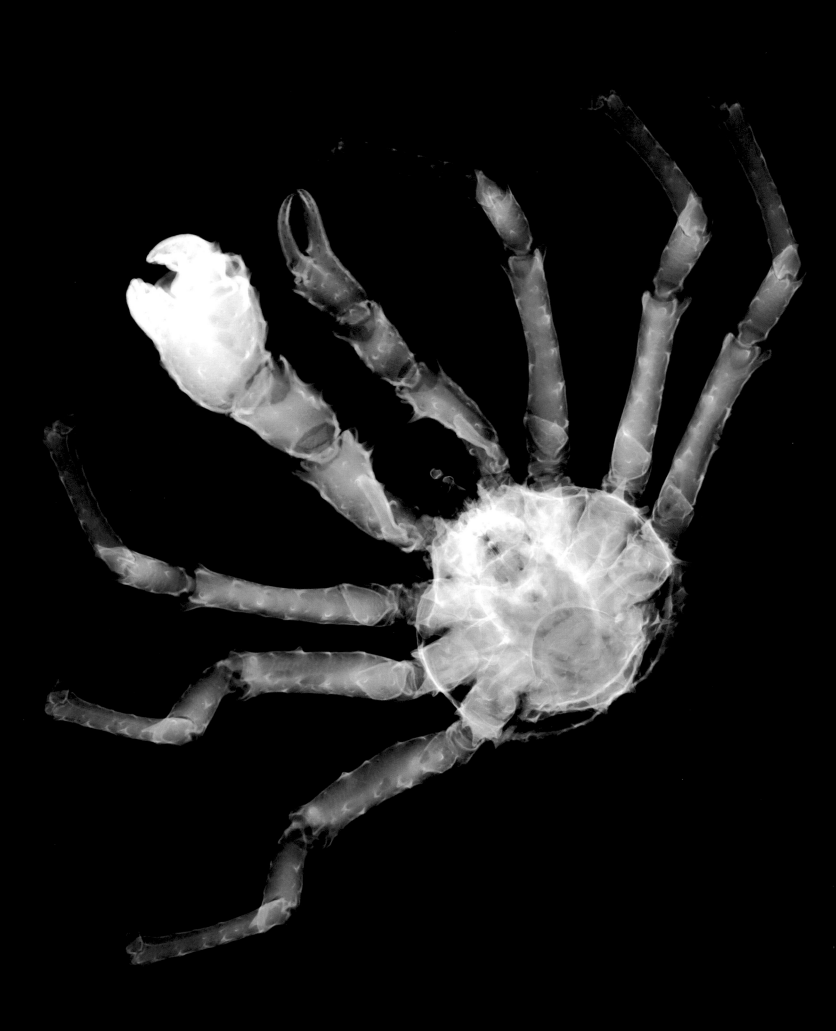

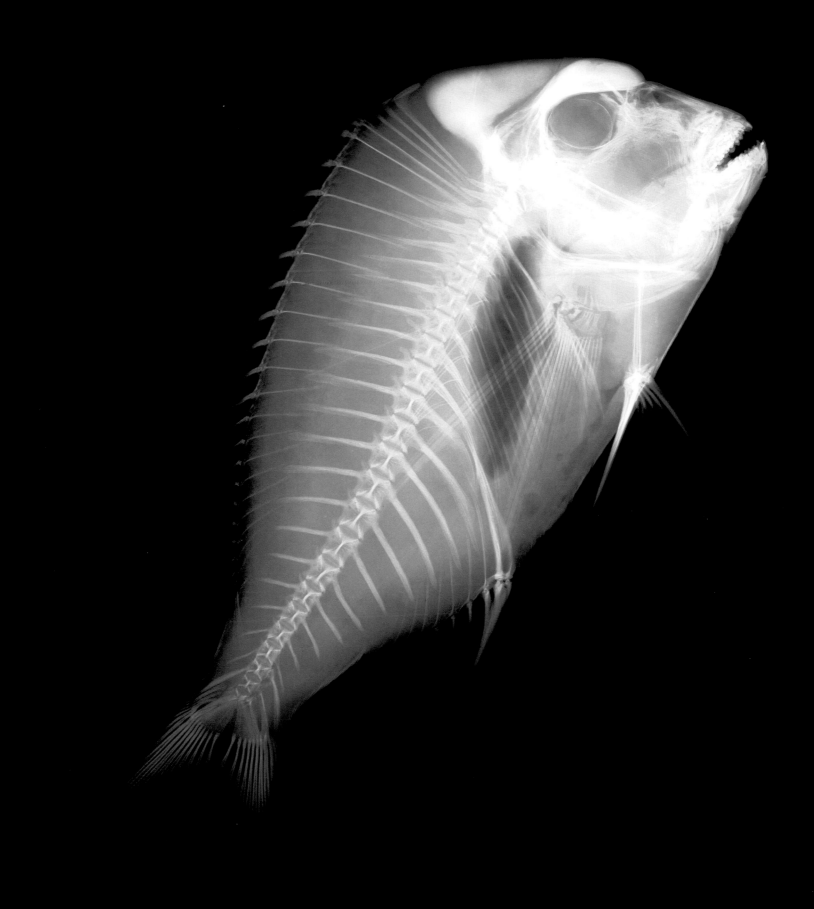

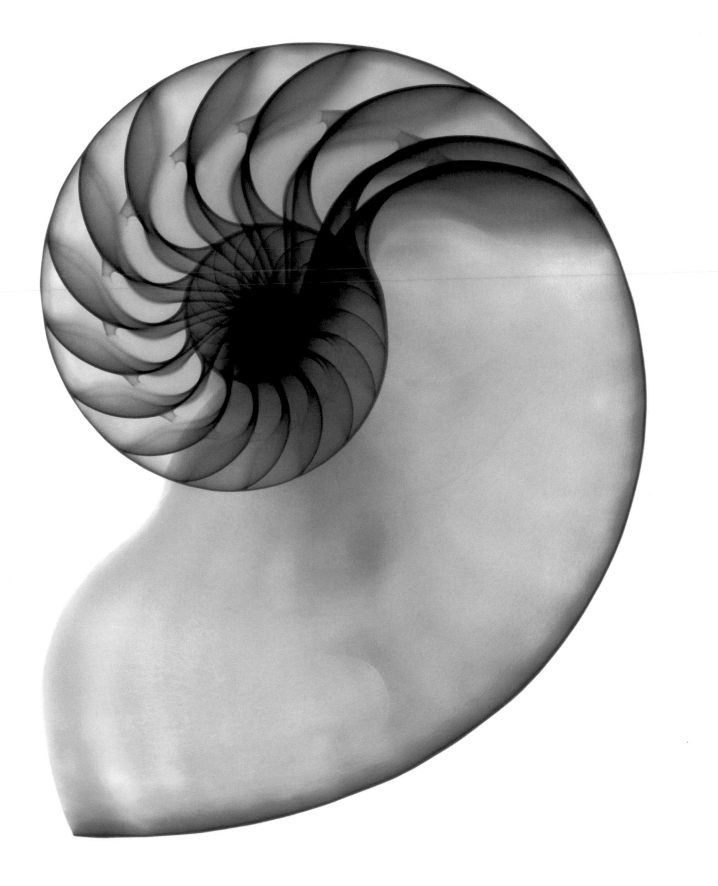

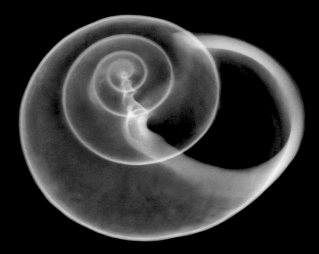

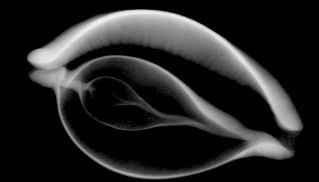

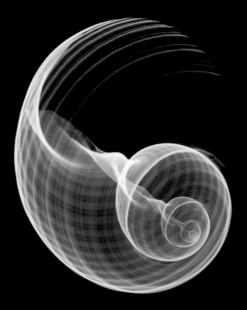

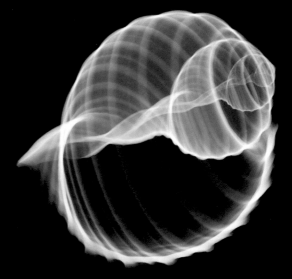

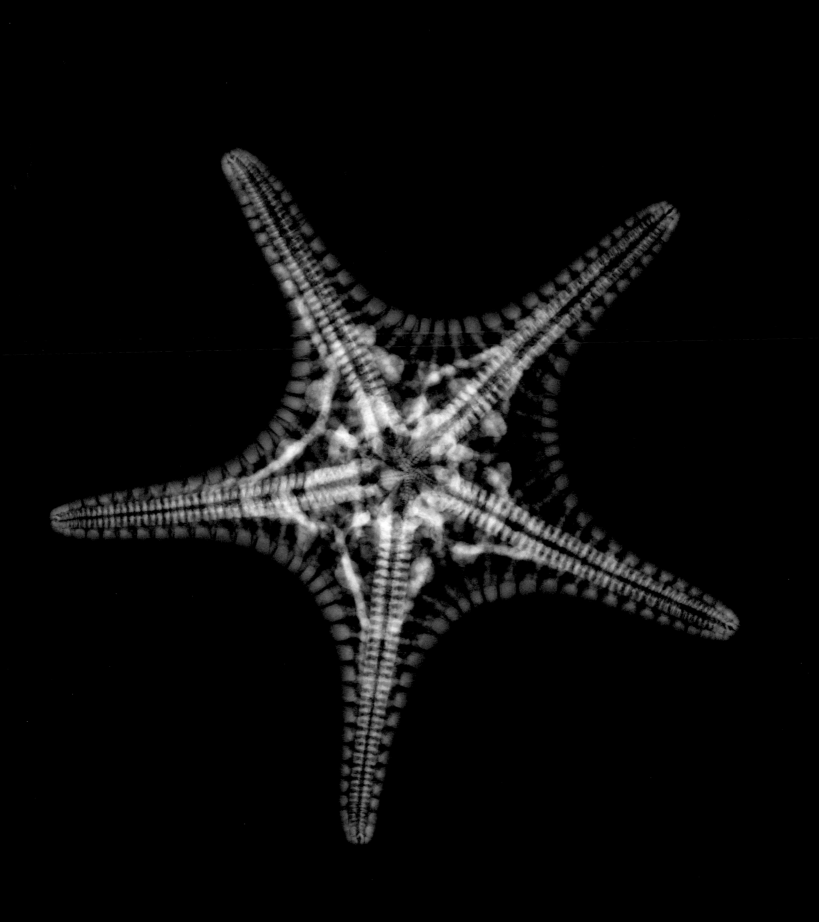

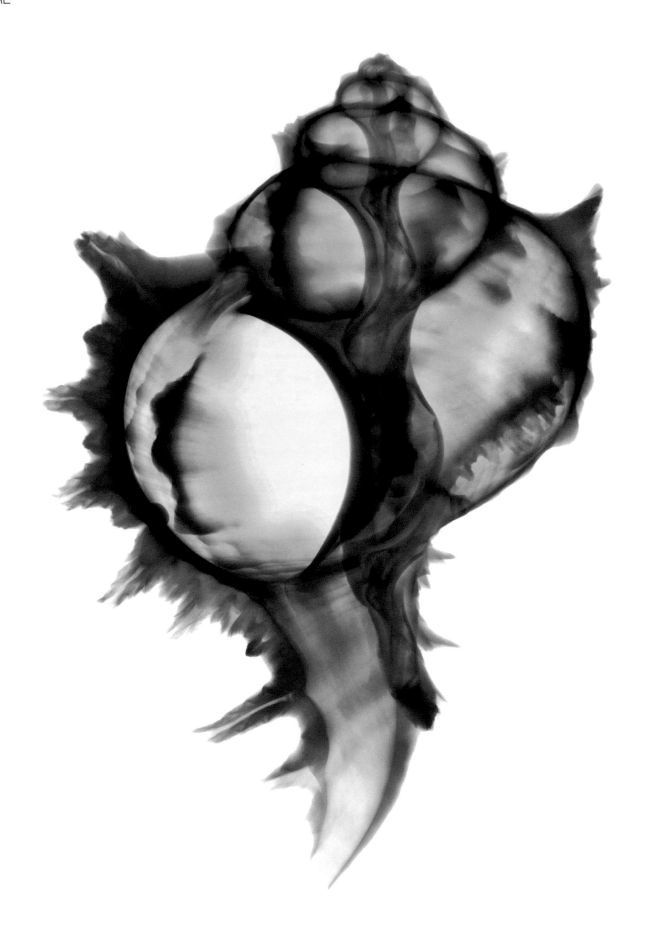

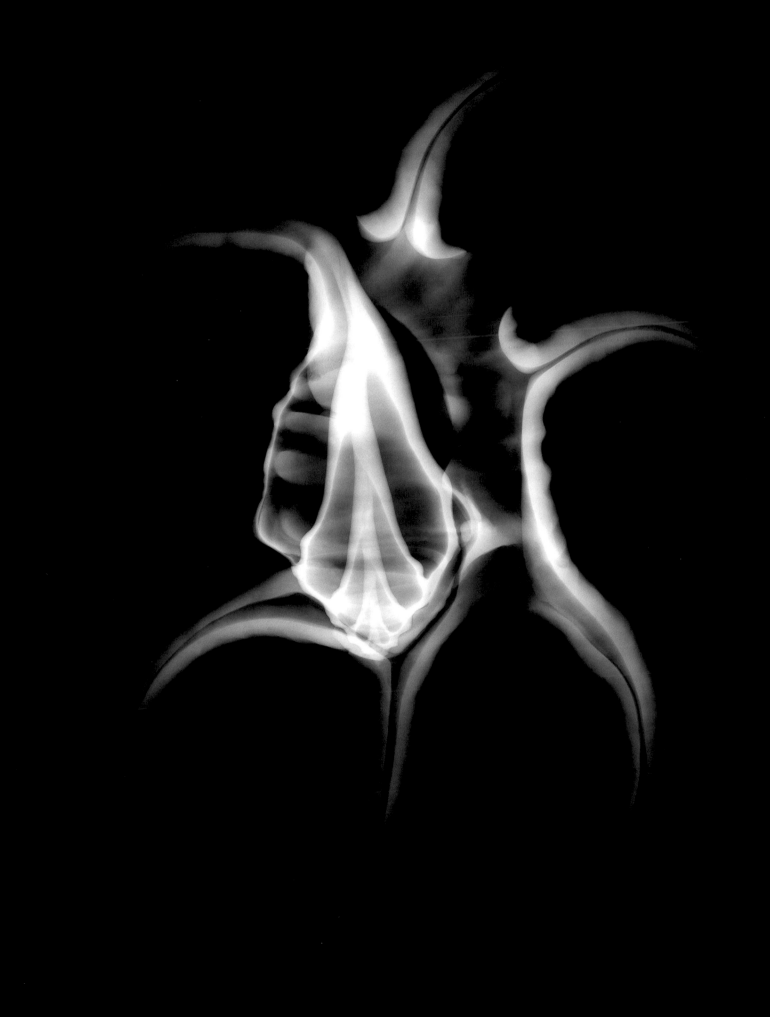

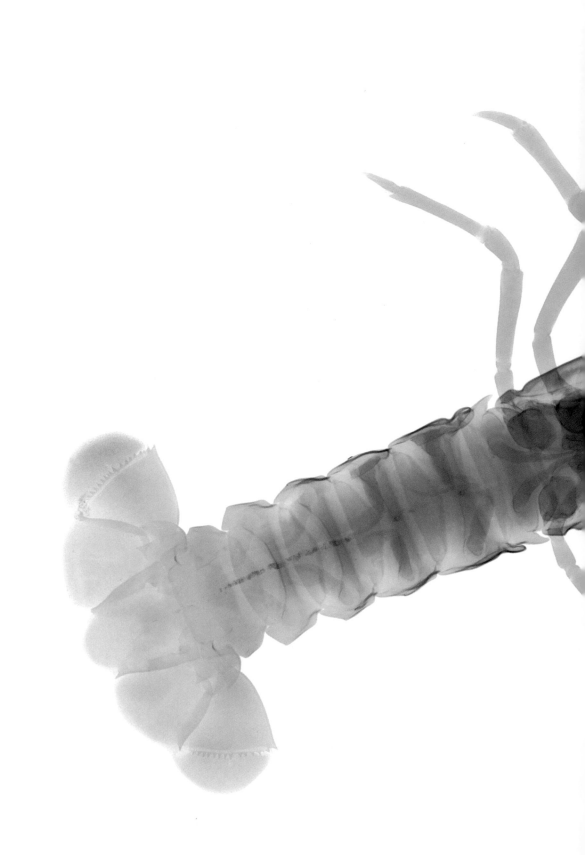

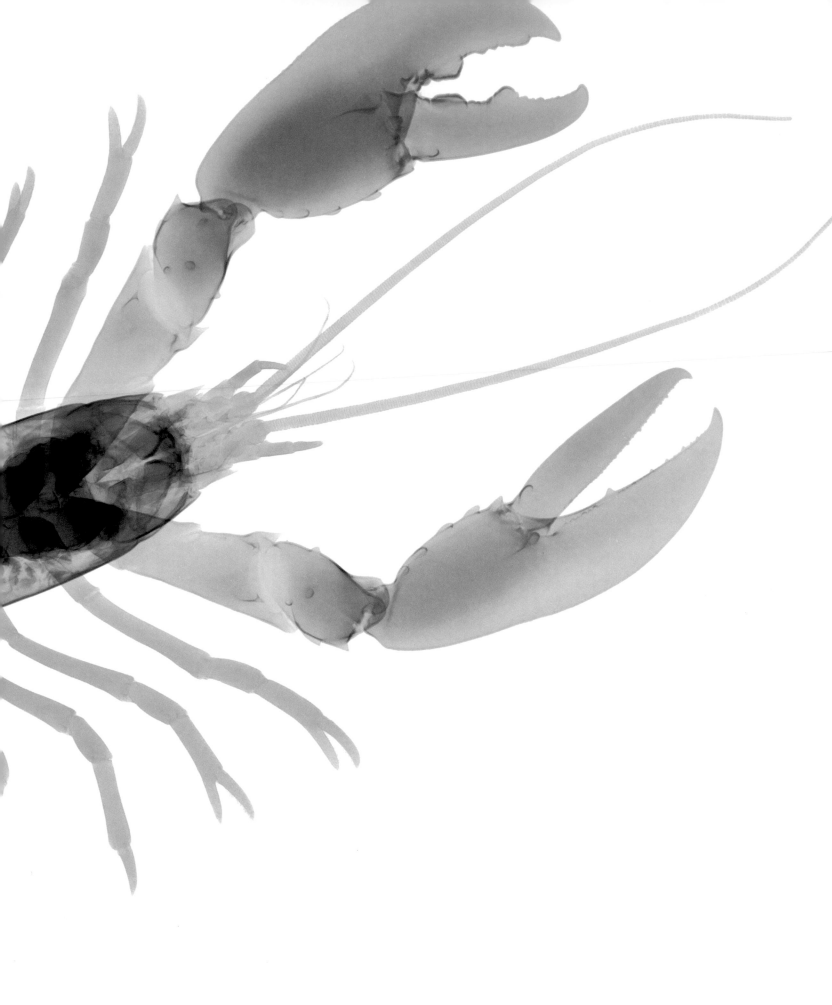

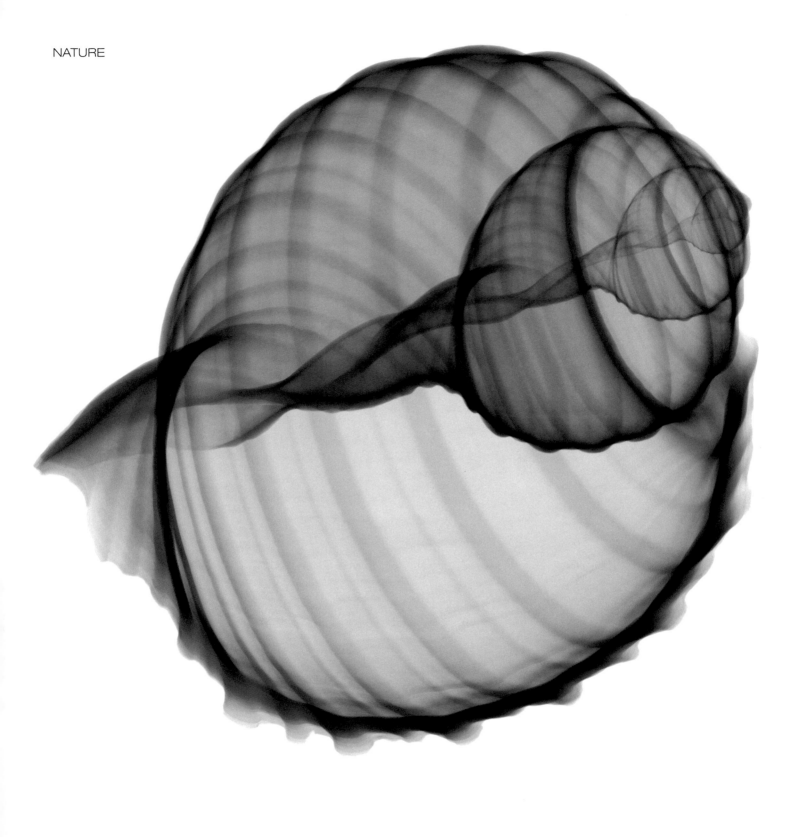

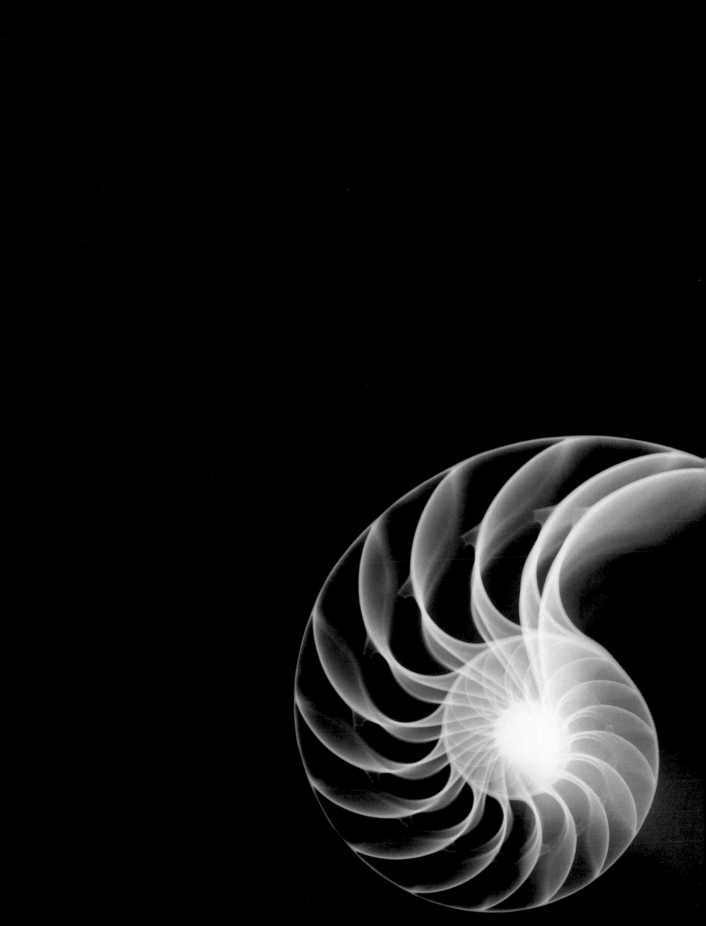

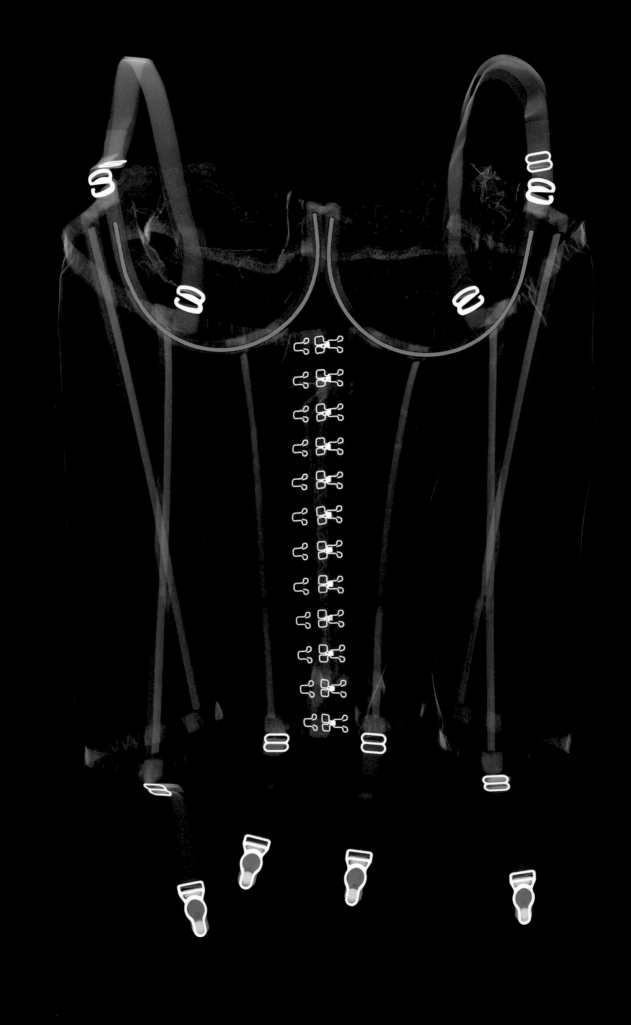

4 FASHION

Looking back through my images for this chapter enforces my belief that my work has a valuable message: beauty is more than skin deep. I'll show a garment or accessory in the most aesthetically pleasing way my technique allows, but that technique does reveal what happens within. X-ray is an honest process, it shows things for what they are, what they are made of. The resultant images can still be beautiful, aspirational even, but they strip the subject matter bare and reveal it for what it is.

Working with people from the fashion industry is hard going – they are extremely high maintenance and demanding – but they do push things forward creatively. And being given something to work with as beautifully designed and well made as an Alexander McQueen dress is a rare treat. That said, when I compare the various fashion images here, the cheap, basic men's underwear holds its own with the best of the designer stuff and that pleases me. When stripped of designer labels and brand attributes, each garment I work with is equal to the next. My work is a great leveller.

I have had more bizarre requests from fashionistas than I care to remember, but one of the strangest was to install an x-ray rig on the catwalk of a prestigious fashion show. The desired effect was to "zap" the models as they passed through the x-ray area and project the skeletal image live on a large screen. When I pointed out that each time the model was x-rayed they would be exposed to radiation, the general response was "So what?" These people certainly don't like taking "No" for an answer.

A complicated technical challenge when you are working with fashion items is creating depth and volume in the finished images. I have inflated balloons inside shirts and ripped dresses in half and x-rayed each side separately, endeavouring to avoid the x-ray mangle look. I prefer a slightly messed up finish rather than over-manicured. The jacket, shirt and tie on pages 195 and 196–197 are a good example of this "rough styling". As I have to convert my x-ray room into a lead-lined darkroom to create this work, and I can't see small details despite wearing night vision goggles, I'm happy with any decent result.

My biggest influence in fashion photography is Guido Mocafico. His work has texture and elegance and real depth. His pictures look like they have been loved. The other fashion photographer I admire is Nick Knight. Nick's work is consistently stunning.

Fashion is in a permanent state of flux. Seasons come and go, styles come in and go quickly out of fashion. It is a fast-moving industry where the right image is crucial to adding value to a brand. Amidst all this chaos, I like to think that my images bring a little serenity. For once it is not about who's wearing what and where, but about the beauty inherent in each garment or accessory. So forget your designer labels and learn to appreciate something for what it is and how it was made.

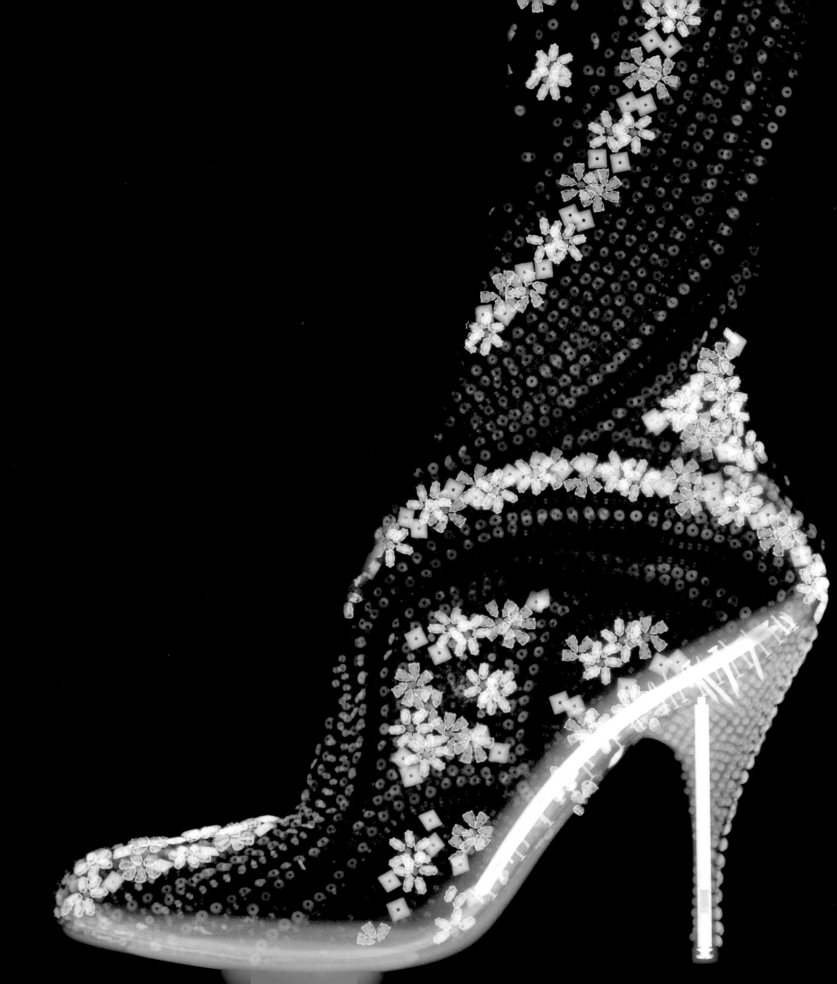

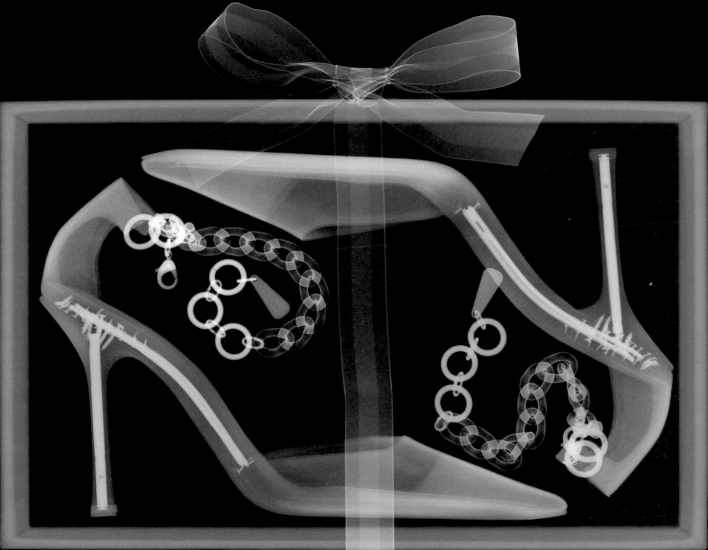

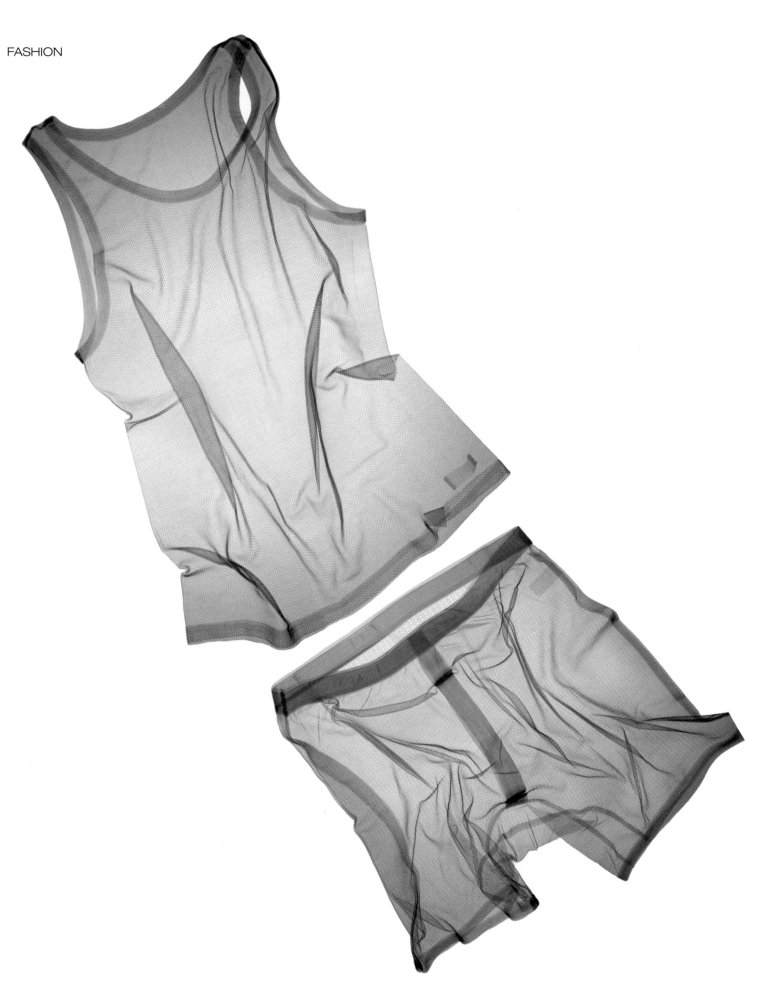

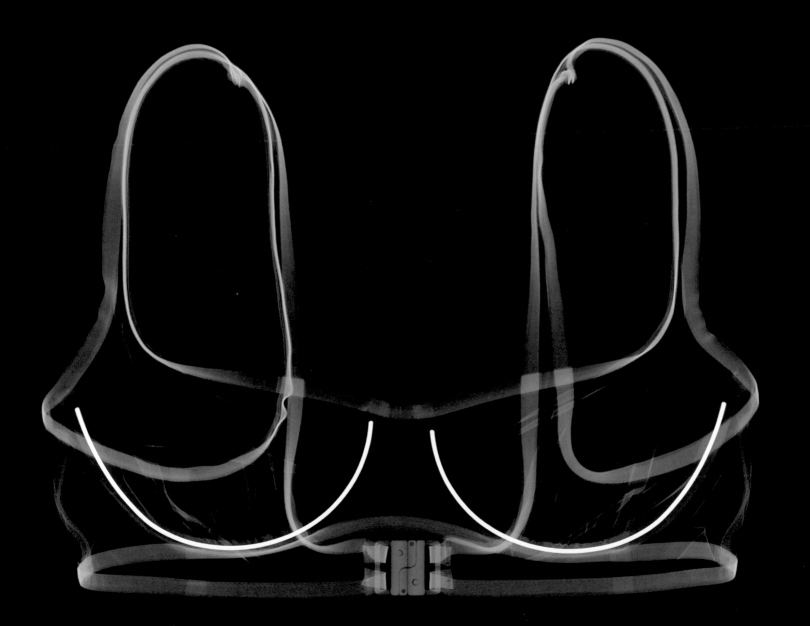

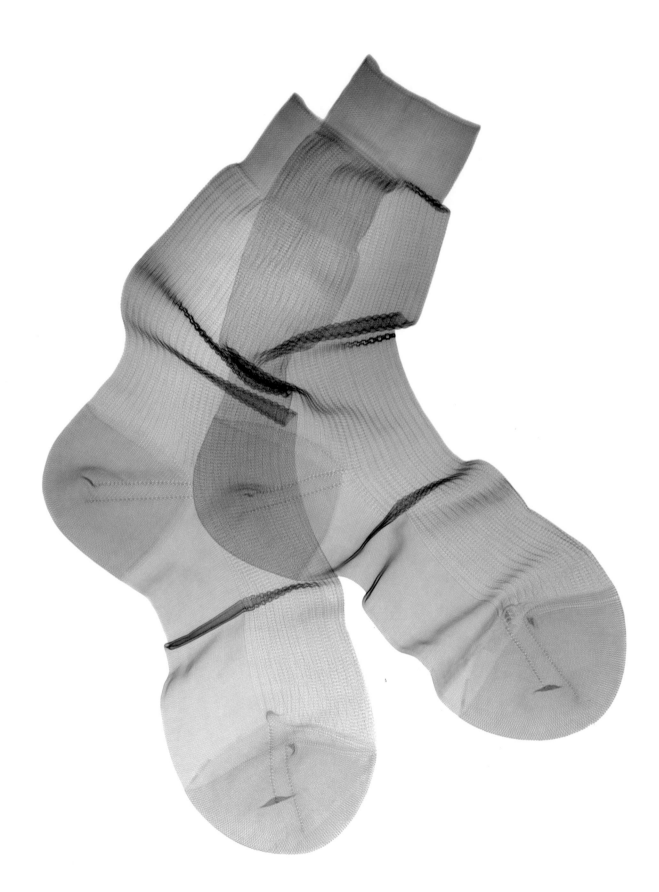

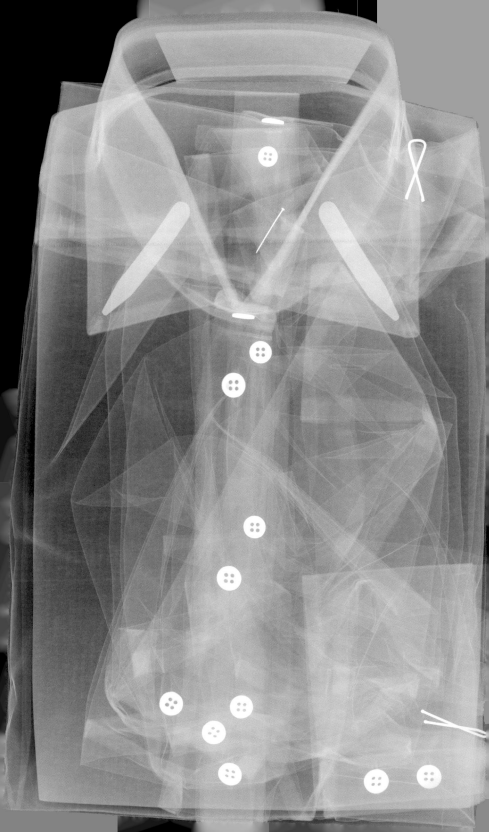

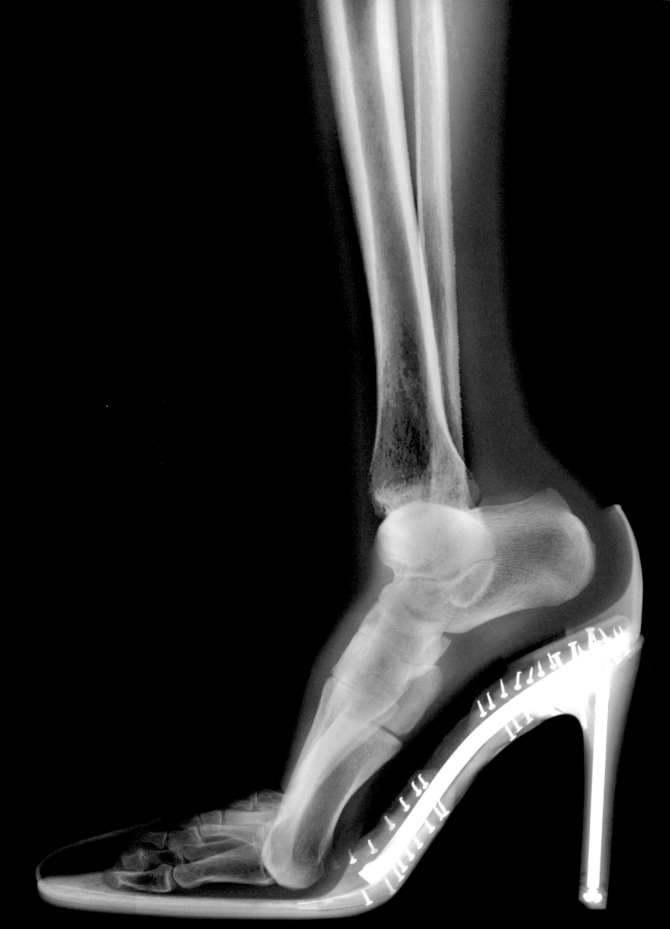

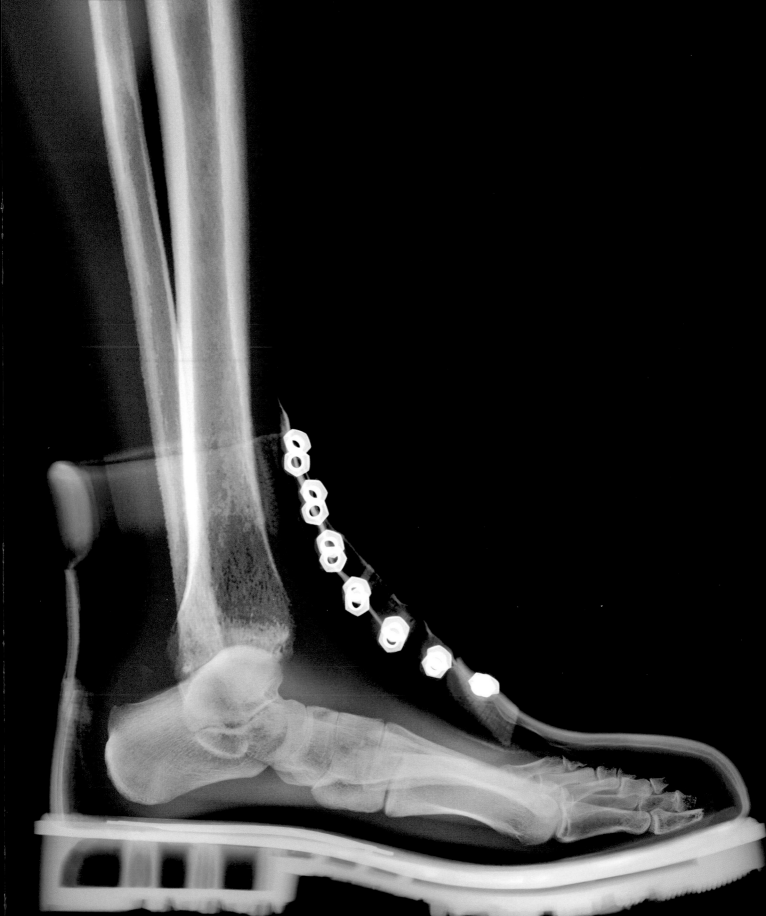

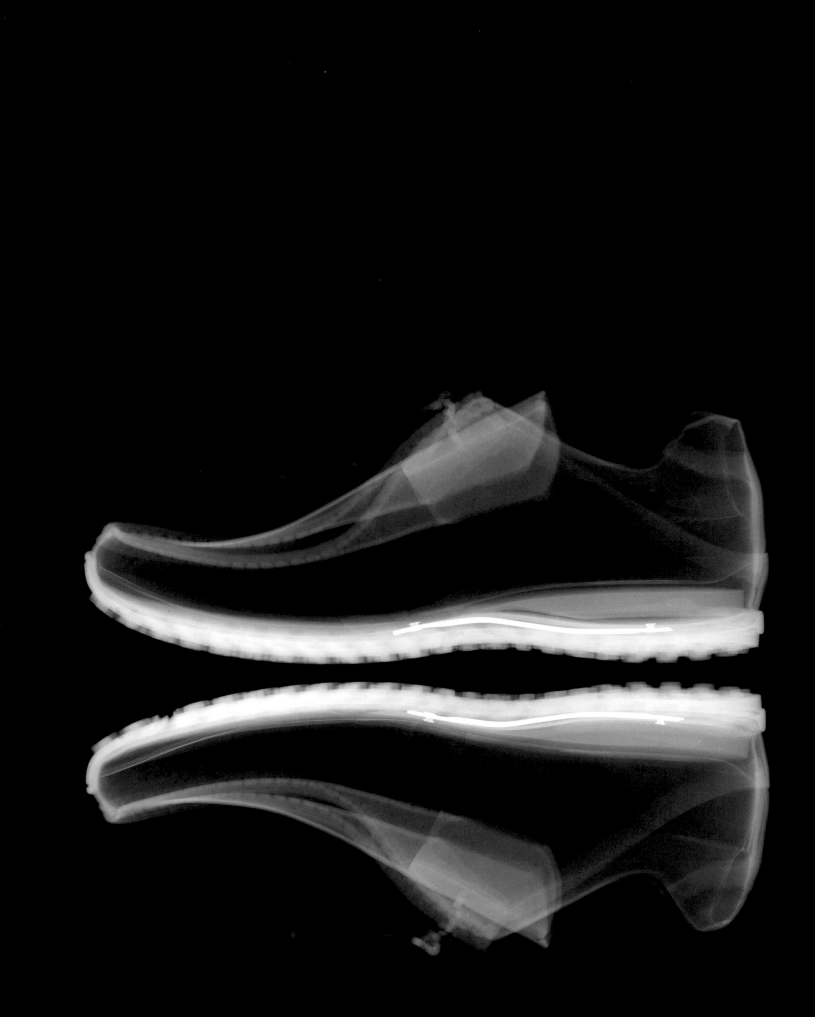

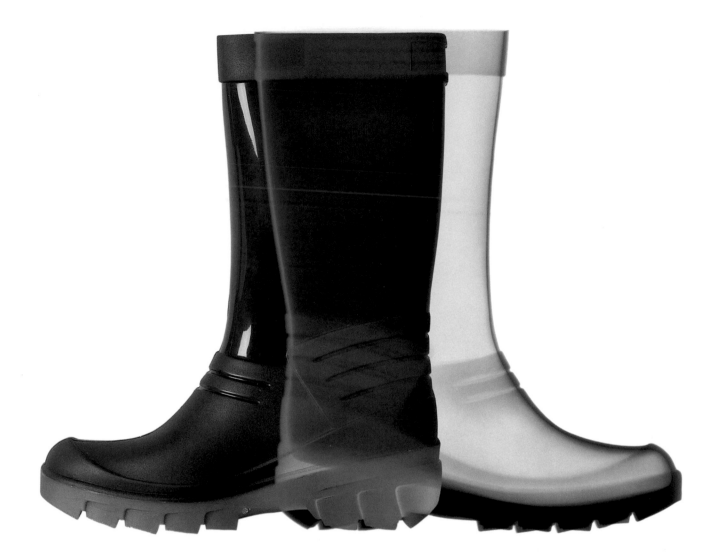

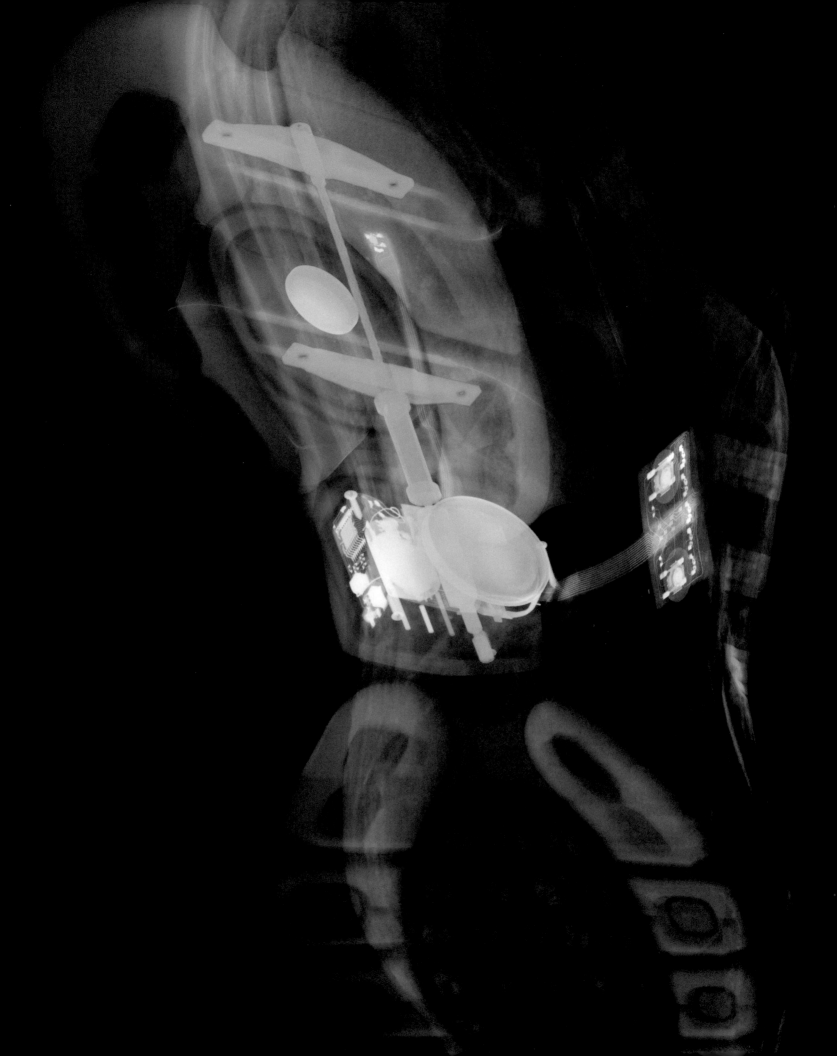

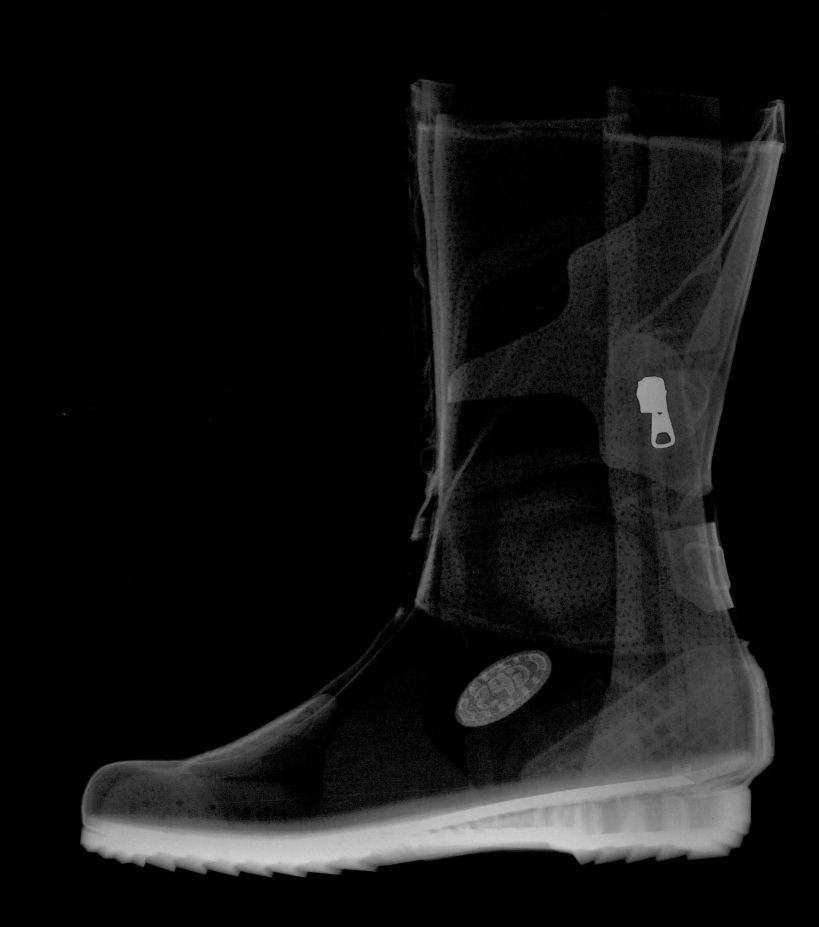

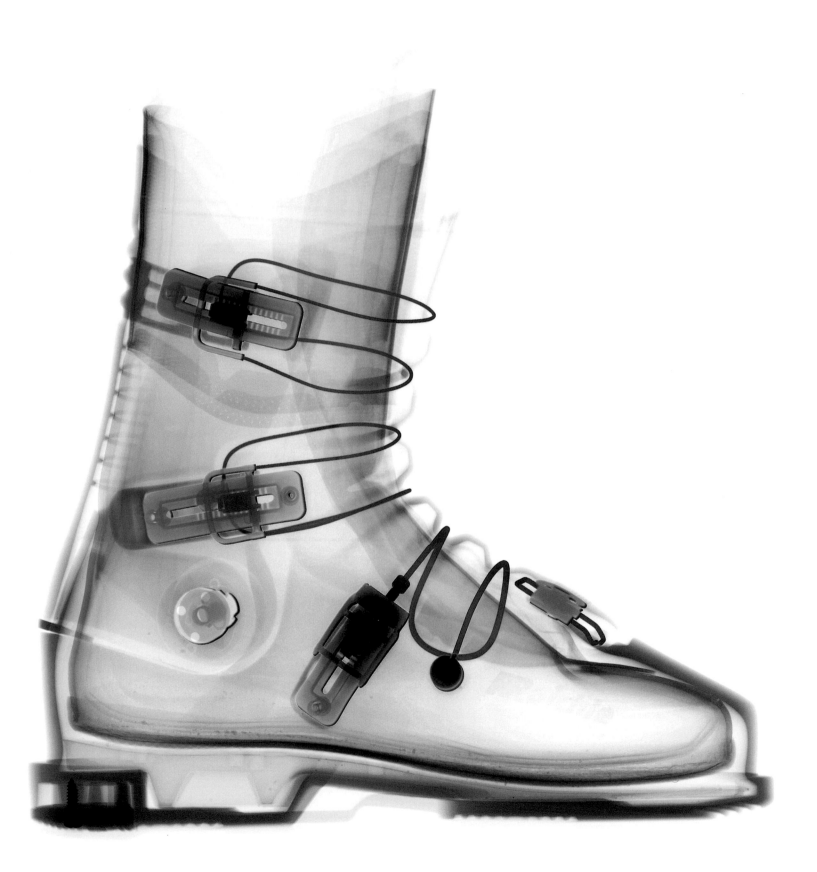

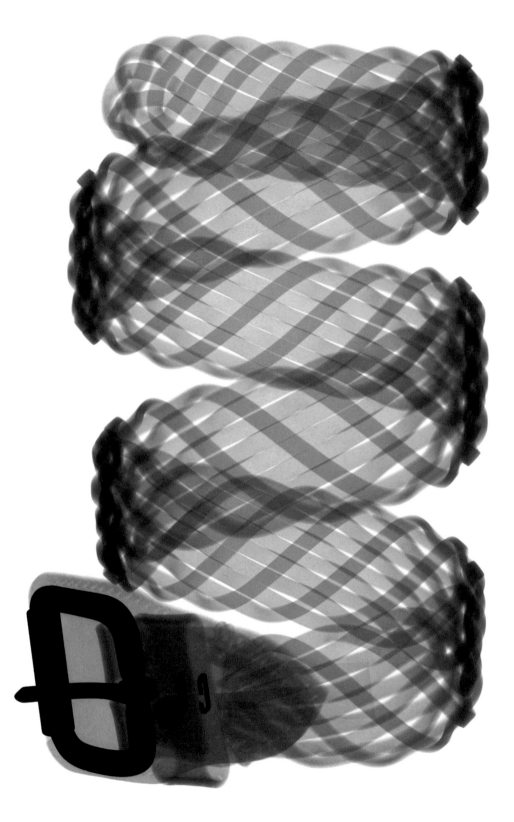

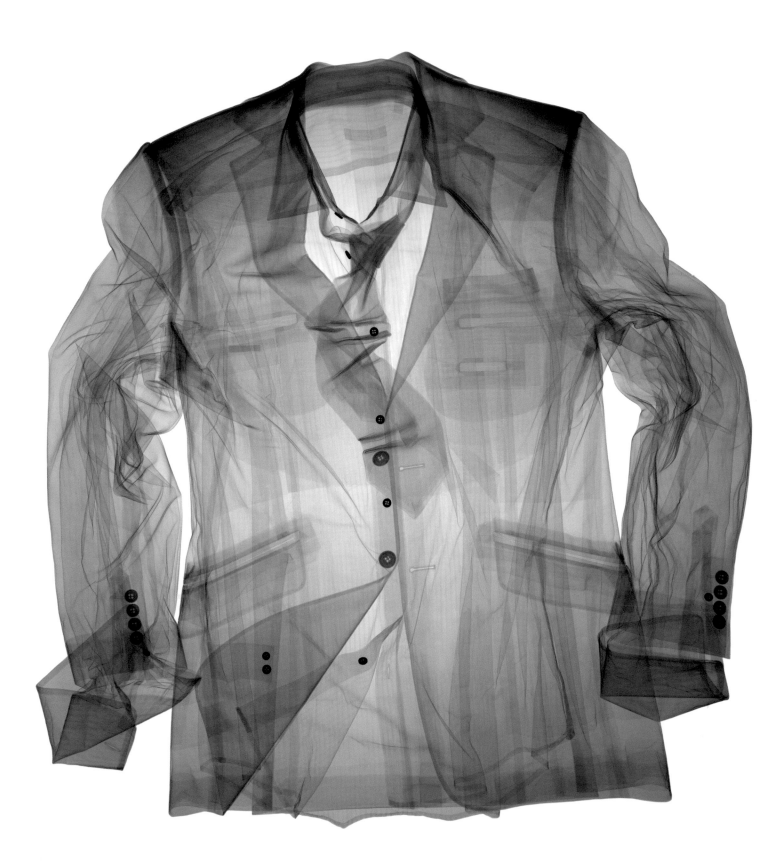

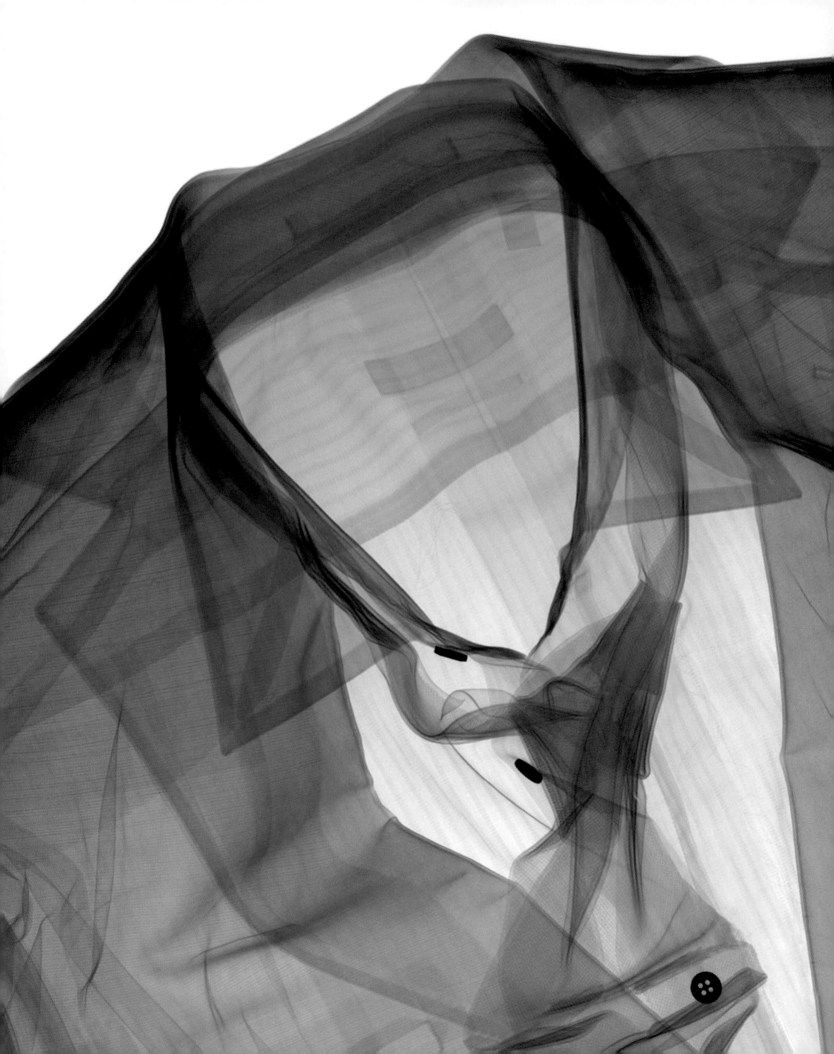

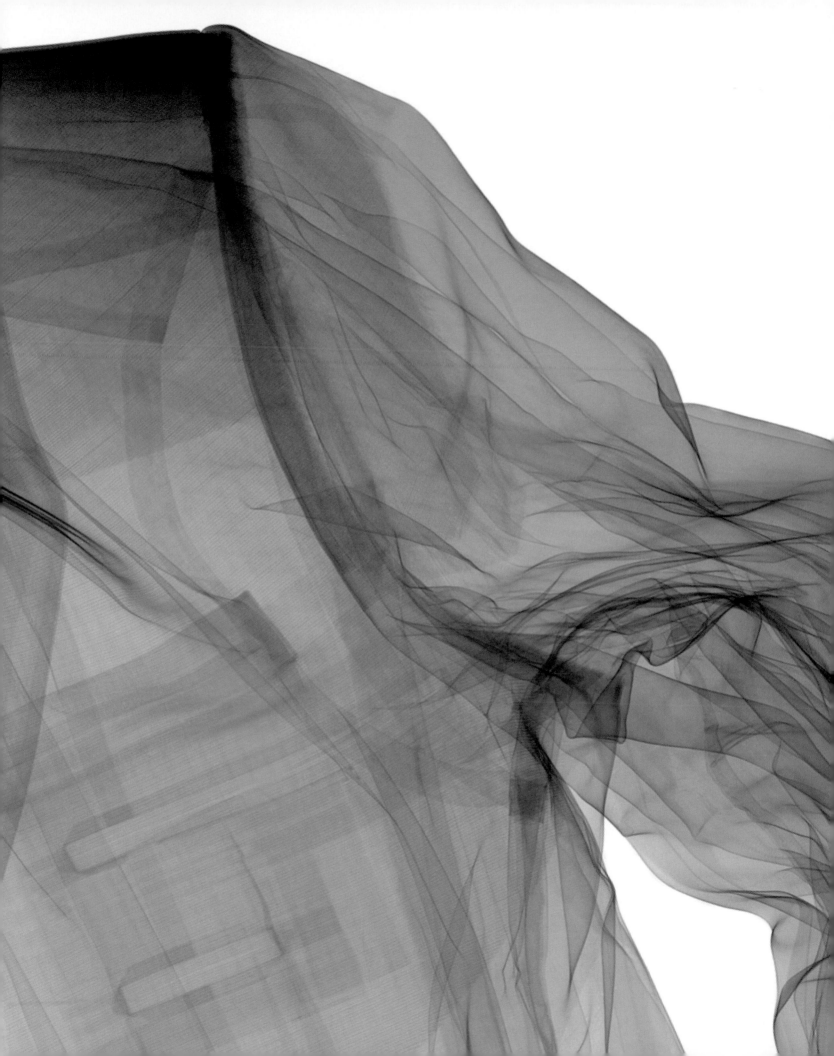

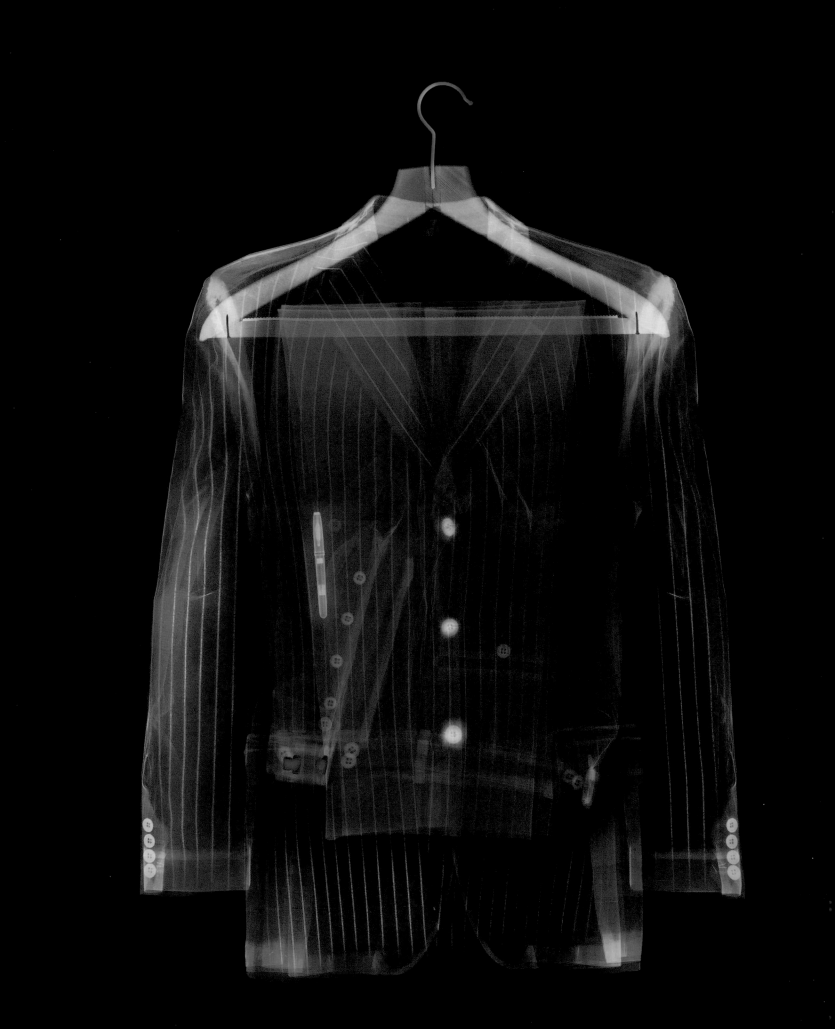

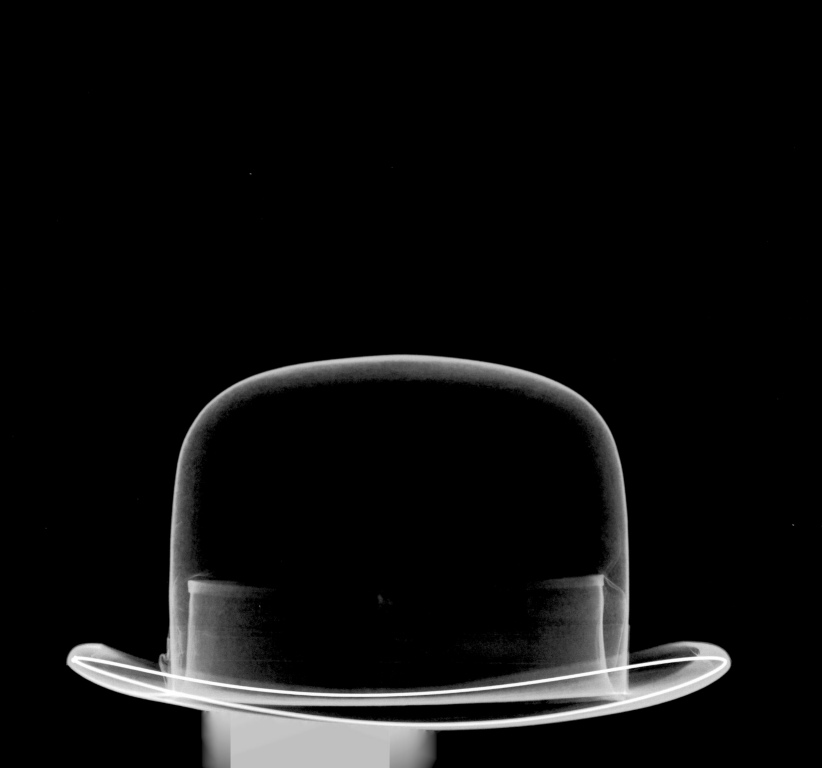

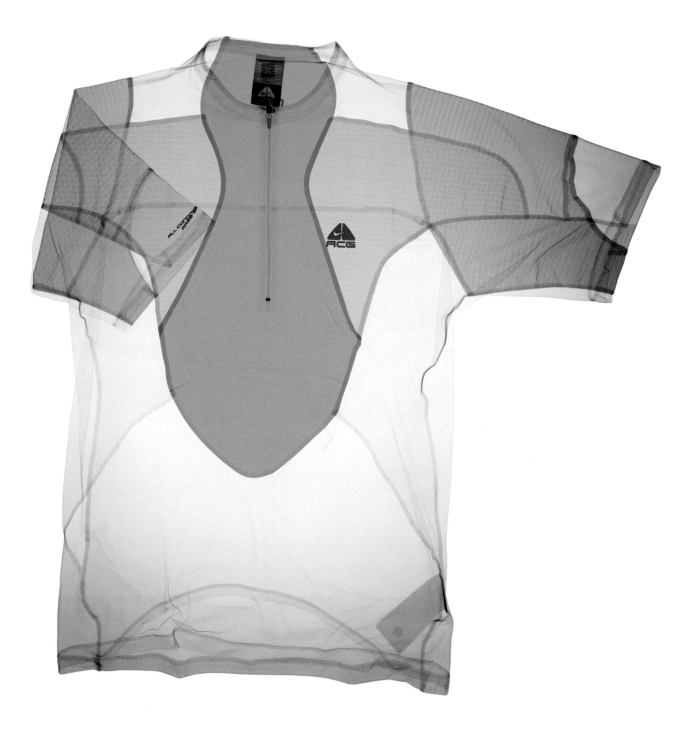

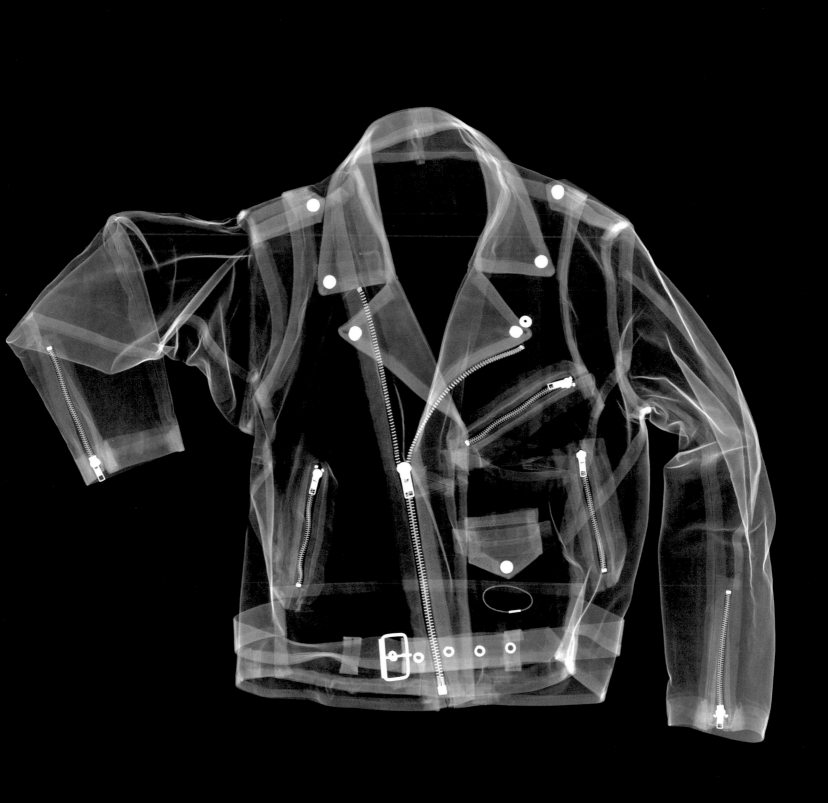

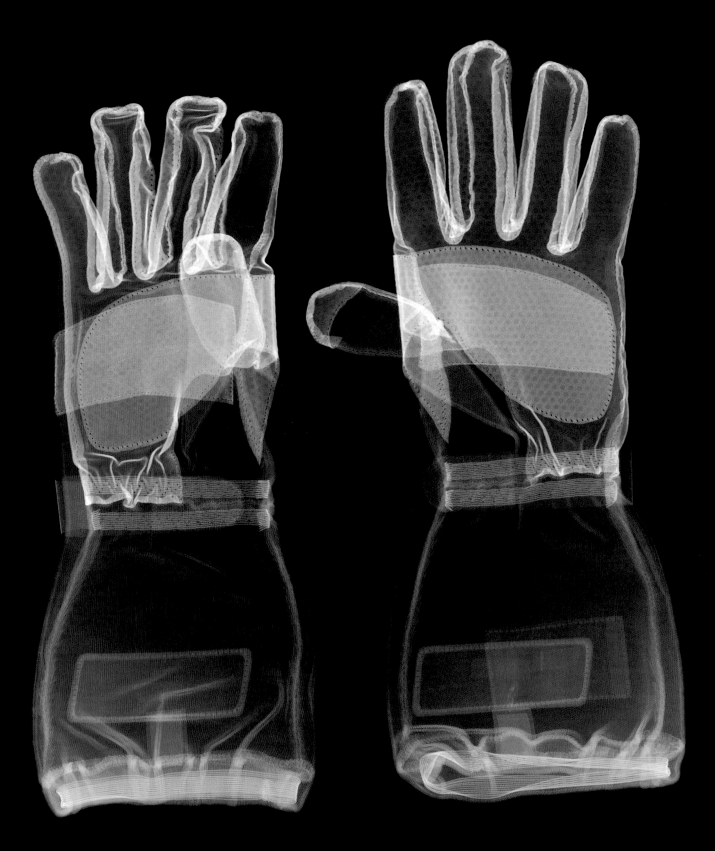

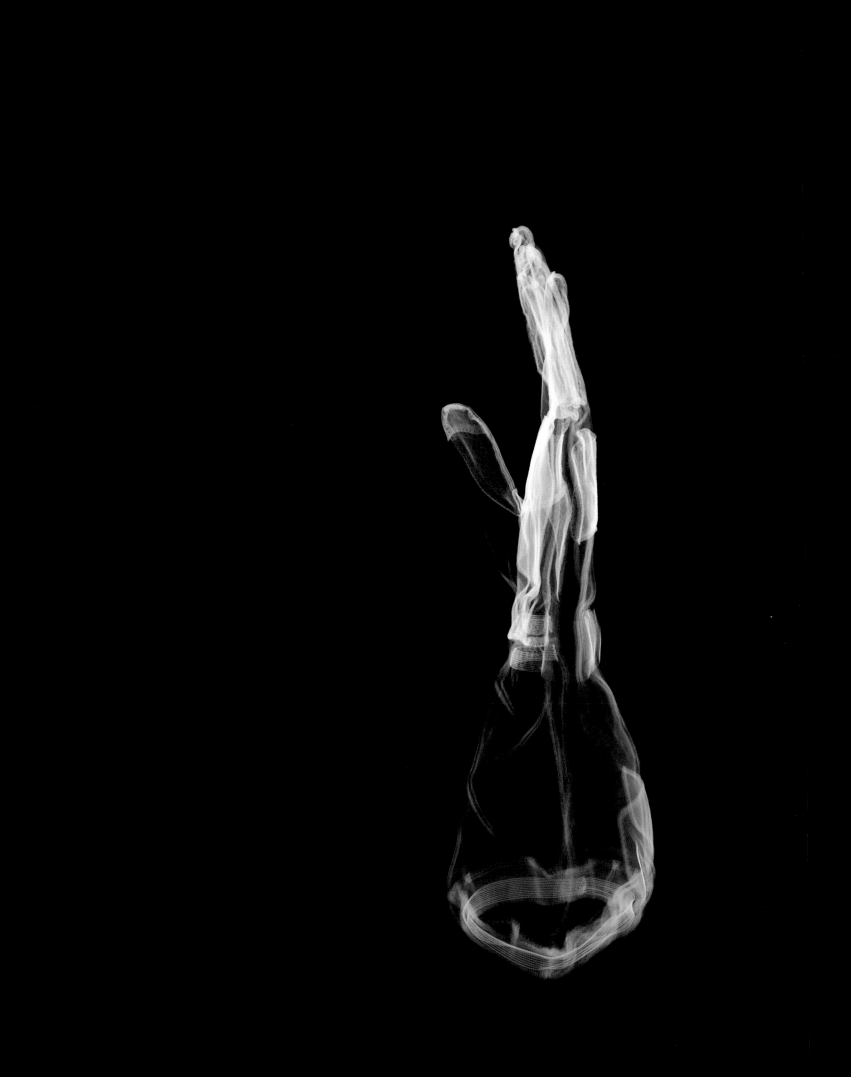

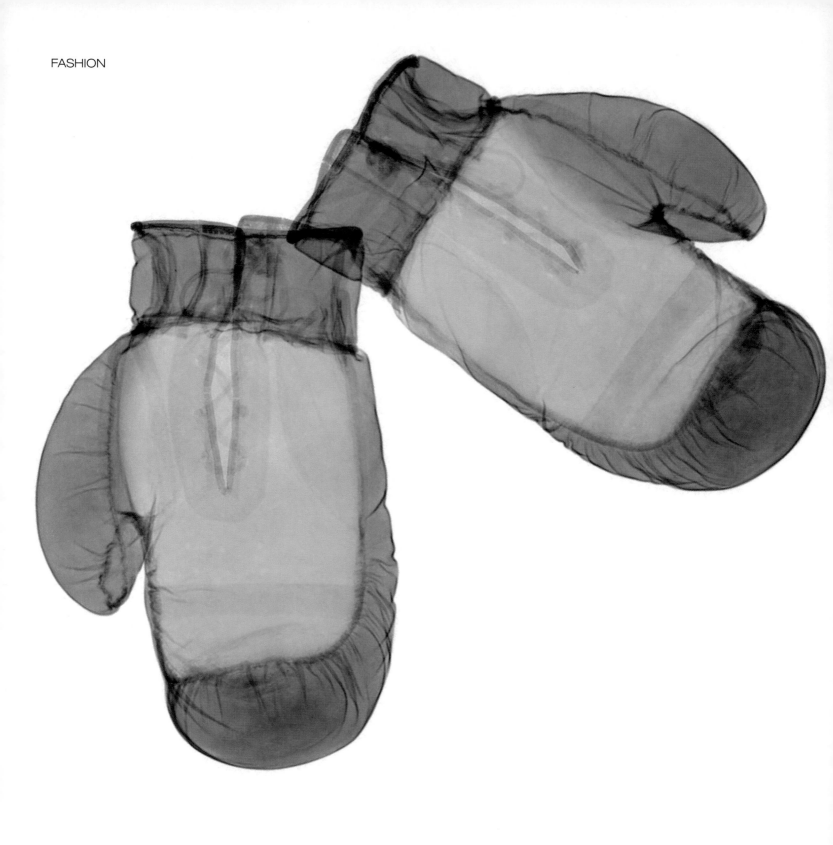

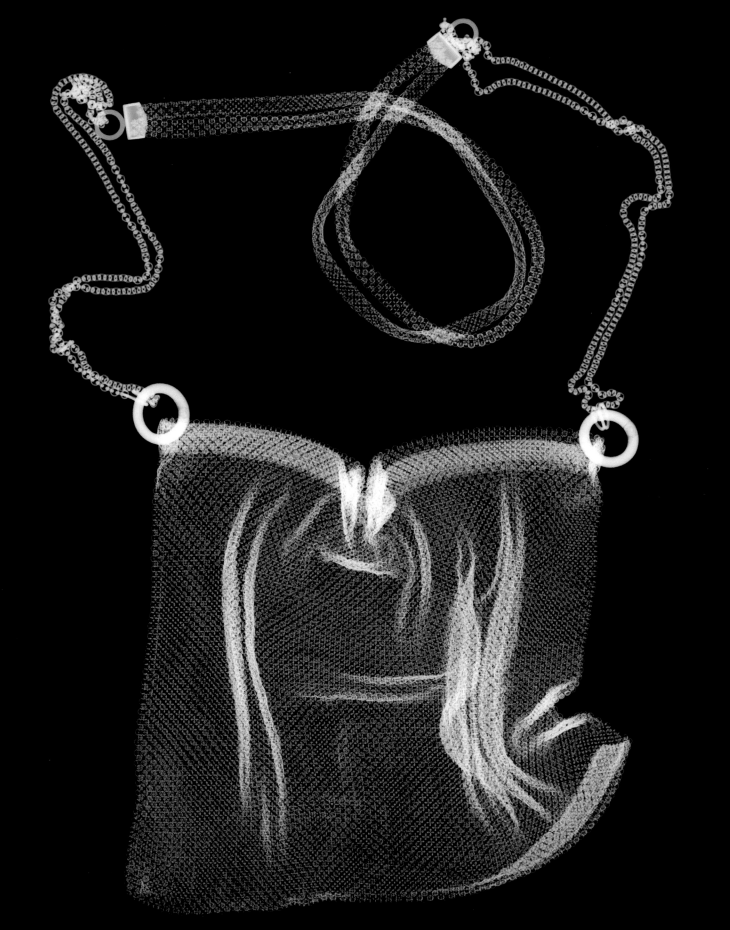

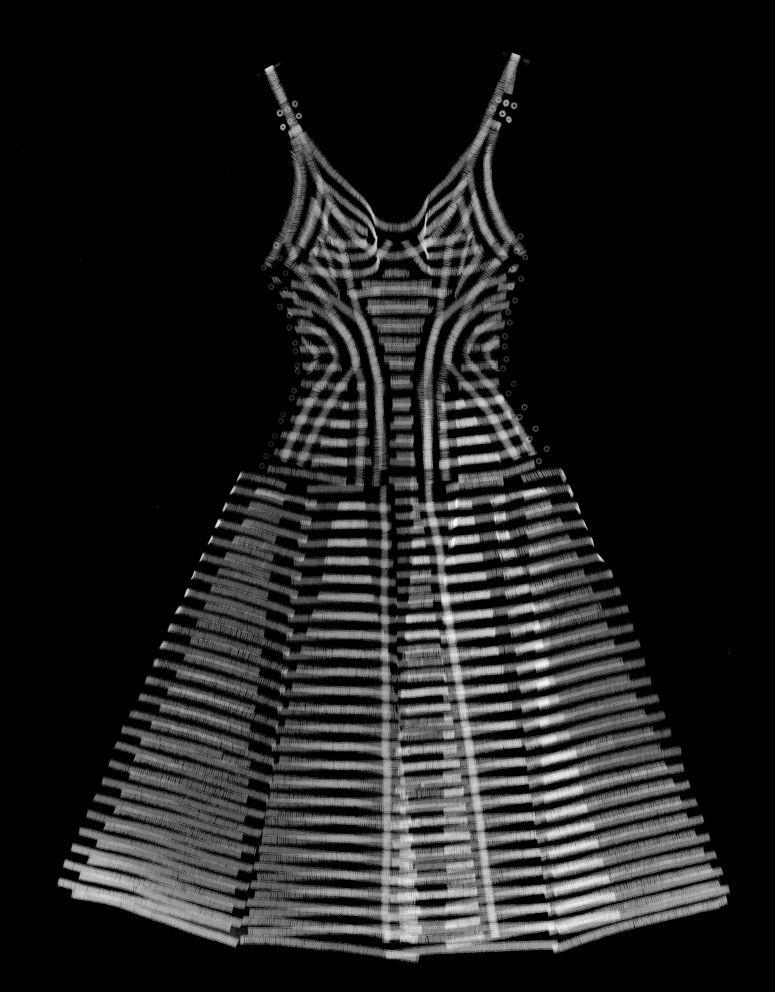

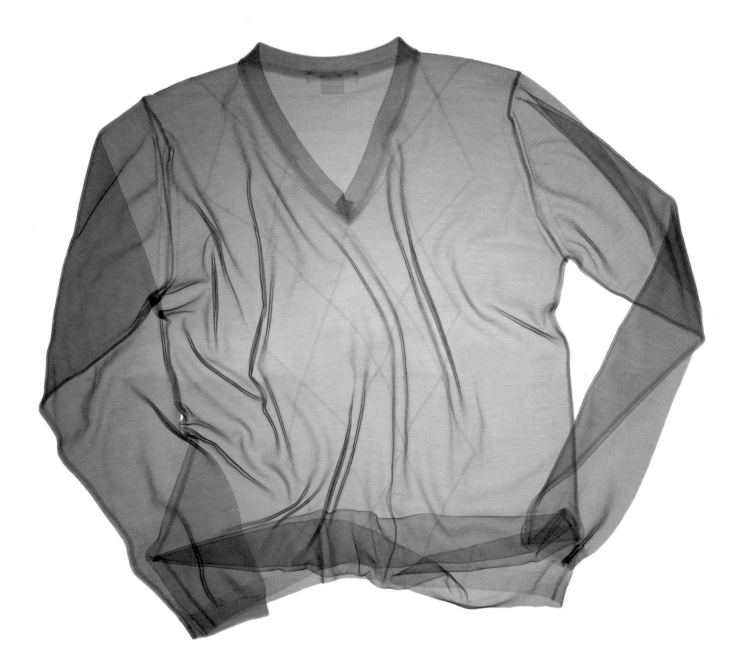

PICTURE INDEX

4–5 Old fashioned, low-tech alarm clocks and watches look much better than fancy digital timing devices in x-ray. The micro-engineering is stunning as the cogs and springs are revealed.

7 This was a smelly and messy day, sifting through rubbish, handling all the different bits and pieces of trash as I tested out several variations. At least the props were readily available. And free.

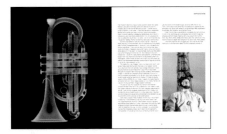

8 This brass cornet is the type of object I love to work with. Beautifully made, with a strong graphic shape, the tubular nature of the construction gives subtle changes of tonal variation as the tubes wind their way inside each other.
9 Photographer at work, in full protective gear with night-vision goggles.

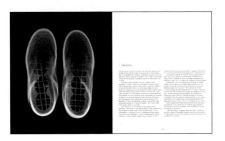

10 That Eureka moment. The first x-ray I did that was any good was of my well-used trainers (sneakers). I was very lucky to get the exposure right first time. As I look at it now, with all the knowledge I've gained since taking this shot, I don't think I could better it. And I probably wouldn't be able to get the exposure right first go again.

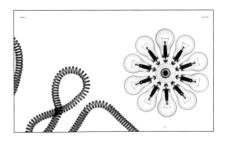

12 The flexible cables of metal detector headphones give off an ethereal glow. This is because the plastic sheathing of the cable is a lighter material than the copper wire within. The plastic is just faintly visible, but that is what gives the visual energy.
13 "The Flowering of Ideas" – I cringe when I think of the concept behind this arrangement of light bulbs. This embarrassment is easier to bear when I remember the relief I felt after hours spent lying on a cold lead floor trying to stop the bulbs rolling about and the resulting image successfully appearing life-size on film, exactly as you see it here.

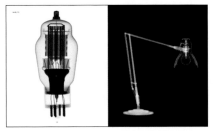

14 Another light bulb, but this one looks like it could double as some weird air quality-monitoring device.
15 The Anglepoise lamp was a labour of love. Every time the thickness of the metal changed, I exposed separately for that particular thickness. As the base is severely heavy, I had to really cook it to get any internal definition. Then I moved onwards and upwards, from the base to the lampshade, decreasing the radiation level to suit the springs and then reducing the radiation again to hold detail in the bulb. Add in a fair amount of fiddling to get the metal tubing perfectly square on throughout the length of the arm and you have the final result.

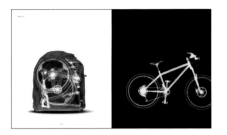

16–17 When I x-ray an object, I lay it directly on the light-sensitive film. The resulting image on that film is exactly the same size as the object. Working with the largest sheets of film available, roughly the same size as this book laid open, I needed seventeen films just to cover the area of a mountain bike. The folding bike was about one third the size of a full mountain bike so six films covered the area. It is placed inside a photo of the bag to show portability.

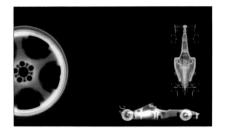

18-19 The wheel is from a real car, whereas the cars are toys. I like the way that the x-rays eat through the metal to give a photo-illustrative feel.

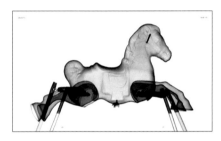

20–21 A real find at a flea market, this rocking horse resulted in one of my favourite pictures, even though it was badly scratched and dented. In this instance it really helps that all surface colour is removed during my process. Without colour, the double-layered mouldings seen in x-ray are just detailed enough to elevate this cute rocking horse into the realms of sculpture. In x-ray, this previously abused, mass-produced toy resembles a beautifully crafted work of art.

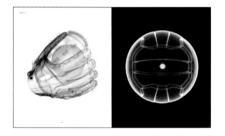

22 Finding the right position for an object involves trial and error. I tried this baseball glove and ball from several angles but the fingers in the gloves and ball overlapped and caused confusion when shot from side angles.
23 Notice how the outer edge of the ball gets brighter. The converging planes help to give a more three-dimensional appearance. Getting balls to look right is tricky; if the ball is slightly off centre from the x-ray beam, I get egg or peanut shapes instead of circles.

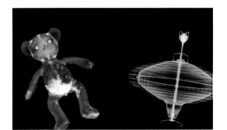

24 Teddy's going on his holidays, but I wouldn't want my children to find out that I use their toys like this. The white beads inside the teddy are balls of polystyrene-like material used to give it shape. At first glance you think it could be drugs, but that's the x-ray image and the associations with security equipment that it conjures up.
25 A classic spinning top. Hours of fun were had pumping the central metal spiral and listening to the high-pitched whine it made as it careered around the x-ray lab.

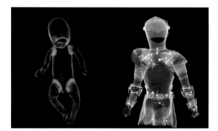

26–27 More toys. The doll is another, rather disturbing, favourite of mine. And what adventures await the faceless Knight? Is it Sleeping Beauty's saviour or an outfit from 1970s' trendsetter Seditionary, Malcolm McLaren's punk clothes shop on the King's Road?

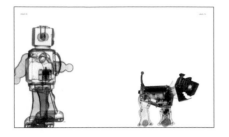

28–29 Time for walkies. The robot is clockwork and the dog is remote-controlled. The dog has a speaker in its stomach, so it must bark or make some noise.

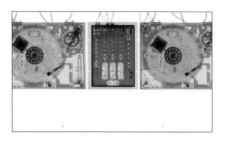

30–31 The challenge with this picture of turntables and a mixer was getting the balance right between all the electronic circuit boards and the moving components. The colouring helps make it work. Without it, the result was a little confusing as the stylus arm merged in with the circuitry.

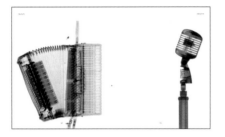

32 The accordion has metal workings and flexible pleated material. To hold both types of material in one x-ray was extremely tricky.
33 The all-metal microphone, on the other hand, was more straightforward. This microphone is reminiscent of Frank Sinatra in his heyday.

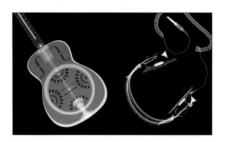

34–35 X-ray is quite an honest process. It reveals the quality of construction of the subject. And this acoustic guitar is beautifully constructed. However, if you look inside the earpiece of the headphones, the wiring is a total mess, which proves that newer isn't always better.

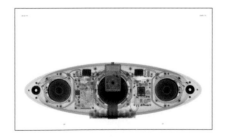

36–37 An MP3 player docked on an eye-shaped stereo unit, very different to the silver or black boxes most of us have. The copper coils and electro-magnets common in speaker production cause havoc with x-rays. The electro-magnetic field they create makes the x-rays bounce around rather than pass through. To overcome this, the speakers often have to be disassembled and separate images taken of the component parts. These are then recombined on the computer into one composite image.

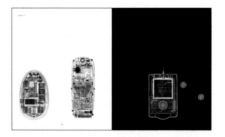

38–39 The computer mouse is a straight x-ray that has been coloured. The mobile phone is an x-ray combined with a photograph of the same. The photograph is only required to capture the detail of the buttons: the numbers and letters do not appear on the x-ray as they are not three-dimensional. Opposite is an MP3 player with in-ear speakers.

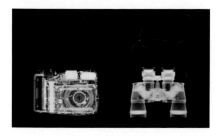

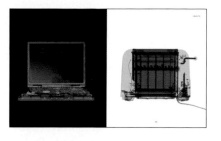

40–41 A rangefinder film stills camera and binoculars. The thick glass used in the optics of the binoculars is extremely dense, so although we think of glass as transparent, in x-ray, the reverse is true.

42–43 The arch at the bottom of the screen of the laptop is the ribbon cabling which these devices use. The toaster shows the zig-zag lines of the heating element. It was fresh out of the box, rather than using my own which would have shown up all the charred crumbs and fritzed raisins knocking around in the bottom.

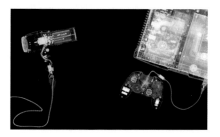

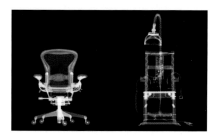

44–45 This hairdryer exposes beautiful detailing in the heating element, making a mundane object look exquisite. The computer games console is attached to a flat screen monitor. Unusually, a teenager is not attached to the games console.

46 This chair was difficult to capture. The perspective was the main problem: as the base is five-pointed and the arms need to look as if they are projecting forward, many slight adjustments in the angle were required.
47 The electric chair was inspired by the film "The Green Mile". Not the easiest product to find, it was made up to a specification found on a very strange website devoted to executions and their associated paraphernalia.

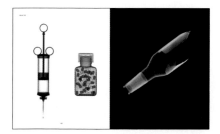

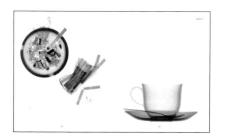

48–49 These images are helped by the sinister overtones of x-ray photography. Even the brightly coloured pills look more like poison than medicine. The broken beer bottle appears particularly menacing, with its highlighted sharp edges.

50–51 We all know smoking can cause lung cancer, and that x-rays can be used to diagnose and treat it, yet using the same imaging technique to illustrate the cause of the illness brings another dimension to the cigarettes. Capturing the smoke as an x-ray involved smoke and mirrors. This thought provoking "statement" is balanced by a simple yet elegant shot of the smoker's companion – a nice cup of tea.

52–53 An abstract x-ray of cooking aids. Note the overlapping weaves of the sieves on the left, and the beautiful tonal gradation in the mesh of the infusion container on the right.

54–55 More weird x-rays demonstrate how the process can transform everyday objects. A Christmas decoration looks like a newly-discovered planet; coiled raffia could just as easily be a primeval life-form.

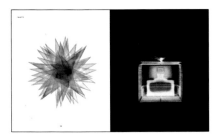

56–57 A paper star, used to decorate a present, becomes wonderfully complex and involving in x-ray. The perfume in its gift-wrapped box reveals the texture of the ribbon and the cardboard. Both these images are very three-dimensional.

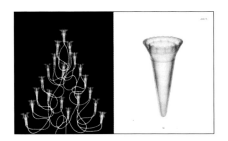

58 Christmas tree lights set out in a tree-shaped formation.
59 A simple ice-cream cone becomes architecturally fascinating as the air locked in the baking of the cone forms miniscule pockets that intertwine in and around the "biscuit". This image has won many awards, yet it would be difficult to find a cheaper, more mundane subject.

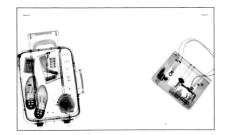

60–61 To create these airport-style x-ray images of luggage, every item is x-rayed individually to obtain the optimum detail. The objects are then "placed" in the bags on the computer. It's like painting by numbers. The colour palette is intentionally limited to reflect the software running on airport security x-ray machines. "Why not just use an airport x-ray machine?" you ask. These systems only produce a lo-res grainy image that is sufficient to vet our luggage, but is not of good enough quality to reproduce in this book. And if all the items in the bags were imaged collectively, the detail would be poor.

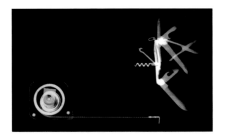

62–63 A tape measure with the innards all coiled up. The pocket multi-tool has a lovely fading to the thinner parts of the blades. This occurs naturally due to the fact that the sides of a blade are made thinner by sharpening.

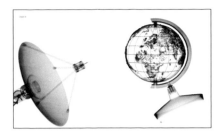

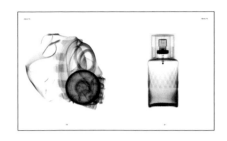

64 Rather than take x-ray equipment to space, this satellite was recreated in the x-ray laboratory.
65 "X-ray the world" was the brief for this image of a globe. To recreate the land mass and give a semblance of topography I made a mixture of ground iron filings and glue and painted it on the surface.

66–67 An interesting juxtaposition: the ultra-fragrant and a device to control the inhalation of toxic fumes.

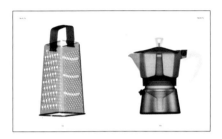

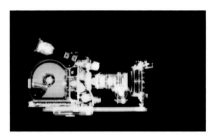

68–69 Quite rare in this book: a three-quarter angle x-ray. This cheese grater has such an iconic shape, with the added benefit of different textures (for different grades of cheese grating) on all four sides, that it works well from any angle. Many objects become confusing when x-rayed from an angle as the exterior planes can overlap and merge. The coffee-maker is a perfect straight-on profile. If it were x-rayed from an angle, the pouring spout would be merged with the upper part of the body and, therefore, it would be less of a graphic shape.

70–71 This film movie camera was a delight to work with. It is just an interesting and well-made object, and the x-ray reveals its inner complexity.

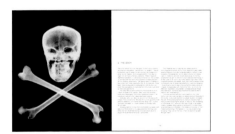

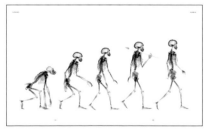

72 Hoist the Jolly Roger – a real skull and crossbones is far more sinister than any pirate flag.

74–75 This picture was inspired by a visit to Downe House, the home of Charles Darwin, expounder of the theory of evolution. Some of his contemporaries reacted with outrage at the suggestion that *Homo sapiens* had evolved from apes.

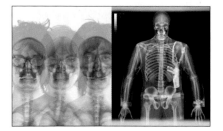

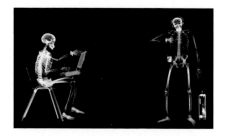

76 Meeting the band Supergrass in the pub before going into the hospital to x-ray them was a mistake. I was still hungover the next day when I had to take individual portrait photographs of all three members. By some fluke it all turned out OK in the end, mostly due to the talents of The Designers Republic.
77 A suit packing heat. I got the idea for the image from the kind of heavies you see guarding politicians, looking uncomfortable in their ill-fitting suits with sinister bulges (hardly) concealing their weapons.

78–79 Work, work. Busy, busy. Late, late.

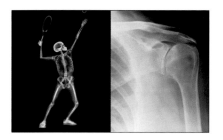

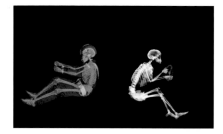

80 By adding x-rayed elements such as the ball, racquet and shoes, this tennis-playing skeleton "comes to life".
81 The human body – such a complex structure.

82 A photograph of a racing driver, with skeleton overlaid. Seeing the underlying bone structure really emphasizes how unnatural the driver's position is.
83 No it's not a scene from "Wacky Races", but the position a tense driver sits in for hours in a car. Seeing the curved spine, clenched jaw and finger bones bent around the steering wheel really heightens the feeling of discomfort.

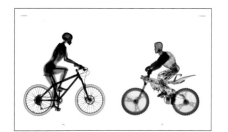

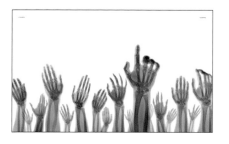

84–85 The human skeleton gets on his bike, only to be confronted by a toy super hero on his toy super bike.

86–87 Hands up! This image is composed from many x-rays of hands in different positions. We altered the sharpness to give a sense of depth. The hand is made up of 27 different bones.

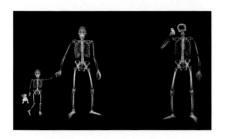

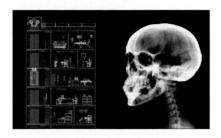

88 Parent and child.
89 I'm on the phone.

90 There are over 100 separate x-rays in this picture. Look carefully at the skeleton on the lower floor of the office block; it is encountering the all too familiar problem of a broken photocopier.
91 A well-used skull – you can see scarring towards the back of the head.

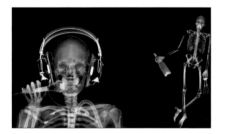

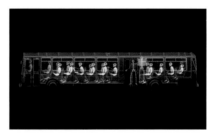

92–93 Exactly what I'm doing now so you can read these captions – typing into a laptop. A photograph of the keyboard was incorporated to show the letters. This helps the eye tell the brain what is happening.

94 These hands have been ravaged by arthritis. The bones are fused at the joints and badly twisted.
95 The coins falling from this trouser pocket are US currency. Look carefully and you can see both sides of the coin.

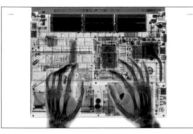

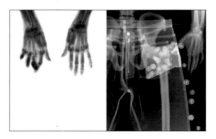

96–97 Social x-rays: the DJ is made from layering separate images to bring the skeleton to life. The microphone and headphones were x-rayed in a position to suit the final assembly. Our DJ is accompanied by a lounge lizard. Once again, the heavier the glass (in the bottle and champagne flutes), the more opaque it is in x-ray.

98–99 To get clearance to use the state-of-the-art technology required to x-ray this bus, I had to be interviewed by US customs, as the machine used plies the US/Mexican border looking for illegal immigrants and contraband. The authorities wanted to know I was not looking for ways to ascertain privileged information. I'd love to have one of these machines but as they start at $5 million I'll have to wait for my lottery number to come up. It's the little details like the bags and hats that make this picture work for me.

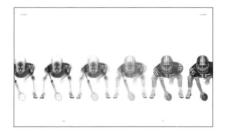

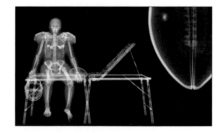

100–101 Graduating from all x-ray to all photograph, this sequence of an NFL football player in the set position reveals some of the protective gear worn by the players.

102 The same sportsman as on the previous pages, but now on the physiotherapist's treatment table.
103 Notice the stitching detail in the leather ball.

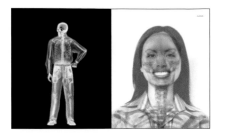

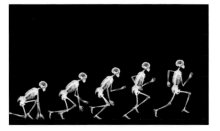

104 What a man, or this man anyway, keeps in his pockets. The shirt was x-rayed separately using inflated balloons that have been retouched out to give the volume required to make it look like it is hanging on the man's back.
105 Bone detail overlaid on to a portrait give this lady's face interest. Her natural teeth and positive smile remain the dominant feature, despite the x-ray layer.

106–107 On Your Marks. Get Set. Go! My homage to Eadweard Muybridge, inspired by his 'Figure in Motion' series. Muybridge was an innovator beyond comparison. Despite being interrupted in his quest during the late nineteenth century to provide photographic evidence that a horse has all four legs off the ground during a fast trot – by appearing in court accused of killing the man who had really fathered the son he believed to be his (for which he was acquitted) – he returned to complete the exercise by inventing techniques to capture motion in sequences. The motion picture was born! His contemporaries must also have held him in high esteem as those who enjoyed his amazing zoopraxiscope projections included Gladstone, Tennyson, Huxley and the Prince and Princess of Wales.

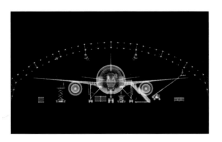

108–109 By some way the largest x-ray ever, this Boeing 777 jet being serviced is applied, life-size, to the front of a hangar at Logan Airport, Boston USA. This picture has won more awards than any other in this book. It took several months to complete and includes over 500 separate x-rays of individual elements that were scanned and re-assembled on the computer.

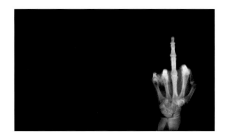

111 The Finger.

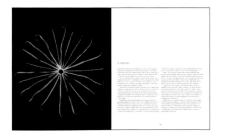

112–113 Vanilla pods arranged in a circular fan, with colour boosting the intensity of the centre of the circle.

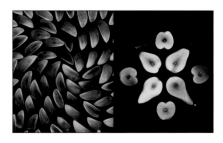

114 Mussels spread across an x-ray plate. No computer trickery here, but composing them in a swirl, like a shoal of fish, gives an eerie effect.
115 A coloured still life arrangement of apples and pears. The liquid present in the fruit adds tonal interest at the expense of detail. This image has the feel of an early large plate colour photograph.

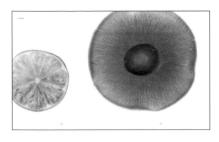

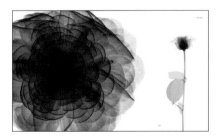

116–117 A lime, showing the interlocking tiny teardrop shapes of the flesh, and a mushroom, showing the mass of ribbed flesh.

118 Two whole chillies with their seeds exposed in x-ray.
119 A halved orange that reveals the segments within the peel.

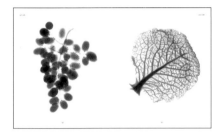

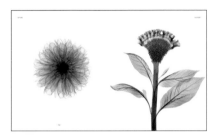

120 One of my first x-rays of food; I really like the wiry veins that the grapes hang from.
121 The bumpy, uneven texture of Savoy cabbage creates a lovely effect. I'm assured by those in the know that the x-rays do not harm the food in any way, but I've never eaten any of it afterwards. I like my food, but even I don't want to eat anything that has been sitting on a lead table all day.

122–123 Nature provides the most stunning of all subject matter. I've x-rayed hundreds of flowers, but none are more naturally beautiful than this Dahlia head (*Dahlia pinnata*). The Celosia (*Celosia cristata*) opposite has an undersea quality.

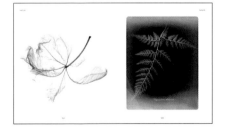

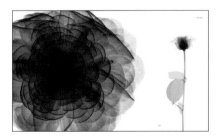

124 Fallen Chestnut (*Castanea fagaceae*) leaves left to dry naturally.
125 A Fern leaf (*Dryopteris dilatata*) in the style of early photograms, or contact prints.

126–127 A close crop of a Ranuncula (*Ranunculus picotee*) with a single Rose (*Rosa centifolia*).

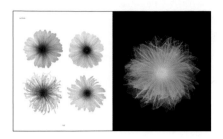

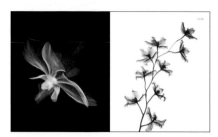

128 Four varieties of Daisy (*Asteraceae*)
129 *Chrysanthemum morifolium*
The hardest things to x-ray are those that have little substance. The x-rays are normally too powerful to hold subtle detail. It took several years to find the right equipment and technique to make successful radiographs of flowers. As the petals of these flowers are really thin, I'm very pleased with the detail these pictures show.

130 *Cymbidium* Orchid
131 *Cattleya* hybrid Orchid
Different types of Orchid call for a different approach.

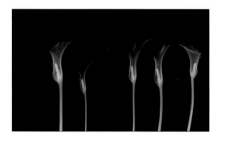

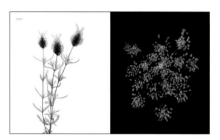

132–133 Arum lilies (*Zantedeschia aethiopica*). The pollen-heavy stamens, which are usually hidden within the petals, stand out here.

134–135 Lavender (*Lavandula angustifolia*) and some dried cow parsley, (*Anthriscus sylvestris*), found by the roadside.

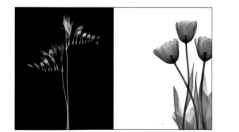

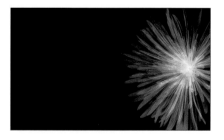

136–137 Two Freesias (*Iridaceae*), gracefully intertwined, and three Tulips (*Tulipa gesneriana*) in full bloom. When arranging flowers for these shots, I am working in the dark, literally: the plants have to be placed directly on to the light-sensitive film. Any light-safe bag for the film is thicker than the leaves and petals and would crush them, so I have no option but to convert the x-ray laboratory into a darkroom and lay the flowers directly on the exposed film in the dark. This means many exposures are ruined by poor composition, because I cannot see as I set the flowers into position. The purchase of night-vision goggles has helped to some extent, but I still get more wrong than right.

138–139 The bloom of a Chrysanthemum flower (*Chrysanthemum morifolium*). Some of the flowers have the look of underwater creatures, such as sea urchins.

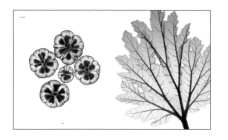

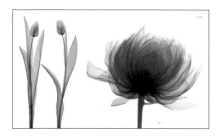

140 Dried small whole Pumpkins (*Cucurbita*). They shrink to such an extent as they dry that they are unrecognisable as the Halloween icon.
141 A *Gunnera magellanica* leaf, showing the network of veins running through the leaf.

142 Note the soil trapped at the point where the leaf uncurls from the stem of the Tulip on the left, *Tulipa orphanidea*.
143 A variety of Peony flower, *Paeoniaceae*.

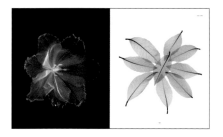

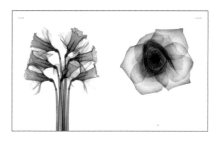

144–145 A serrated or Parrot Tulip (*Tulipa*) flower and Lemon tree (*Citrus limon*) leaves.

146–147 Six Daffodil (*Narcissus pseudonarcissus*) heads, and a Rose (*Rosa centifolia*) from above.

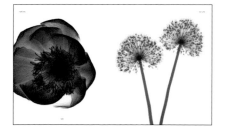

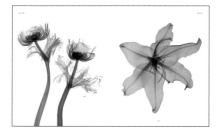

148–149 A Japanese Anemone (*Anemone hupehensis*) flower, plus two Alium stems.

150–151 Two Anemones (*Ranunculaceae*) plus a single Lily (*Lilium longiflorum*).

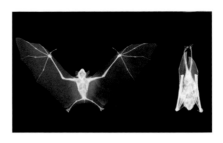

152–153 The small holes in this Rhubarb leaf (*Rheum palmatum*) are evidence of insect activity.

154–155 Two Fruit Bats (*Nyctimene albiventer*), one flying and one sleeping. These are scary enough in the flesh, but in x-ray…

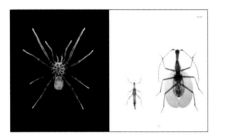

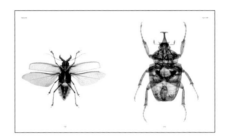

156 *Poecilotheria rufilata*, a member of the tarantula group of spiders, makes a fascinating x-ray study. Even though it was dead, I had to wear gloves and a mask to handle it, so dangerous is its venom.
157 *Extatosoma popoi horridus*, a member of the leaf beetle family that has unsurpassed camouflage – it looks exactly like a leaf. The larger image is *Mormolyce phylloides*, a Kricketune Violin Beetle.

158–159 I have to thank an entomologist who grew up in Papua New Guinea for many of these insect specimens. My studio became a creepy place during this particular project, and many practical jokes were carried out on squeamish colleagues. *Macrodontia cervicornis* has two pairs of wings which amplify that annoying buzzing sound as they approach you. I wouldn't like that to land in my soup. The beetle (*Fornasinius russus*) is a good example of the marvellous engineering evident in the structure of insects. You can start to appreciate how well designed for beetling and associated activities they are. These insects are immensely strong, adaptable and hardy in their habitat.

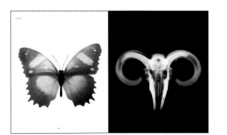

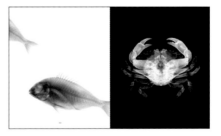

160 Butterflies are the most fragile things I've ever worked with. I have to move them into the x-ray laboratory, pick them up with tweezers and place them directly on the film each time I make an exposure. Again, all this is carried out with me stumbling about in darkness. The antennae drop off and the wings tear, so I have to get the image at the first time of trying. This Gladiator butterfly is *Hypolimnas dexithea*.
161 Rams use their horns in fights, hence the density of the bone where the horn emerges from the skull.

162 Red Snapper (*Lutjanus campechanus*) fish. The clarity of bone and teeth detailing in the original x-ray gave us the freedom to use paler colours than anticipated.
163 To obtain the best contrast and detail I experimented with very slowly drying out this crab and photographing it at different stages in the process. When it was fresh and wet, the inherent moisture softened the details in the image. Getting the moisture content just right, before the crab dried too much and started shrinking and cracking, was one of those things that you'd think would be easy but actually took days.

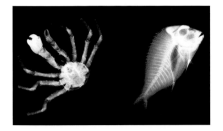

164–165 This Spider Crab (*Maja squinado*) was huge – about 600mm (2ft) across. I certainly wouldn't like it nibbling my toes in the sea. The fish is a Tilapia (*Tilapia cichlid*) and has very sharp bottom fins that pricked my finger. Opening the mouth helps show the sharp teeth.

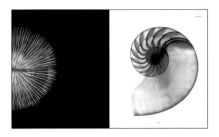

166–167 The coral, on the left, has multiple sharp thin ridges. The Nautilus Shell, on the right, is one of those natural organic forms that you often see repeated in man-made structures. It has inspired many designers over the years.

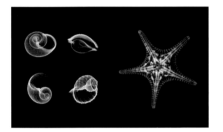

168 Clockwise from top left: Adler's Necklace Shell (*Polinices polianus*), Cowry Shell (*Cypraeidae*) and two Conch Shells (*Strombidae*) at the bottom. The Cowry Shell was used as currency in Africa and was a treasured item in the ancient civilisations of Asia. It's certainly more attractive than my credit card. They uncurl beautifully.
169 The Starfish opposite is a Vermillion Star (*Mediaster aequalis*). The hundreds of tiny grippers used to cling on to rocks in stormy seas create beautiful patterns and texture.

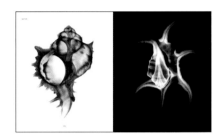

170 In some ways this shell (*Bolinus brandaris*) looks prehistoric, but it could equally be from some futuristic movie set in outer space. The flowing organic curls are countered by its spiky rugged exterior. As I've said before, you can't beat nature.
171 Aporrhaidae Shell (*Aporrhais serresianus*), also has otherworldly connotations, with its spiny points providing a protective barrier.

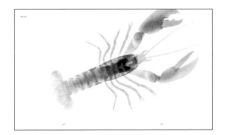

172–173 The European lobster (*Homarus gammarus*), is a tough cookie. Not only does it have a hard shell and huge claws, the x-ray reveals the strength of its joints.

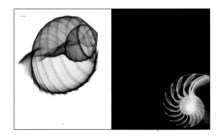

174 This Conch Shell (*Strombidae*), has a lovely ethereal glow which naturally occurs in the x-ray exposures as the thickness of the shell decreases towards the edge.
175 A Nautilus Shell (*Nautilus pompilius*) section, highlighting the swirly, fan-like internal structure.

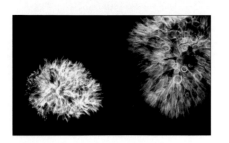

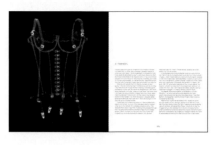

176–177 These two corals are bizarre looking creations. *Lophelia pertusa* is on the left; *Cladocora caespitosa* on the right shows the cell structure within the tubular arms. It feeds by osmosis along the cells in the tubes.

178 A lacy basque. The metal hooks and eyes run up the back of the basque. As they are made of metal, they appear brighter on the x-ray and therefore visually come to the foreground. It is difficult to work out the front of the basque from the back, but then again I'm no expert.

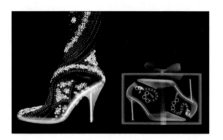

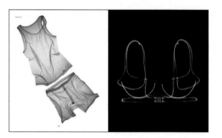

180 An Alexander McQueen Shoe Stocking – a shoe that merges into a bejewelled stocking. The quality of workmanship was simply stunning.
181 A gift-wrapped pair of Jimmy Choo shoes. I love to show such desirable objects are made with nails and metal plates. The shoe when displayed in luxurious stores looks extremely elegant and the level of finishing on the surface is fantastic. This picture sums up the way my process has a love/hate relationship with fashion. In my x-ray the shoes are still desirable objects, but by showing the jumble of nails around the heel, the image makes us question how they are made, not just what they look like.

182 From designer elegance to a string vest and underpants. They may not be as sexy or glamorous as a pair of Jimmy Choo shoes, but the texture and detail in these garments really appeal to me.
183 A sports bra, revealing its underwiring and a strong clasp.

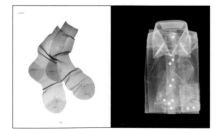

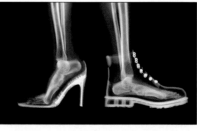

184–185 What I love about this picture is that it takes such an unpromising subject as a pair of socks to a level not imaginable with the human eye. The subtle creases and lines of these socks make this most basic item of clothing a piece of art. It is my favourite image in this chapter, in fact I don't even mind being given socks for Christmas any more, because they remind me of this picture. The picture next to it is not bad either – follow the folds in the wrapped shirt.

186–187 A clear illustration of the difference between men's and women's shoes: the stiletto-heeled shoe on the left contorts the bones of the foot and ankle, and throws the wearer's weight on to the big toe joint. On the right, the man's boot leaves the foot in a natural – and comfortable – position. In addition, the steel pins and metal tacks in the woman's shoe make it look more like an instrument of torture than a fashion statement.

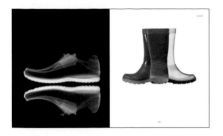

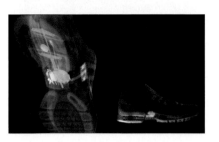

188 It's not a reflection, but the other half of the pair.
189 These Wellington boots are a photo and x-ray merged and overlapped.

190–191 These trainers have an in-built sensor that automatically adjusts the amount of support given as the terrain changes. If you run from grass on to concrete, the sensor detects the change and responds by giving the foot more support, as concrete is less forgiving.

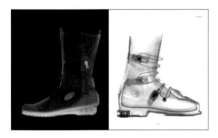

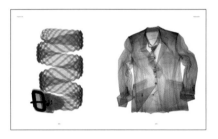

192–193 A leather motorcyclist's boot and a ski boot that has been gradually coloured. This type of colouring takes many hours of work on the computer.

194–195 A woven leather belt, and a jacket, shirt and tie. The level of detail in the jacket is excellent – you can see how the shirt creases at the elbow and mingles in with the jacket and its lining. This shot consists of eight overlapping x-rays, all exposed in the dark. Individually scanned and then tiled back together, the overall effect is of translucence.

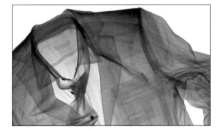

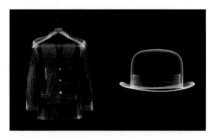

196–197 A closer look at the jacket, shirt and tie to explore the detail. The shirt maker's tag is clearly visible, as are the interior pockets set into the lining of the jacket.

198–199 A pinstripe suit on a hanger, next to a classic bowler hat. The cloth made to make this suit had a defined chalk stripe which, as it is a thicker weave than the rest of the material, gives definition. Note the wire used to stiffen the hat brim.

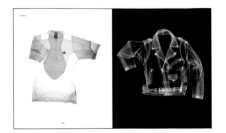

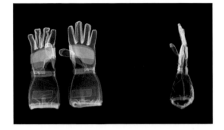

200 This athlete's shirt has been coloured to match its real appearance. Different hi-tech fibres allow the body to breath during exercise yet retain warmth.
201 The leather biker's jacket on the right doesn't have protective pads. The ring in the pocket in the bottom right hand corner isn't a hair elastic but the price tag. I had to leave that in so I could take it back to the store and get my money back after I'd finished with it.

202–203 Leather motorcycling gauntlets from two different angles. To get the image from the side I threaded fine cotton through the gauntlet and one finger and used this to suspend the glove in front of a lead plate. I then rotated the image 90 degrees.

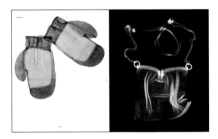

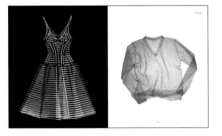

204–205 Boxing gloves, and a handbag made of a material resembling chain mail. Both items look surprisingly light and delicate given their purpose.

206 This dress, another Alexander McQueen creation, was made of expandable metal strips all sewn together. It was seriously heavy. I do not envy the size zero models labouring as they struggle down the catwalk dragging this dress on their backs. Yet again the detailing was superb.
207 To finish, a golfing v-neck that just reveals the diamond pattern embroidered into the knit of the textile.

Acknowledgements

In no particular order I'd like to thank:
Rick Mayston at **getty**images®, whose initiative and tenacity made this book happen. Piers and all at Carlton Books for showing faith in my work. John Twydle at GE Inspection Technologies for support and guidance. Chris, Jamie, Mike and all at the x-ray lab. Lesley Hollister for teaching me so quickly and always making it such a laugh. The many radiographers, scientists and equipment manufacturers that have helped me out. Jerry Tavin for being a gentleman. Spencer Nugent for the great nights and inspiration in ultraviolet. All those from GIANT – where I learnt the value of ideas and had so much fun it is embarrassing to recall actually getting paid.

Over the years there have been many people foolish enough to commission me. A big THANKS to one and all.

Colleagues present and past with my respect: Katie Wellsford – a true artist and a lovely person, Al and Wendy at my studio and Stuart O'Neill, whose expertise has proved invaluable in creating most of these pictures.

My family have provided stability and given me the opportunity to express myself. In particular I'd like to record my gratitude to my mother, Alice, for devotion beyond the call of duty, my late father, Herbie, for instilling self-belief, my brother Michael for encouragement and my aunt Mrs Eileen Gilham – a lady with morals and integrity.

Truly I'm a lucky man. My wife Zoe has guided me creatively and made me believe it could happen. Without her I'd be lost.

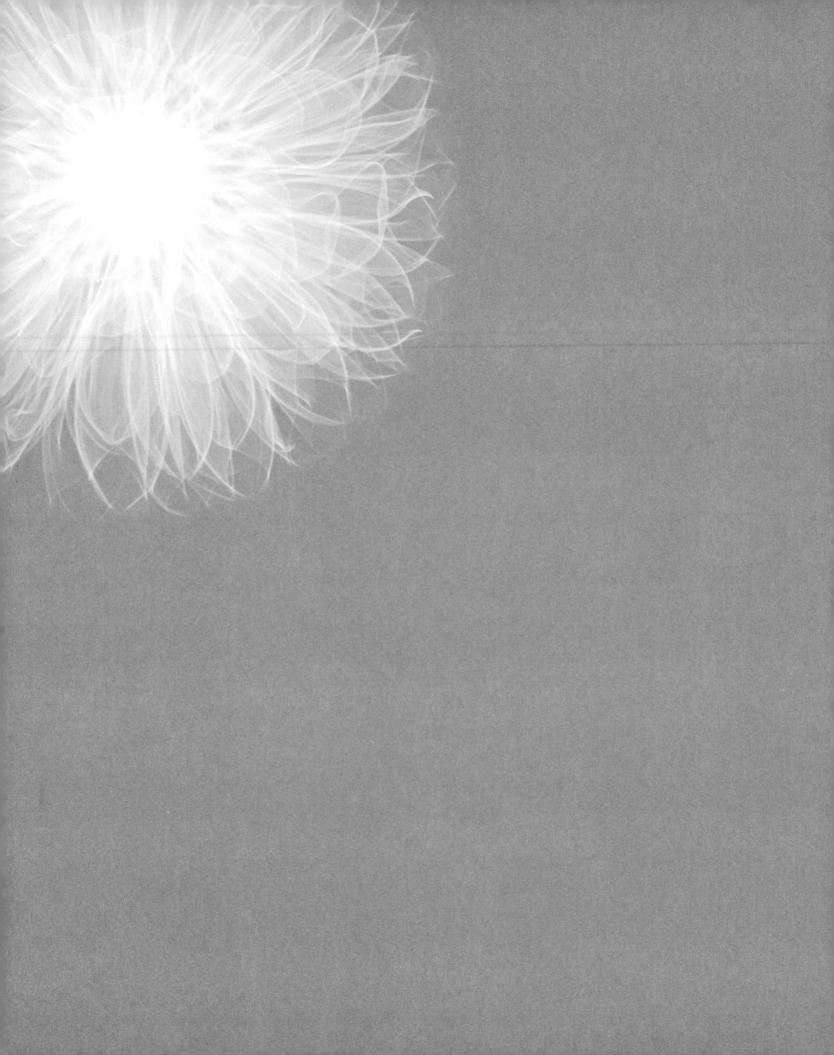

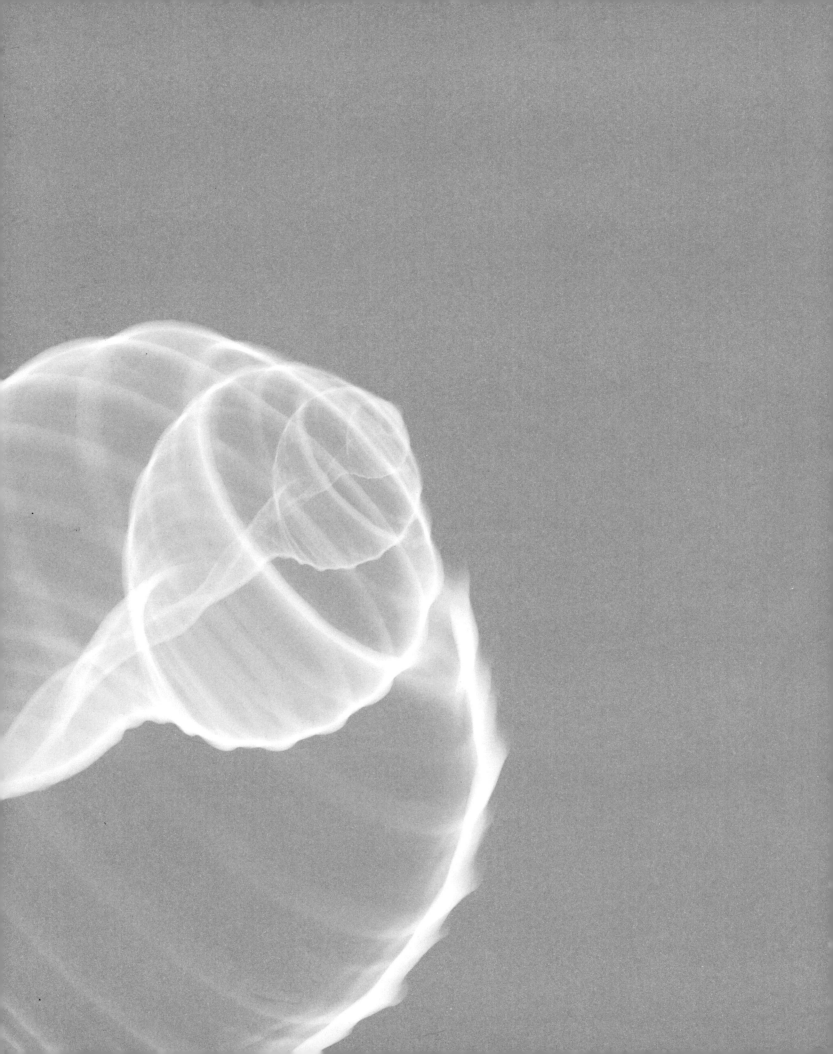